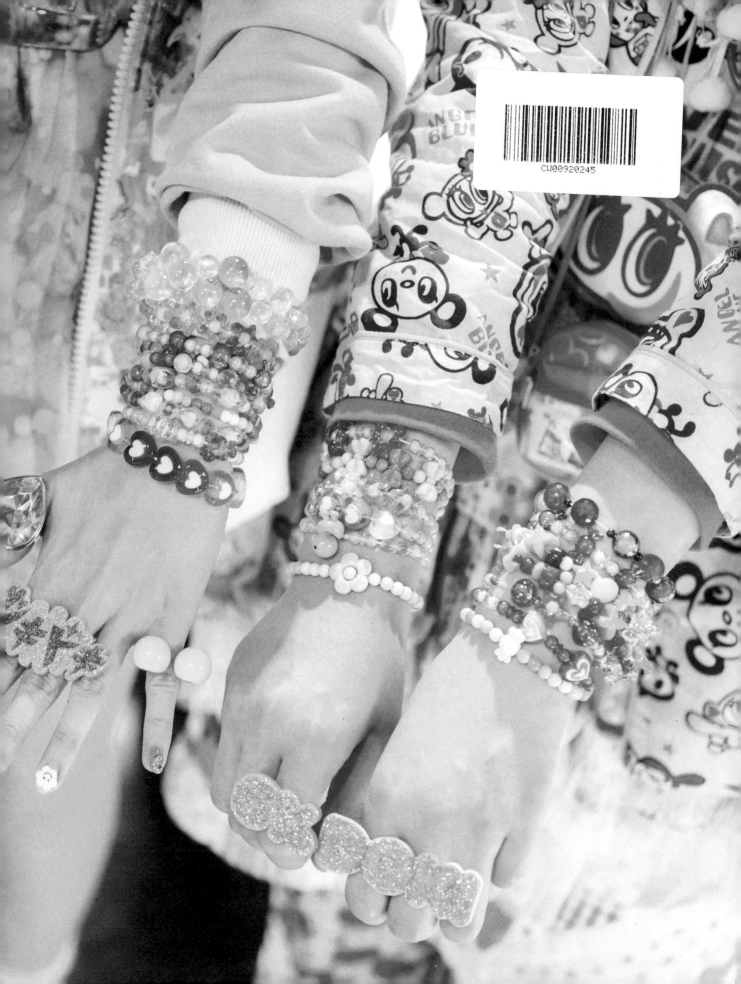

# THE OBSESSED

Otaku, Tribes, and
Subcultures of Japan

gestalten

# TABLE OF CONTENTS

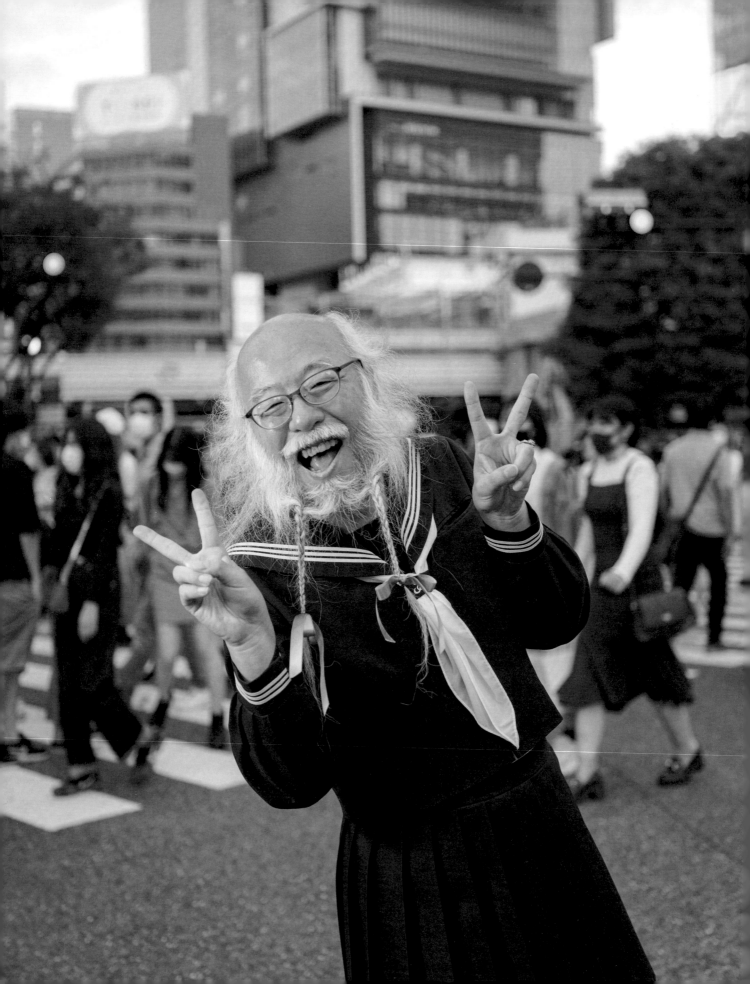

# THE MEANING
# OF OBSESSION

Foreword by Irwin Wong,
photographer and co-editor

There is a phrase in Japanese, 出る杭は打たれる *(deru kui ha utareru),* meaning: "The nail that sticks out will be hammered down." In other words, an excess of talent or flair is likely to be sanctioned or subject to criticism. While this phrase is present in some shape or form in other languages and cultures, it seems to encapsulate many of the stereotypical traits the rest of the world associates with Japan: a populace that sacrifices individuality to maintain the harmony of the whole, a community-minded culture that values conformity to social expectations.

It seems counterintuitive then, that Japan has some of the most exuberant and recognizable subcultures in the world. Their breadth and depth are stunning. Some have become so pervasive that words like "otaku" and "cosplay" have made their way into the Oxford English Dictionary; others, such as the home-grown, head-turning fashions of Harajuku and Shibuya have enamored international artists and designers, and influenced the way we dress.

From the outside, many of these niche interests might seem bizarre. Yet for those dedicated to them, they are a way of life— a community with which to explore shared passions and even alternative identities to escape into, away from the everyday grind. The one thread connecting all these disparate subcultures is the utter devotion their proponents show to their lifestyle. Whether spending over 50,000,000 yen on customizing a truck or building a full-sized army vehicle from scratch in a garage, the otaku, or super-nerd, pursues their hobby to a point beyond all common sense and reason. Their dedication gives new meaning to the way we identify with the things we are passionate about and begs the questions: Do we also pursue our interests to the degree we would like to? Are we brave enough when it comes to showing the world how much we love something?

The people in this book are the nails of Japanese society that refuse to be hammered down. They have all, in their own way, decided to carve their own unique paths, and in many cases, have found a microsociety that accepts and nurtures them for their differences. In these pages, we celebrate these individuals in all their glory. Without them, our world would be many shades less colorful.

Irwin Wong is an editorial and commercial photographer based in Tokyo. Originally from Melbourne, Australia, he moved to Japan in 2005. He was also co-editor of gestalten's *Handmade in Japan,* published in 2020.

# OTAKU: WHO ARE YOU?

Tracing the shifting meanings of otaku,
from the 1980s to the present day.

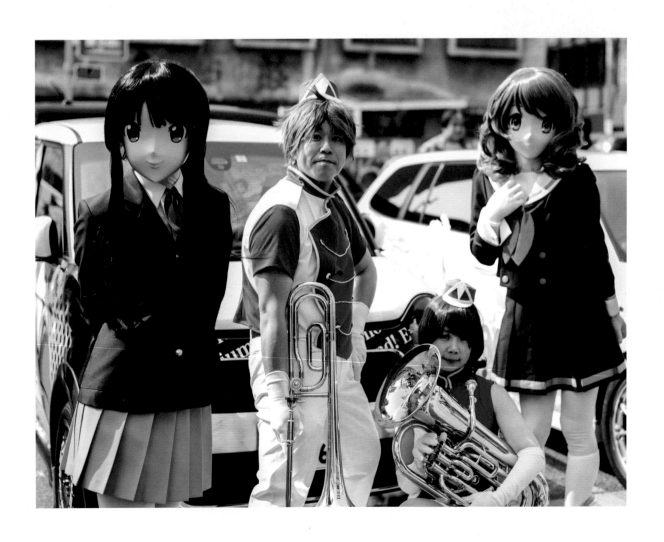

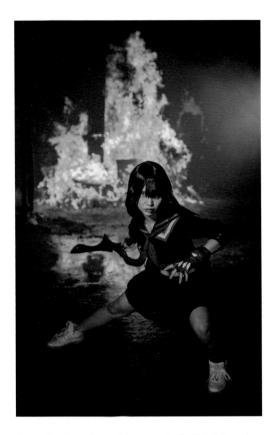

Above: Cosplayer Tanya dresses as Ryuko Matoi from the anime *Kill la Kill*. Opposite page: Fans come out in force for Nipponbashi Street Festa, the largest cosplay event in Osaka.

*Otaku.* The meaning may seem obvious enough. But it's worthwhile reflecting on what exactly it is we think we know. The assumption of knowledge tends to close down critical inquiry and reinforce stereotypes, after all, and this is particularly problematic when it comes to otaku because the media has played such an important role in setting the parameters of discussion. With its dense web of popular print publications and television shows, Japan is extremely adept at creating media events and phenomena. From herbivore boys to *hikikomori* (a term used to describe those who avoid social contact), there is an endless cycle of new identities, fashions, and social issues. Much of this is self-referential, and, through citation and repetition, these media fictions and fantasies transform into so-called realities.

The word otaku literally means "your home," and is used in some settings as a second-person pronoun. In Japan during the early 1980s, however, it began to be associated with the perceived excesses and perversions of people with obsessive interests. Terms such as *fan* (*fanjin*, fanzine) and *maniac* (manga mania, manga maniac) were already in circulation, but otaku was meant to refer to something different: something strange, weird, wrong, and/or abnormal about certain fans and maniacs.

An early examination of the term appeared in a series of articles in *Manga Burikko*, a comics magazine targeting fans of cute girl characters, an audience which in many ways defined otaku. From June to August 1983, in his *Otaku no kenkyū* (*Otaku Research*) column, writer Nakamori Akio called out unfashionable and obsessive fans, deriding practices such as attending fanzine conventions, costuming as characters, and lining up overnight for the release of animated films. While Nakamori labeled everyone from trainspotters to idol chasers–men and women of all shapes and sizes with varied interests–as otaku, the bulk of his criticism was reserved for male fans of manga/anime-style cute girl characters. Describing such men as having a "two-dimensional complex" (*nijigen konpurekkusu*), he called them "gross" and "faggy," fueling a backlash amongst some readers.

For his part, the editor of *Manga Burikko*, Ōtsuka Eiji, saw Nakamori's name-calling and line drawing as an extension of what Ōtsuka described as the "game of differentiation." In the heady media-commodity system and

オタクってどんな人？

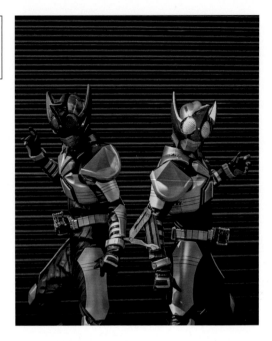

<u>Above:</u> High-level *Kamen Rider* cosplayers on parade at Nipponbashi Street Festa.

information-network society of the day, there emerged those sensitive to symbols and brands and capable of manipulating them to create minute, arguably artificial differences–tiny details that made all the difference between cool or cringe for the hipsters and in-crowd. Those labeled otaku seemed to have failed the game of differentiation somehow or have had no interest in playing it. Nakamori's column focused on the style and sexual status of otaku, while, at the same time, distancing Nakamori's own interests in media and material culture from those with a "two-dimensional complex." His writings reflected a broader discourse of negative identity politics that defined the self in relation to an "other."

Perceiving the column to have gone beyond the mischievous roasting of his readers, Ōtsuka canceled it. A final installment, however, written by an associate of Nakamori named Eji Sonta, appeared in the magazine in December 1983. In it, Eji portrayed otaku as men unwilling to grow up and face reality, leading them to cling to relationships with manga/anime characters and form cliques that support, if not encourage, social and sexual immaturity. Rather than take this criticism as a spur to join Nakamori and Eji's apparently more adult club, *Manga Burikko* readers playfully self-identified as otaku and reclaimed the word for themselves.

The use of otaku as a pejorative returned with a vengeance at the end of the decade. In 1989, 26-year-old Miyazaki Tsutomu was arrested for molesting, murdering, and mutilating four girls between the ages of four and seven. This shocked a nation renowned for its low rates of violent crime, and people scrambled for an explanation. When it was discovered that the murderer owned 5,763 videotapes, based some of his crimes on horror films, and recorded those crimes for his collection, an image of pathological media consumption began to take shape.

The press tied Miyazaki's sickness to his interest in manga/anime-style cute girl characters. Photographs of his room–crammed with boxes of media piled to the ceiling and blocking out the sun–were dissected in tabloids and on talk shows, with much speculation about the manga magazines visible beside the bed. Journalists present during the photographing have since suggested that the few pornographic manga that Miyazaki owned

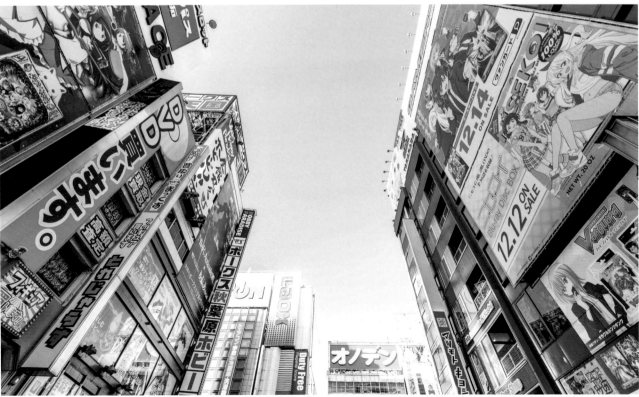

Top and bottom: Brilliantly garish billboards in Akihabara, Tokyo's shopping hub for electronic products and the center of Japan's otaku culture.

オタクってどんな人？

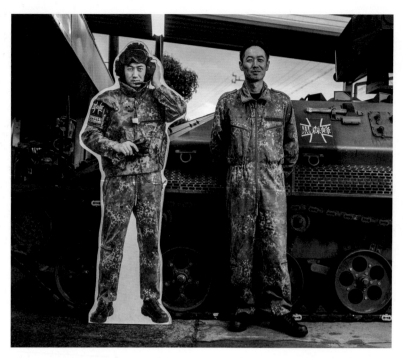

Left: Ohashi Yasuhiko created
his own armored vehicle at
home. Right: Vinyl figures
are one of the most popular
collectibles in Japan.

were laid out next to the bed, bolstering the assumption
that the boxes behind them contained manga and anime.
As numerous talking heads weighed in on whether
or not manga/anime fans were dangerous, *The Book of
Otaku* (*Otaku no hon*, 1989) and *The Generation of M* (*M no
sedai*, 1989) were rushed to print. Accepted or denied,
connections were being forged between otaku and a
monstrous serial killer.

In phrases such as "otaku youth," "otaku tribe,"
and "otaku generation," the word became a label for
manga/anime fans who "might be mentally ill and perhaps
even a threat to society," as Frederik L. Schodt wrote
in his 1996 book *Dreamland Japan*. Indeed, as the 1990s
unfolded and economic instability led to social unrest
and a perceived crisis of out-of-control youth, talking
about otaku became a way for media pundits and cultural
critics to convey anxieties about Japan and its future.

With the phenomenal success of the *Neon Genesis
Evangelion* animated franchise in the second half
of the 1990s, there was a reevaluation of the potential
of works made by and for otaku. The flow of positive
feedback began to surge in the 2000s, sometimes
referred to as the "otaku boom," a time when Japan
as a nation seemed to embrace its inner obsessive.
Culturally, manga/anime expression was elevated as an
art in global exhibitions such as Murakami Takashi's

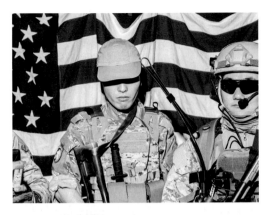

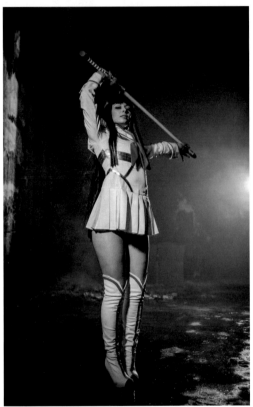

Top: Military enthusiasts have a large community here.
Bottom: Yuriko Tiger cosplays as Satsuki Kiryuin from *Kill la Kill*.

*Little Boy: The Arts of Japan's Exploding Subculture* (2005). Economically, otaku appeared to be a driving force in innovation and creativity, contributing to robust domestic sales and exportable products. Politically, otaku were visible and vocal fans of manga and anime around the world, which suggested new directions for public diplomacy.

Beyond deconstructing otaku fictions and fantasies, however, it might be useful to consider what imagined transgressions inform them. During the otaku boom, sociologist Thiam Huat Kam interviewed Japanese university students who did not identify as otaku, and codified rules that they perceived otaku to be breaking. He found that the students applied the term to those who took consumption and play beyond "common-sense limits," associating otaku with escaping from reality and abandoning social roles and responsibilities. They saw them as people with an inability to communicate, an interest in minor things, and failed or aberrant gender performance. These studies demonstrated how norms are negotiated through the figure of the otaku: just as the negative assessment of "them" defines "us," "I" depends on "you."

Thiam Huat Kam also revealed lacuna in the discourse around otaku–for example, some of the people he interviewed could not picture women as otaku. Otaku men have become hyper-visible subjects, a fixation that blinds us to realities past and present, including the central role of women in the history of manga/anime fandom in Japan from the 1970s onwards. The gender bias that exists–from *Manga Burikko* to *Neon Genesis Evangelion*–obscures the diversity of fan-oriented media in Japan and beyond. Ultimately, otaku means nothing out of context and a great deal at specific times and places. A fuller picture will require fresh and attentive explorations of the dynamics and politics of the meaning-making process.

**Patrick W. Galbraith** is an Associate Professor in the School of International Communication at Senshū University in Tokyo. He holds a PhD in Information Studies from the University of Tokyo and a PhD in Cultural Anthropology from Duke University. Recent publications include *Otaku and the Struggle for Imagination in Japan* (2019), *AKB48* (2019), and *Erotic Comics in Japan: An Introduction to Eromanga* (2020).

オタクってどんな人？

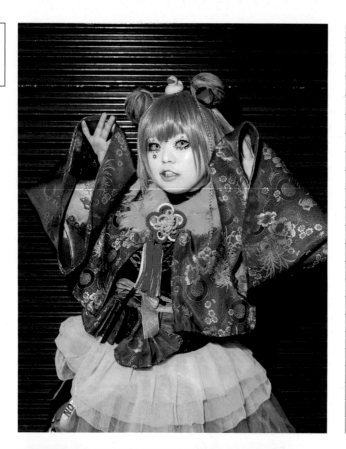

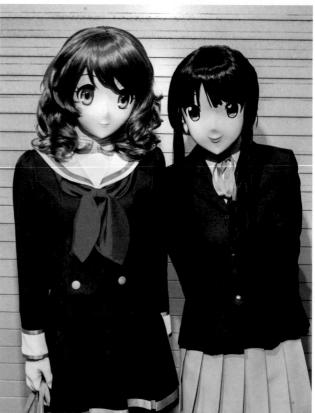

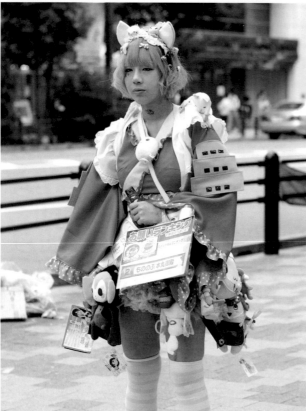

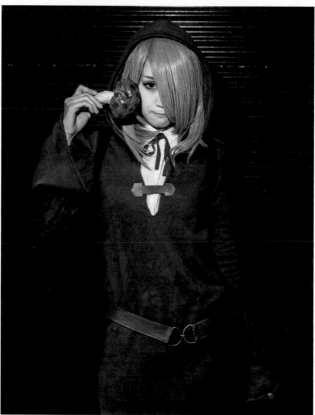

This page and opposite: An explosion of colors and accessories, adorable mascots, and cosplay–inspiration for every style obsession can be found on the streets of Tokyo.

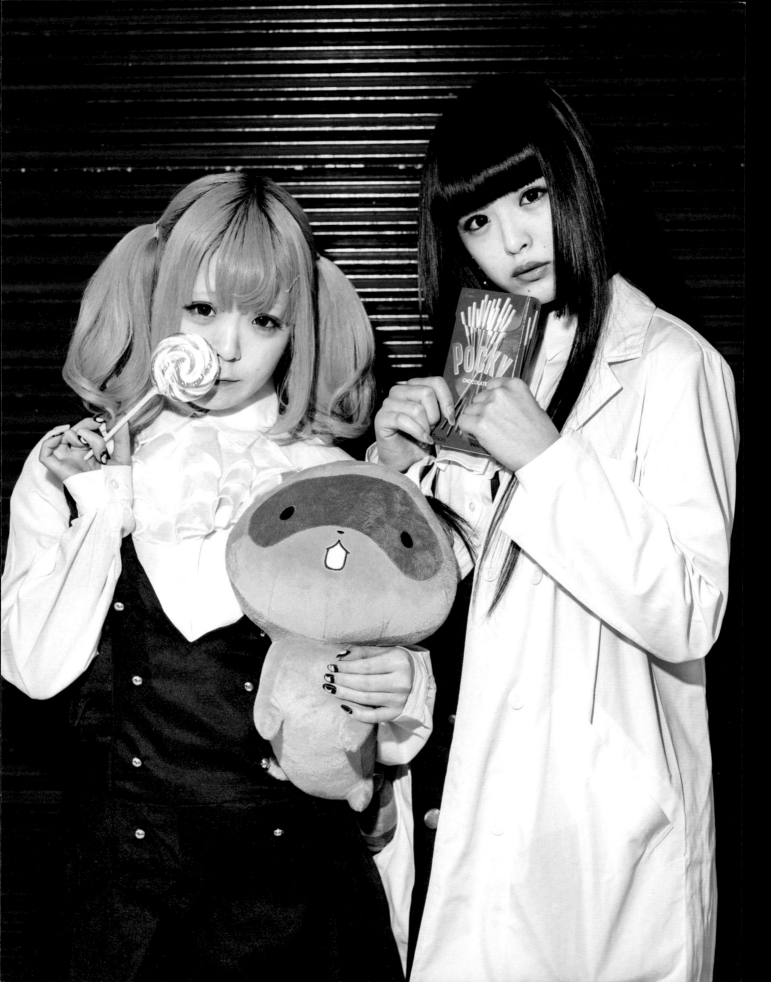

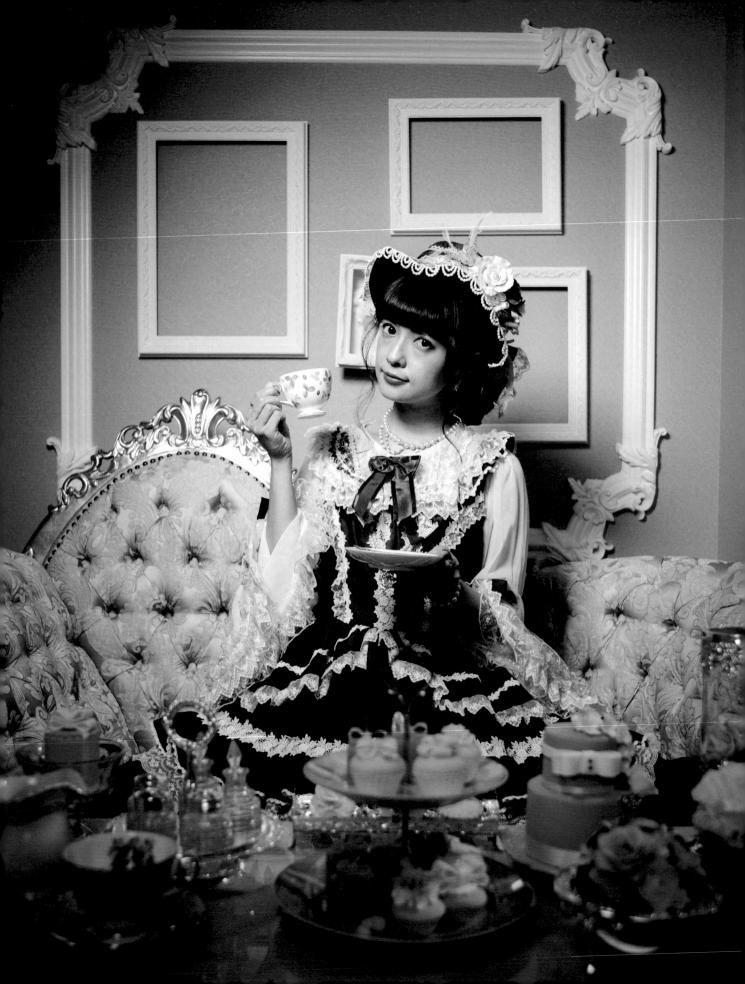

青木美沙子

Aoki is one of the most recognized Lolita fashion models in the world and an official kawaii ambassador.

## AOKI MISAKO

The ambassador of kawaii for Japan.

In the world of Lolita fashion, you cannot go for long without hearing the name Aoki Misako. She was discovered by ground-breaking fashion magazine *Kera* at the age of 15, and one of her earliest assignments was to model Lolita looks. While initially unsure, she found that the voluminous nature of the garments helped her feel more confident about her body insecurities while still feeling cute. She has since rocketed to stardom in the fashion world and become an official "kawaii ambassador" for Japan's Foreign Ministry, helping spread the word of Lolita style across the globe. In addition to modeling and promoting kawaii culture, she is also a registered full-time nurse. "I can switch gears very easily," she says. "When I put on my nurse's uniform, I'm 100 percent in that mindset. When I wear Lolita, I act more cute and effeminate."

Having been a Lolita figurehead for more than 20 years now, Aoki wonders if there will come a time when she will transition back to more mundane clothing. But for now, she remains an inspiration to people of all ages who are drawn to the style. "Lolita fashion looks innocent and sweet, so people think it's only for young people. That is not true at all. By wearing Lolita, I want to show that if you like something, you should wear it for as long as you want."

璃
月
愛

## AKIZUKI AI

A leader of tea-party loving Lolitas.

The meaning of Lolita fashion, as it is
known in Japan, has diverged quite far
from the original connotations of the word
"Lolita" in Nabokov's 1955 book. Following
the publication of that novel, the term
began to be used to refer to a young girl
who was unassumingly seductive despite
her innocence. In Japan, however, it has
come to encapsulate a style of dress that,
while girlish in the extreme, is decidedly
not intended to be attractive to the
opposite sex. Created in Harajuku, it draws
inspiration from the many-layered frilly
frocks and petticoats of the Victorian
and Rococo era, with a more contemporary
twist: Ankle-length dresses are often
done away with in favor of skirts that come
down to the lower thigh, coupled with knee-
high socks. This emphasizing of a sweet,
innocent nature is another manifestation
of the kawaii mentality.
 Akizuki Ai was drawn to Lolita fashion
from a young age after being influenced
by her mother. "I always wore clothing like
this," she says, "even without knowing it
was a genre. When I went to Harajuku and saw
magazines featuring my style of clothing,
I felt a shock throughout my whole body." Now,
Akizuki is a leader in the Lolita fashion
world, regularly organizing tea parties for
those who share the same passion. Akizuki's
style is generally considered to be *ama-loli*,
which emphasizes sweetness and innocence,
but she feels every style is as valid as
the next. "The best thing about Lolita
fashion is that you can give form to your
own personal kawaii style."

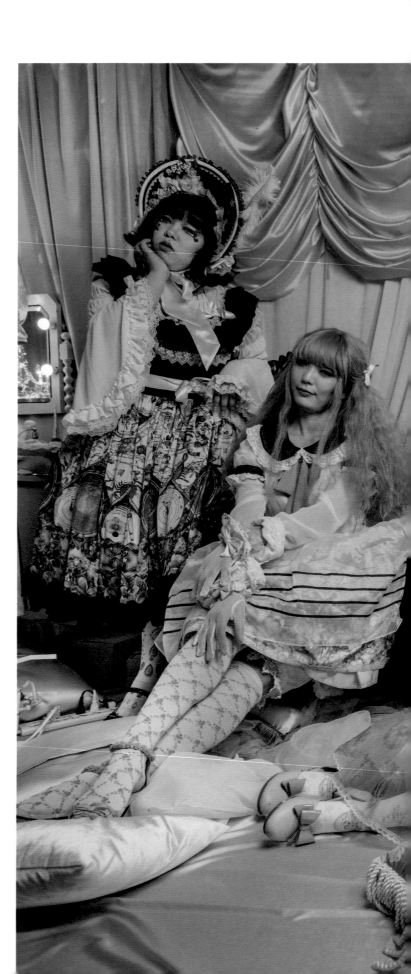

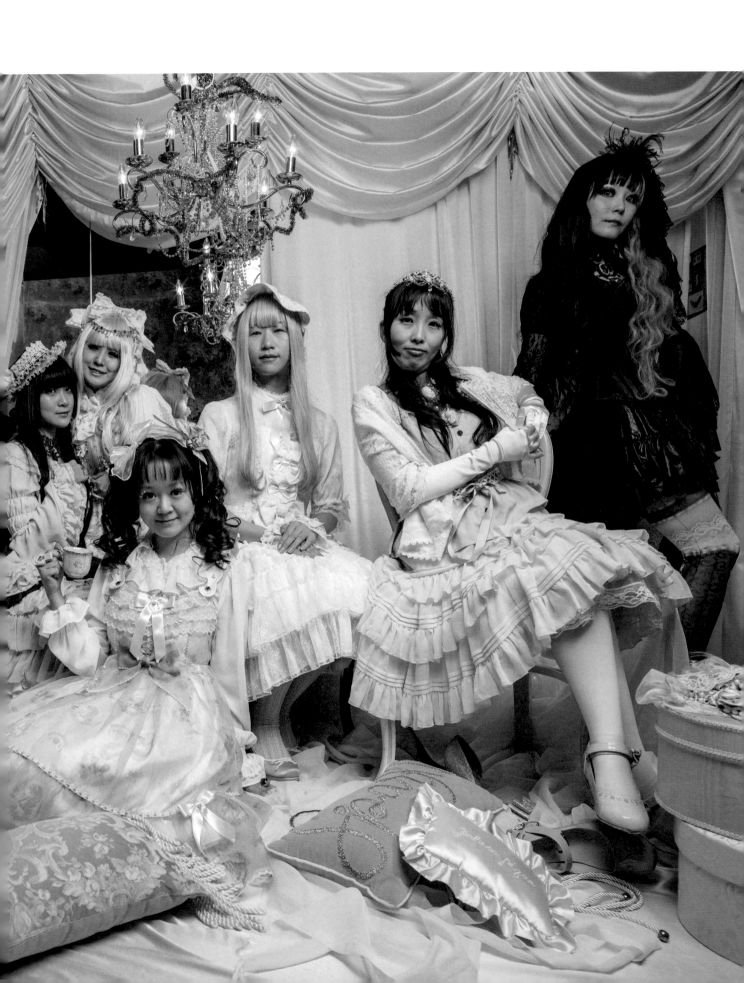

璃
月
愛

一

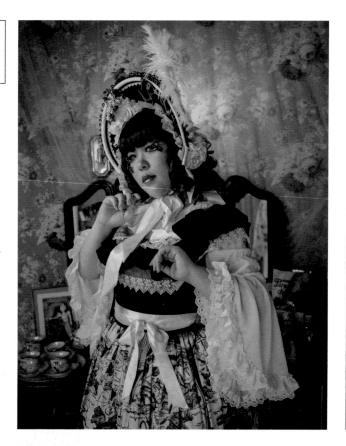
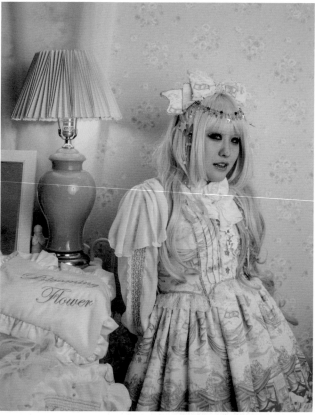
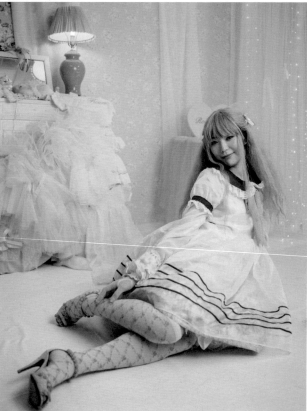
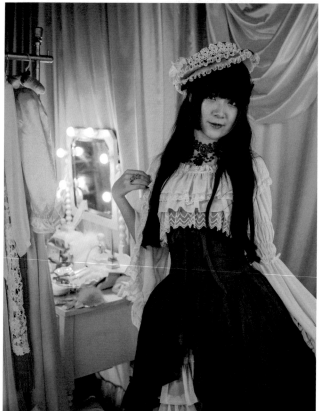

This page: Akizuki's circle of Lolita-loving friends represent many of the different sub-genres of the fashion. Opposite page: Akizuki's style, *ama-loli*, is a portmanteau of *amai* (sweet) and *loli* for Lolita.

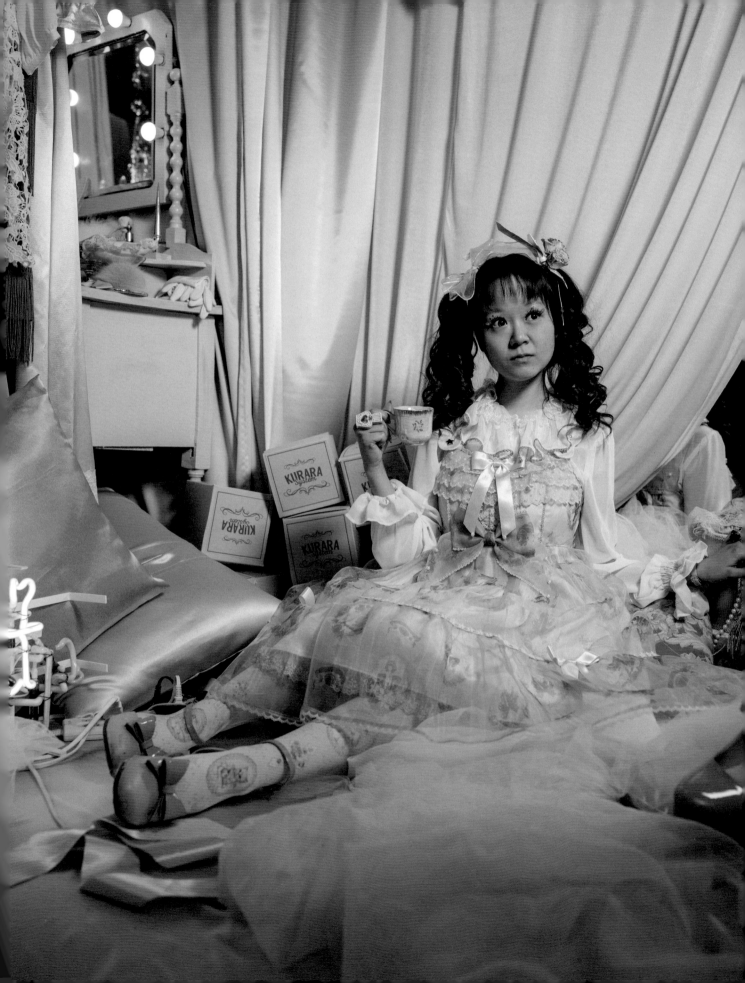

## MAID CAFES

A frilly staple of otaku culture,
and a common sight in Akihabara.

The word "kawaii" is more or less known around the world to mean "cute," but in Japan, it can be used to describe a positive quality in anything. In the 1990s, a new word emerged in mainly otaku circles that became the new parlance for describing one's feelings toward cute female characters: *moe*. This word is the currency of the gigantic industry of Japan's maid cafes.

"Moe can mean all sorts of things: healthy, ephemeral, cute," says Mahore, a veteran maid of over 17 years at the maid cafe Mailish. "But it also refers to the feelings of protectiveness a man feels when they see girls who are innocent, clumsy but good-hearted." This definition, while unwieldy, offers a good insight into what you can expect in most cafes–cute young ingenues who, while not always the best at their jobs, try really hard nevertheless. The maids themselves are unlikely to use their real names, and their persona may be fabricated to pull at the moe heartstrings of their customers. Stepping into a maid cafe is akin to stepping into a roleplay in which you're the main character in a carefully constructed otaku fantasy.

Maid cafes emerged in the late 1990s when cosplay began taking off in popularity. Seeing an opportunity for promotion, video-game companies began operating cafes with waitresses dressed in the costumes of the game characters. A seminal influence in this trend was the dating sim game *Welcome to Pia Carrot 2*, a video game set in a cafe where all the waitresses–dressed in maid outfits–were objects of potential romance for the player character. This formula proved successful, and while the popularity of the video game waned, the maid cafe concept had taken root. Non-game affiliated cafes sprang up around Akihabara, serving as little oases for otaku to rest in between the hard hours of arcade gaming or figurine shopping. Competition between maid cafes is notoriously fierce, with dozens opening and folding every year. Despite this, their enduring popularity comes down to a common element. "Maid cafes are a place where you can be yourself without anyone looking down on you," says Mahore. "You'll always find someone eager to talk to you about your hobbies."

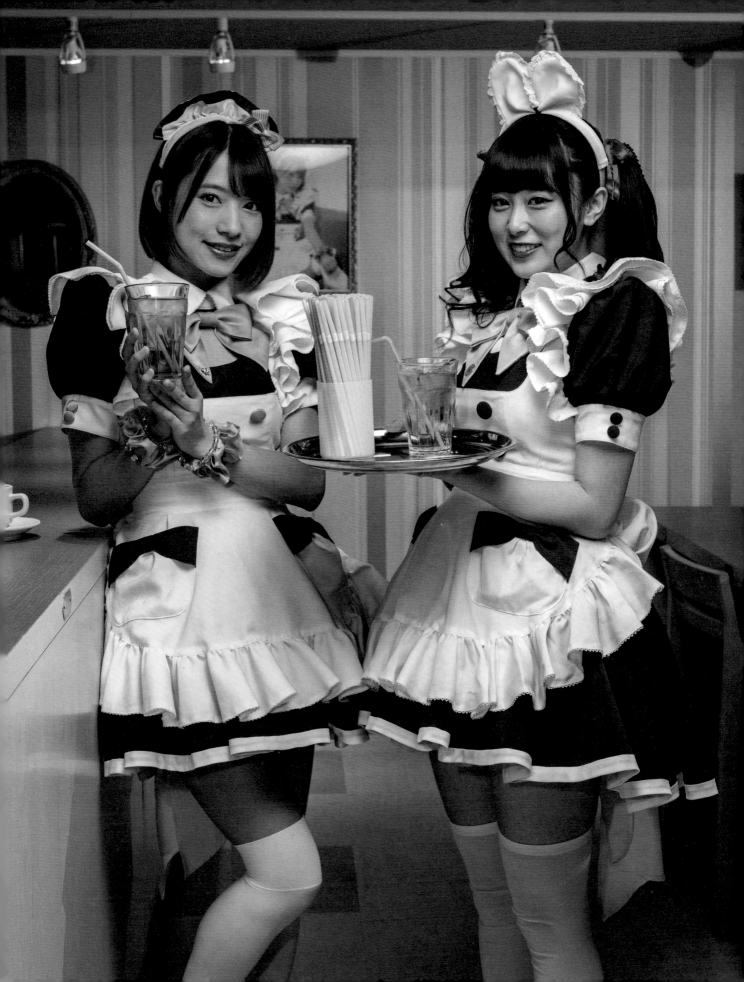

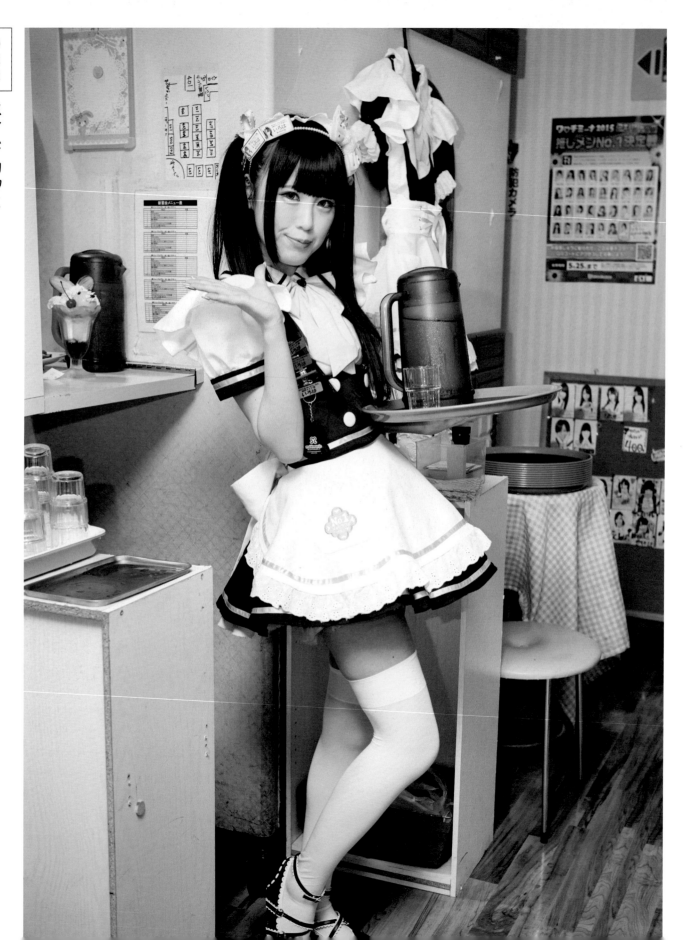

Above: Maid cafes emerged in the late 1990s and sprang up around Akihabara, serving as little oases for otaku. Below: Competition between maid cafes is notoriously fierce, with dozens opening and folding every year. Opposite page: Maid in a maid cafe in Akihabara.

単眼面

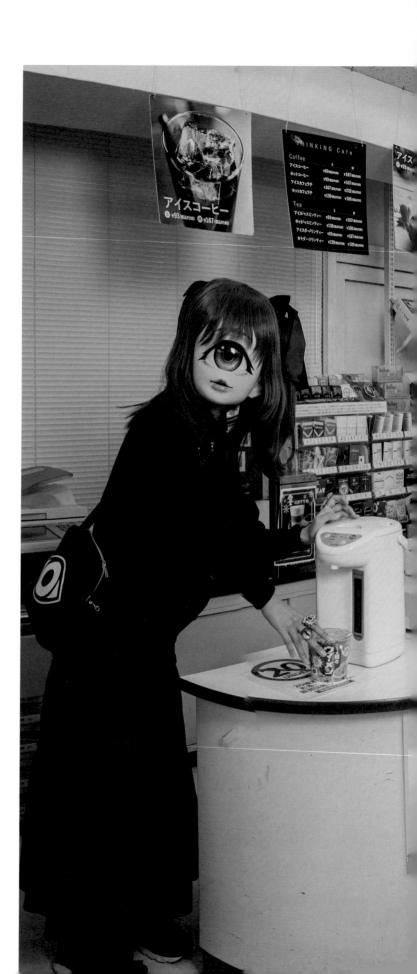

# TANGANMEN

These one-eyed masks have become a cult hit, much to the amazement of their creator.

On the outskirts of Akihabara is an interesting cafe with a unique staff. Monster Party is a monster-themed cafe, but not in the traditional sense of Japan's most famous kaiju, namely Godzilla. These monsters are cute kigurumi girls with one defining feature: Their masks are dominated by one gigantic eye in the center. These *hitotsumemen* (one-eyed masks) were created by the artist Ozawa Dango. "I originally created a one-eyed mask just for myself," she says. "I had no idea that people would be interested in buying them." She became interested in kigurumi in her early 20s but soon found that the overwhelming majority of kigurumi wearers were guys cosplaying an anime character. Finding it difficult to join that community, Ozawa decided to make her own character with her own rules. "Chimo," she says, explaining her mask's identity, "is a regular girl who wears cute clothes and just happens to have one eye."

She debuted the character in 2012 at Design Festa, an event for indie artists and crafters, and was surprised by the positive reception, especially amongst women. "A lot of people wanted to buy one, so in 2014 I started selling them," she says. "It was strange—many customers were not even interested in kigurumi culture, but when they put the mask on, their personality changed. A lot of people have that inner personality that they want to let out, and the mask is a way to feel comfortable doing that, I think."

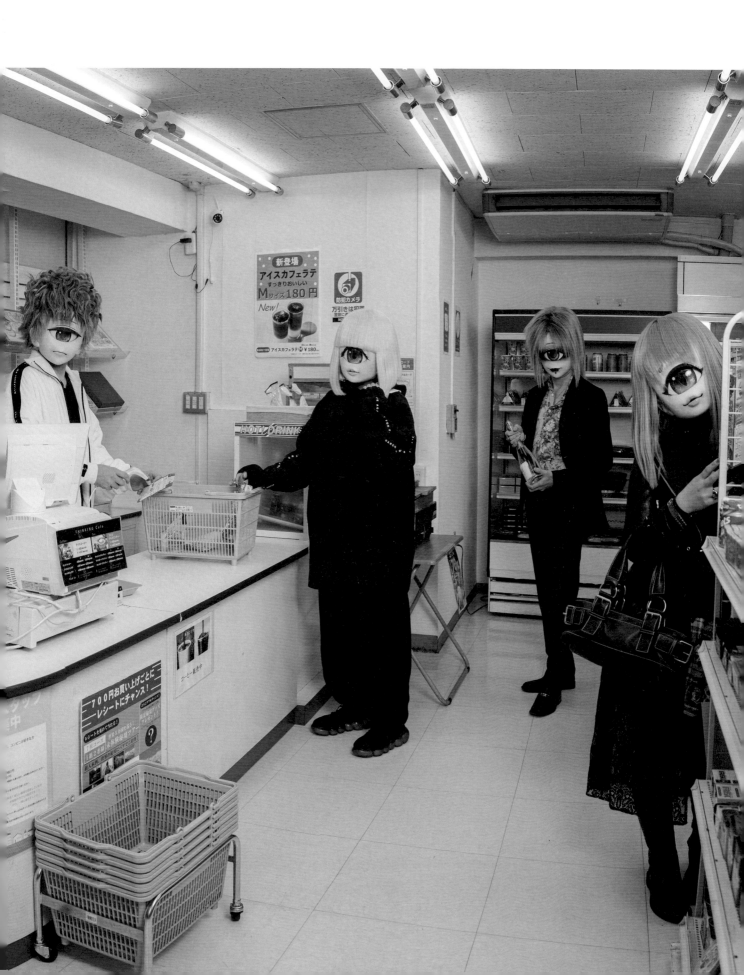

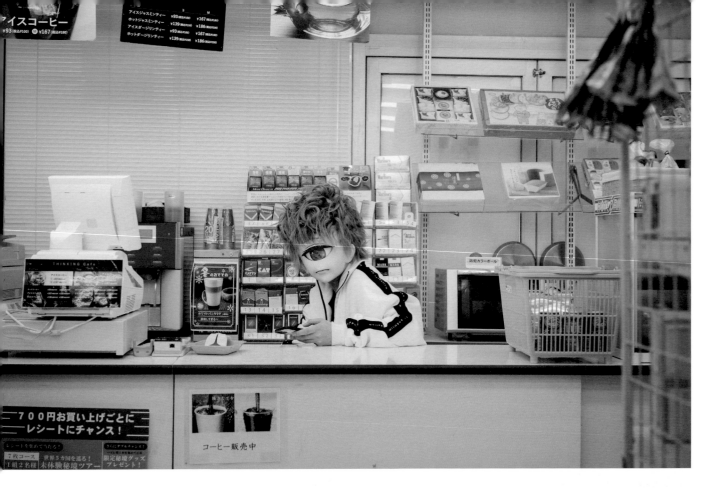
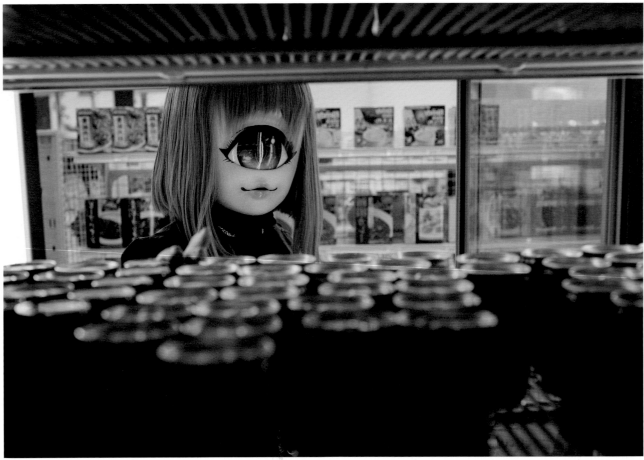

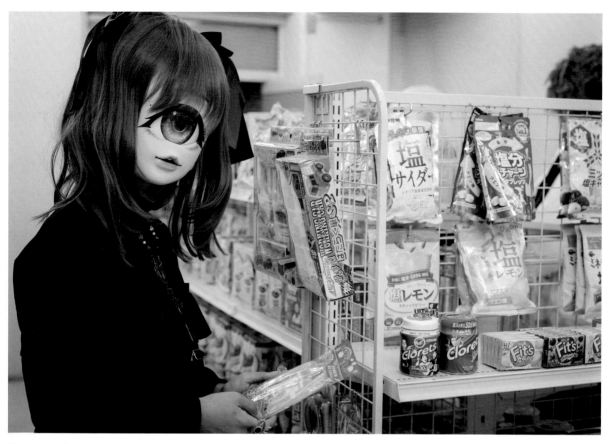

This page and opposite: Tanganmen wearers are not actually allowed in convenience stores due to their full-face covering, so these images were made in a studio.

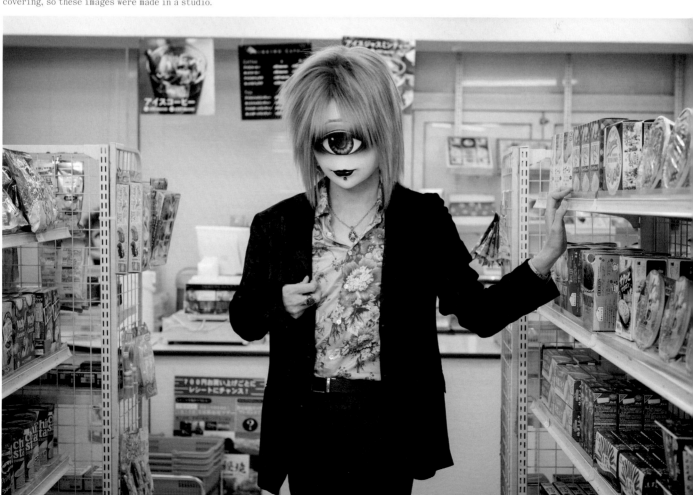

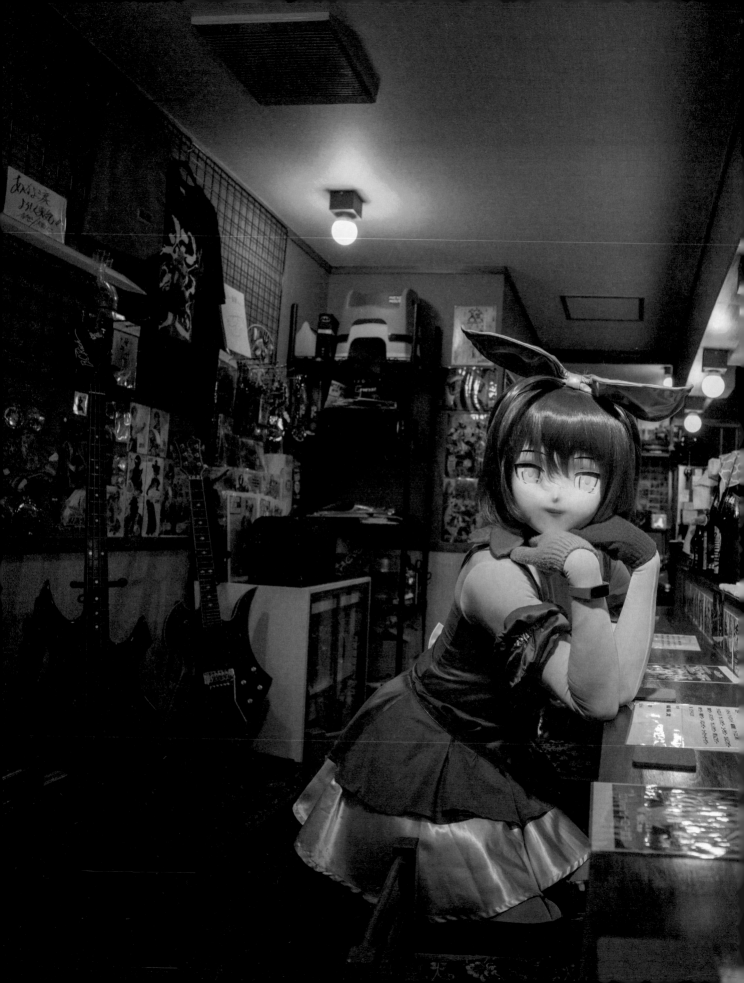

## ANIMEGAO

This special type of cosplay involves
donning an anime-character mask.

Dedicated cosplayers are known for crafting their
costumes down to the most minute detail. Another
splinter of the cosplay world takes this even further,
donning masks in the style of anime girls in order to
inhabit their character more fully. This type of cosplay
is referred to as "animegao" (literally, anime face)
in the West, but in Japan, it is more commonly known
as *kigurumi*, or full-body outfits. Yumekuri Neko is
one such kigurumi cosplayer who says his interest in
wearing these outfits started when he was five years
old. "The greatest thing about kigurumi is I can hide
myself and fully become my character," he says. "It's
opened up so many different avenues for me, from be-
ing invited to overseas events to being on TV." When
Yumekuri is in character, he doesn't speak and uses
exaggerated anime-style gestures to communicate to
customers of his Akibaland Tours business. He has also
created an original kigurumi character as a mascot for
the town of Chōshi. "The most difficult part about being
a kigurumi cosplayer is increasing the opportunities
to wear it," he says. "I would wear it all the time if
I could."

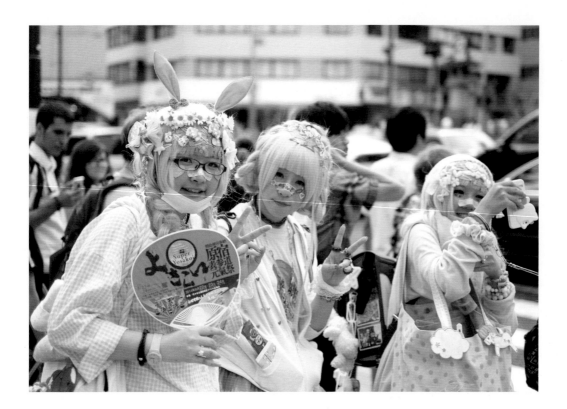

What began as a reverence for childlike innocence has evolved into a worldwide phenomenon.

# A BRIEF HISTORY OF KAWAII

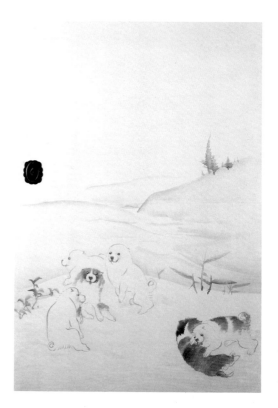

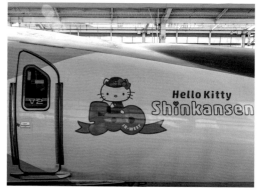

Top: *Puppies in the Snow* by Nagasawa Rosetsu, a Japanese illustration from the late eighteenth century.
Bottom: The Hello Kitty Shinkansen runs between Hakata and Shin-Osaka stations. Opposite page: Decora fashion lovers hanging out in Harajuku.

Kawaii may be the most commonly used word in the Japanese language. In Japan, even utilitarian things like manhole covers, road construction barriers, and public safety posters are "cutified" to soften their impact. And it doesn't end at the island nation's shores. Outside Japan, the kawaii revolution is ongoing: Our interconnected, globalized society propels the spread of cuteness culture from Hello Kitty to Harajuku fashion, from J-pop to manga and anime.

As ubiquitous as kawaii may be today, its origins stretch far back in Japan's cultural history: A thousand years ago a gentlewoman in the court of Empress Teishi wrote a classic work of Japanese literature called *The Pillow Book*. The author's poetic musings include a catalog of the various small, brief encounters that pierce the heart with cuteness. From baby birds to small children, dollhouse furniture to tiny lotus leaves, Sei Shōnagon's list of cute things captures the affinities for diminutive objects and transient moments that imbue Japanese art and culture to this day. Like cherry blossoms, which bloom for only a few glorious days, kawaii is appreciated in children and animals as a playful, carefree quality that will soon vanish. The love of small things continues to manifest itself in everything from haiku poems and bonsai trees to Pokémon.

*The Scroll of Frolicking Animals* is another master-piece of the Heian era (794–1185), officially registered as an ancient national treasure in 1899 and loved to this day. Nearly 12 meters long, the scroll reveals various lively scenes of anthropomorphized animals playing out like an animated film. Simple outline drawings depict monkeys, frogs, and rabbits in a cute and engaging style, achieving maximum effect with minimum detail. Such restraint and economy are hall-marks of Japanese design, appearing not only in mini-malist Zen rock gardens and the austere tea ceremony, but also in the stark simplicity of the mouthless Hello Kitty and countless other kawaii characters.

During the Edo era (1603–1868), Japan was largely closed to the outside world. However, some artists managed to study Western artistic techniques and blend them with traditional Japanese aesthetics to create a new way of depicting cuteness. Master artist Maruyama Ōkyo (1733–1795) was known for his frolicking puppies,

かわいいの歴史

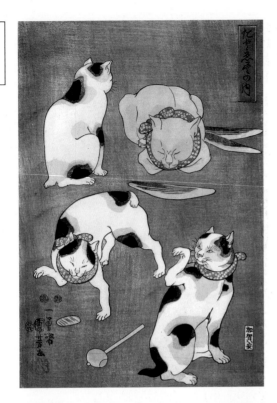

Top: *Series of Proverbs* (1852) by Kuniyoshi Utagawa, a woodcut print illustrating four cartoonish cats in different poses. Bottom: A figurine collection featuring *moe* characters.

while the charming cats of woodblock printmaker Kuniyoshi Utagawa (1797–1861) were widely popular. At the time, most Western artists painted animals realistically, but Ōkyo and Kuniyoshi's cartoonish creatures look like characters from a contemporary storybook or animated film.

Kawaii didn't become explicitly gendered until the early twentieth century when it became part of a developing "girls' culture." Illustration, fashion, design, literature, and manga for girls became increasingly kawaii, and in the process, this aesthetic became both a mode of consumption and a means of self-expression. In particular, the incorporation of Western motifs and settings enabled kawaii to become a reflection of Japanese women's dreams, desires, and aspirations in a society in which they struggled to attain full gender equality.

From the 1970s, kawaii began to expand across broad segments of Japanese society. Though Japanese youths had joined the worldwide student protest movement in the 1960s, they were unable to achieve their political goals. Disillusioned young people began to explore modes of community and world-creation outside of the conservative norm. In the 1970s, women artists broke into the male-dominated field of manga, adding complex inner psychology to cute characters. Harajuku became a mecca for young fashion tribes, and kawaii became a mode of self-expression that broke with traditional expectations.

Young men adopted kawaii elements into their fashion too, and many began to read girls' manga. Unlike manga for boys, which concentrated on action and adventure, girls' manga explored the inner psychology and complex emotional states of its cute characters. For Japanese boys and men, borrowing and adapting kawaii from girls' culture functioned as an exit strategy from rigid gender norms and the glacial rate of social change. For both women and men, kawaii represented an alternative to an adult world they saw as static, bleak, and corrupt. Kawaii values innocence and finds strength in immaturity; thus, kawaii culture became a means by which young Japanese could create their own world.

Underground artists created the *bishōjo* (cute girl) character in the 1970s by adding lashings of kawaii to the typical look of girls' manga. Initially created by

Sailor Moon is the most recognizable *bishōjo* character from Japan.

Top: People play *Pokémon Go* in Tokyo's Akihabara district. JR East railway company installed posters in Shinjuku station to caution commuters about the dangers of using mobile devices to play games whilst walking in the station. Bottom: *Frogs in Clamshell*, a nineteenth-century ivory netsuke.

mostly male artists for a niche market, these fetishized characters eventually went mainstream. Cute female characters that embarked on adventures and fought evil in short skirts proved an irresistible combination for both young male and female fans. In the 1990s, the cute girl character was supercharged with extra kawaii to create *moé* characters, inspiring even more devotion from fans. *Sailor Moon*, based on a manga by a woman artist, is just one example that met with world-wide success.

The spread of kawaii outside Japan is usually traced back to the appearance of Hello Kitty in the 1970s. However, the first craze for all things Japanese began more than 100 years before the iconic white cat's debut. In 1858, following a campaign of bombardment by American naval commander Matthew C. Perry, the Treaty of Amity and Commerce was signed between the United States and Japan, opening the country's borders to trade and bringing the isolation of the Edo era to a close. Western artists from Monet to Van Gogh were entranced by the playfulness combined with restraint they saw in Japanese woodblock prints and painted hanging scrolls. Small ivory *netsuke* carvings, a traditional male accessory, were often carved in the shape of cute animals or amusing figures and proved popular with collectors. However, cheaper items like pretty porcelain dishes and kimono-clad dolls–often depicting children with small limbs, big heads, and sweet faces–were the real hits of the first Japan craze.

During this time, the position of children was rapidly changing with the advent of universal education and child labor laws. Accounts of Japan's kind and lenient treatment toward children filtered through to the West, leading to the widespread perception that this country famous for its adorable dishes and dolls was a paradise for the young, magnifying the stereotype of Japan as an exotic land full of cuteness. Lafcadio Hearn, who wrote a dozen popular books on Japan starting in the late nineteenth century, described the whole country as delicate and exquisite, full of "curiosities and dainty objects," spreading the idea amongst Europeans and Americans that everything Japanese was endearingly small and adorably childlike.

Eventually, this first Japan craze cooled. When it rose again 100 years later, there was a crucial

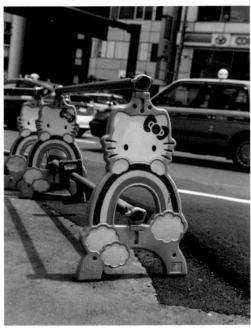

Top: Cute surfer character Chiitan on a pink manhole cover on the beach promenade of the American Village in Chatan. Bottom: Hello Kitty barriers on a Tokyo street.

difference: Namely, in the late twentieth century nobody realized that the products that enchanted them were from Japan. This was a deliberate post-war strategy by Japanese companies to market their products "without nationality" (*mukokuseki*). It was a highly successful formula. By the early 1960s, Japan was the world's largest exporter of toys, and in the 1980s, it led the way in computerized toys and video games. And yet the Mario brothers are Italian plumbers, Hello Kitty is supposedly from London, and Pac-Man and Sonic the Hedgehog are—well, not Japanese at least.

This began to change in the 1990s. Initially, games like Pokémon and anime such as *Sailor Moon* were still heavily localized to fit Western tastes. However, kawaii—that mix of Japanese aesthetics sprinkled with Western motifs—became a powerful hook that reeled in fans until they became interested *because* the things they loved were from Japan, not in spite of it. As they grew up, children fascinated by Japanese video games, manga, and anime began to prefer the culturally distinct fantasylands presented in the real thing rather than the localized versions marketed for export. They wanted manga with panels that read right to left like in Japan and stories that didn't censor same-sex relationships or gender-bending fantasy. They started clubs to make their own subtitles for anime and began to cosplay as their favorite characters. The new Japan craze was born from this desire for authenticity.

The nineteenth-century stereotype of Japan as an exotic land where cuteness reigns was born from lazy assumptions and the certainty that the West was the center of the world. The images in *The Obsessed*, however, tell a different story. Long present in Japanese art and girls' culture, kawaii expresses a human emotion that has no borders. In these pages we see real people showcasing the restless creativity that fuels their obsessions. The passion for kawaii is most visible in the faces of the people it inspires.

Joshua Paul Dale is the founder of Cute Studies, a new academic field. In 2020, he was awarded a JSPS grant to study the Japanese kawaii and American cute aesthetics. His book *Irresistible: How Cuteness Wired Our Brains and Conquered the World* is forthcoming from Profile Books.

ちいたん

## CHIITAN

The cute but trouble-making otter mascot.

Japan's obsession with cuteness has led to some interesting outcomes. One is the phenomenon of *yuru-chara*, or mascot characters. In 2015, over 1,700 entrants were logged in the Yuru-Chara Grand Prix, a contest to determine Japan's favorite mascot. Of these characters, some names tower above the rest in fame and international recognition. Chiitan is one of these. Originally the unofficial mascot for the small city of Susaki, it gained international notoriety on John Oliver's late-night satire *Last Week Tonight*, for its slapstick stunts on social media. Often appearing in videos swinging a plastic baseball bat, Chiitan's popularity stems from trying—and failing—to do something dangerous, often with hilarious results. This has landed the adorable mascot in a great deal of hot water, and the stunts have caused numerous complaints, leading the city of Susaki to distance itself from the mascot. Chiitan is also the only mascot to have had its Twitter accounts suspended due to sometimes-questionable content. However, it seems the public's love for the mascot has not waned—Chiitan has found a new job as the official ambassador for the Akihabara Tourism Promotion Association.

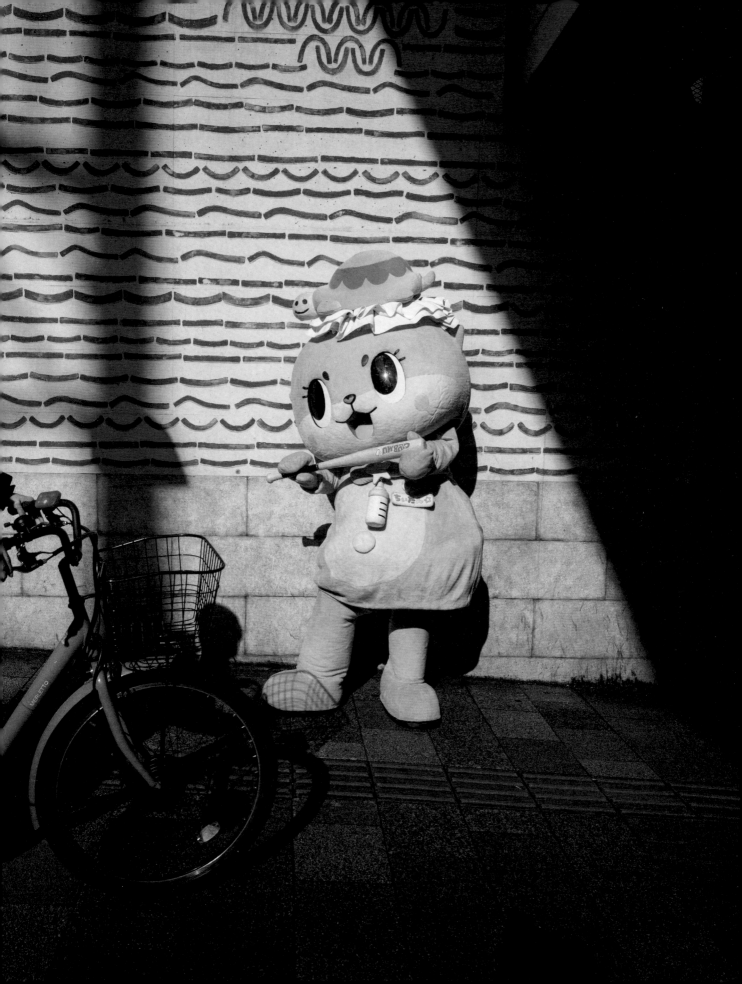

宮本彩希

## COSPLAY IDOL
## MIYAMOTO SAKI

Cosplay is open to everyone, but
it sure helps if you're cute.

Of the many thousands of avid cosplayers
in Japan, there is a subset of mostly female
cosplayers with gigantic followings. These
cosplayers are idolized for portraying
provocatively dressed characters from
games and anime, and are often responsible
for drawing legions of fans to conventions
in the hope of catching a glimpse of these
subculture superstars. Miyamoto Saki
belongs to this subset of mega-popular
cosplayers, although her roots are bound
in old-fashioned fan cosplay. "My first
cosplay was a character called C.C. from
the anime *Code Geass*," she says. "I loved
that character so much that I made my own
costume from scratch." Since that day her
popularity has taken her to conventions
and events around the world. She professes
surprise at how cosplay has opened doors
for her. "I never imagined it could become
my career," she laughs. Even now, with a
Twitter following of 393,000 and counting,
she still makes most of her costumes and
finds time to enjoy video games and anime—
just the same as any otaku.

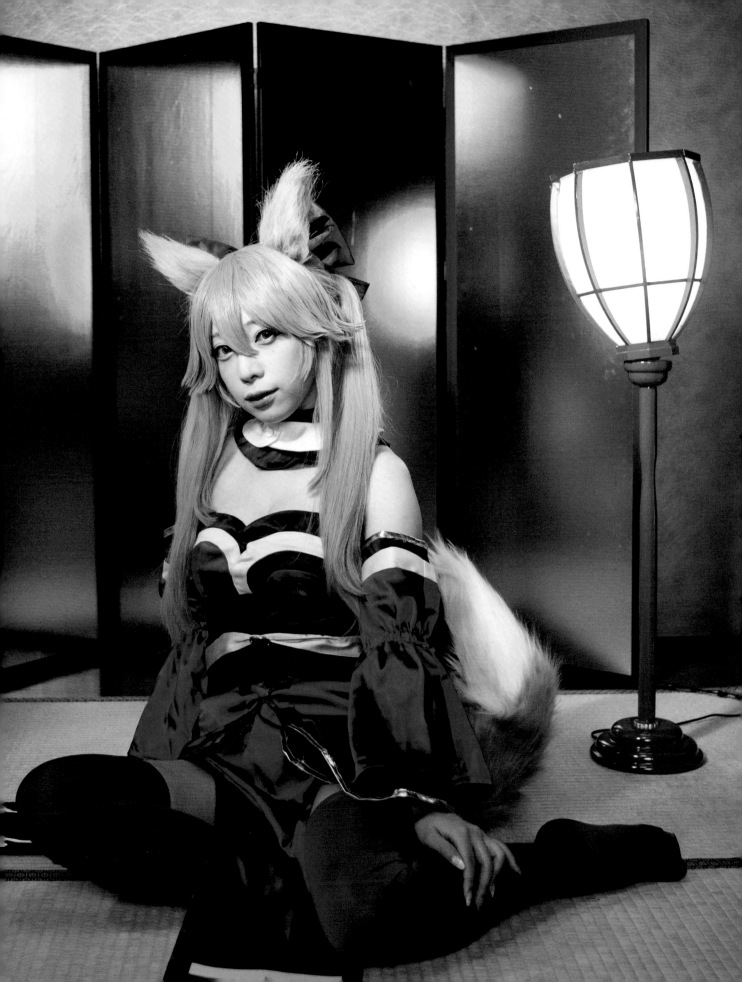

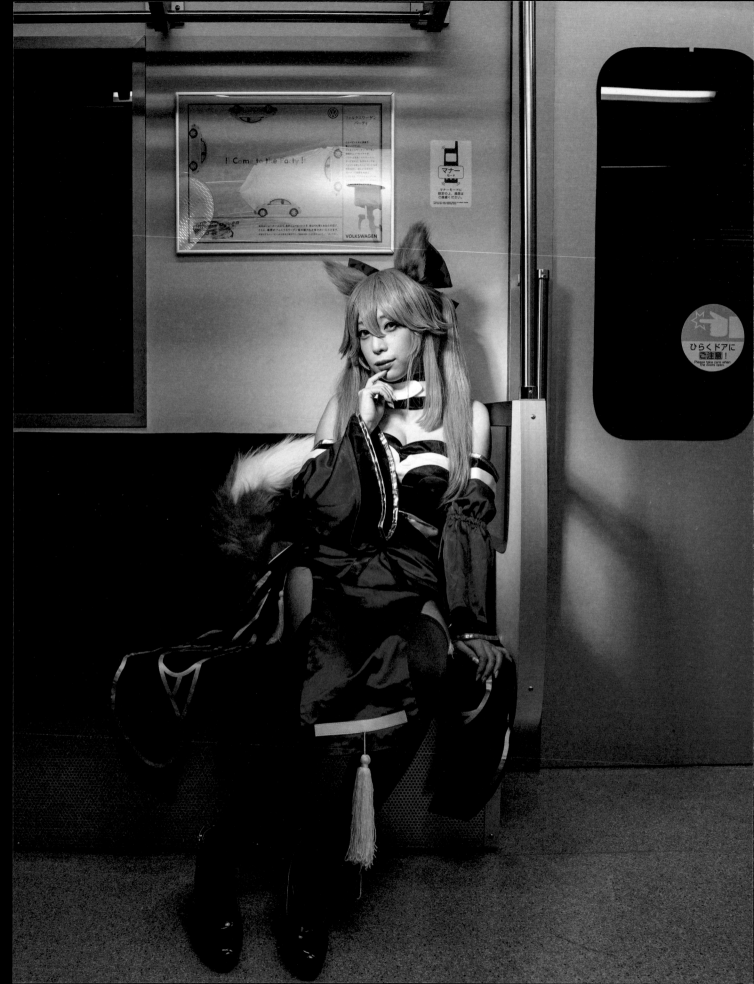

<u>Above:</u> Miyamoto also produces her own original clothing, pictured here. <u>Opposite page:</u> Cosplay in public places is frowned upon by the community. This was photographed in a studio made to look like a train.

星音早那

Seine's headpieces are
original creations
pieced together from
store-bought items.

## SANA SEINE

Lolita goes gothic.

Lolita fashion takes its main cues from Rococo- and Victorian-era clothes, emphasizing frilly, voluminous dresses, corsets, and petticoats. Unsurprisingly, several subgenres of Lolita fashion have developed over time, including the style known as "gothic Lolita." In contrast to pastel, soft colors meant to evoke feelings of innocence and sweetness, gothic Lolita's hallmark is black upon more black, with a rare splash of color to further emphasize the dark, moody aesthetic. Sana Seine has been dabbling in Lolita fashion since she was 10 years old and settled on gothic Lolita as her look of choice: "It's the sense of the extraordinary amongst the mundane that I like," she says. "The generous use of frills, ribbons, and other decorations gives the clothing a beautiful form. The fun part about dressing in gothic Lolita is figuring out what to add and what to subtract. If I have a puffy skirt, then I contrast it with a tight corset and maybe a smaller headpiece, and so on." The only problem is finding the space to store all the bulky, frilly items–let alone any new clothes she wants to buy. "As soon as I make space, it gets filled up," she laughs.

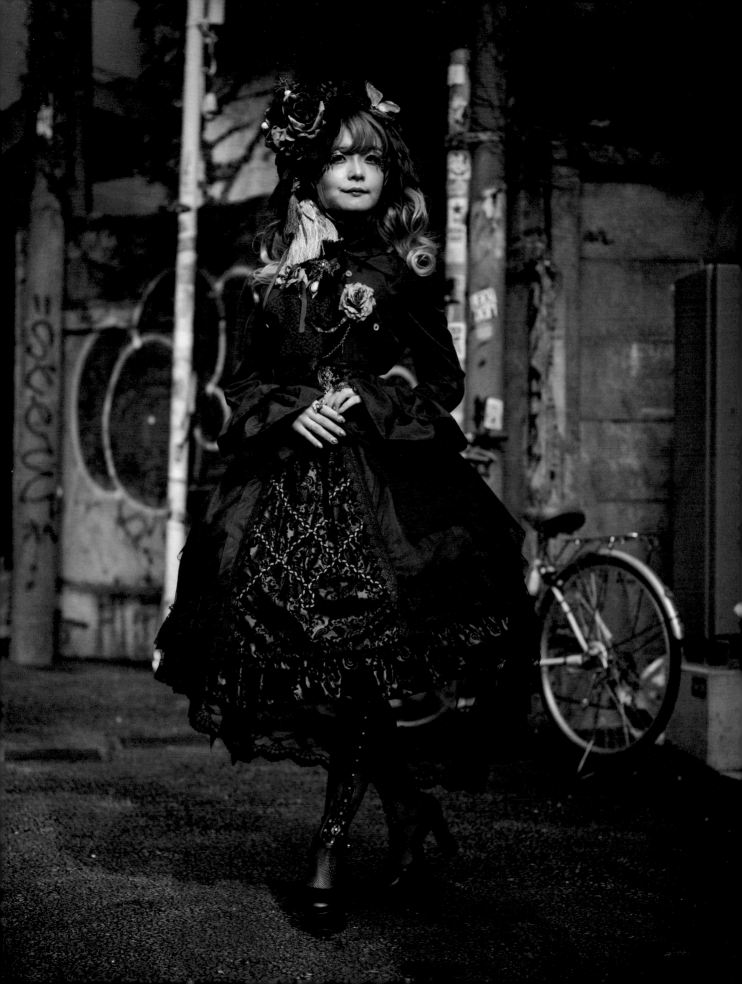

星音早那

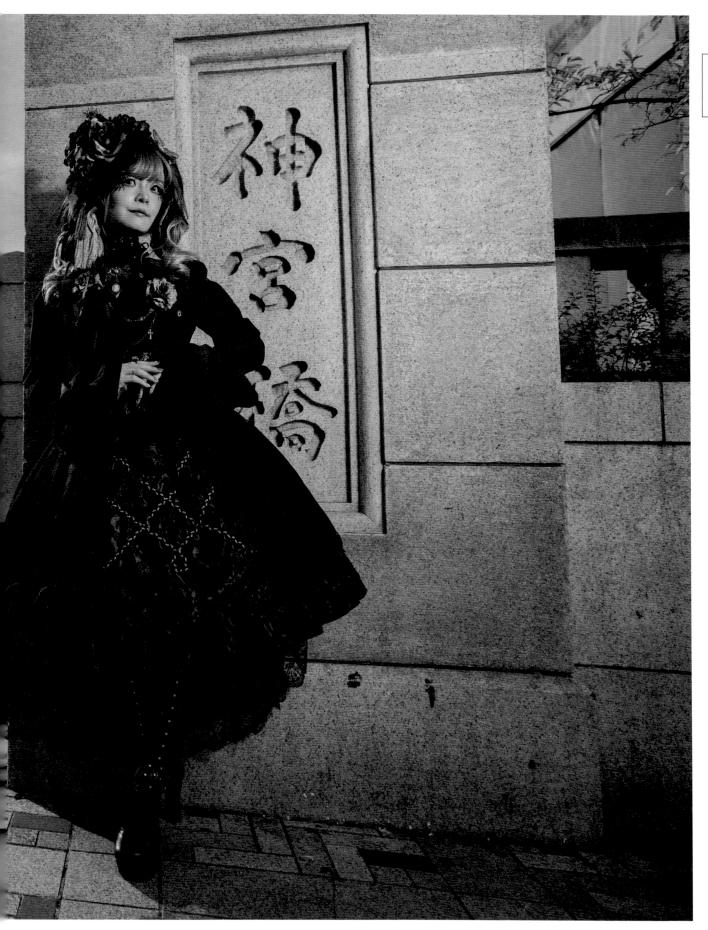

白塗り作家みのり

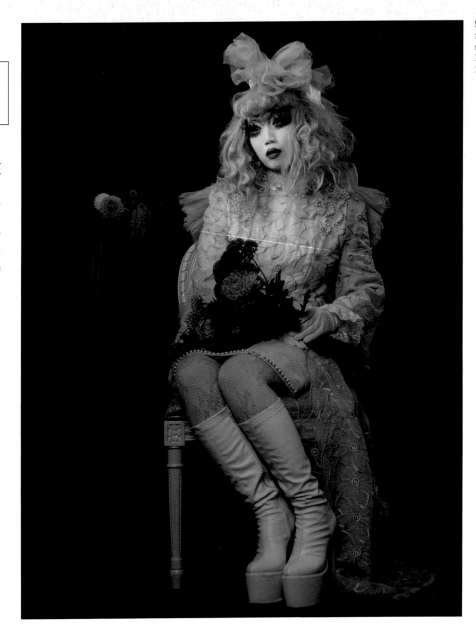

Minori's makeup and fashion choices are strongly rooted in her love of nature and all its colors.

## SHIRONURI ARTIST MINORI

A Harajuku icon, Minori's spectacular makeup has received acclaim from around the world.

Shironuri is the practice of covering one's face and sometimes hands completely in white paint. There are many kinds of shironuri in traditional Japanese history, but the artist Minori has made it her own, turning heads even amongst the more outlandish trends of Harajuku. "I used to wear gothic and Lolita-style clothing," Minori says, "but I felt that my face and makeup weren't doing justice to the beautiful details of the clothes. With shironuri, I could turn my entire face into a canvas and create a new work based on my imagination." The history of shironuri in Japan goes back to the eleventh century in Heian-era Kyoto, where high-ranking members of the court would paint their faces white as a sign of their status. A different, unrelated example of shironuri is perhaps the most well-known: *maiko*–apprentice geisha–painting their faces white to enhance their beauty under candlelight. Minori's modern take has inspired others to try it, even though it is labor-intensive. "It takes four to five hours to put it on," she says, "but this is how I express my creativity."

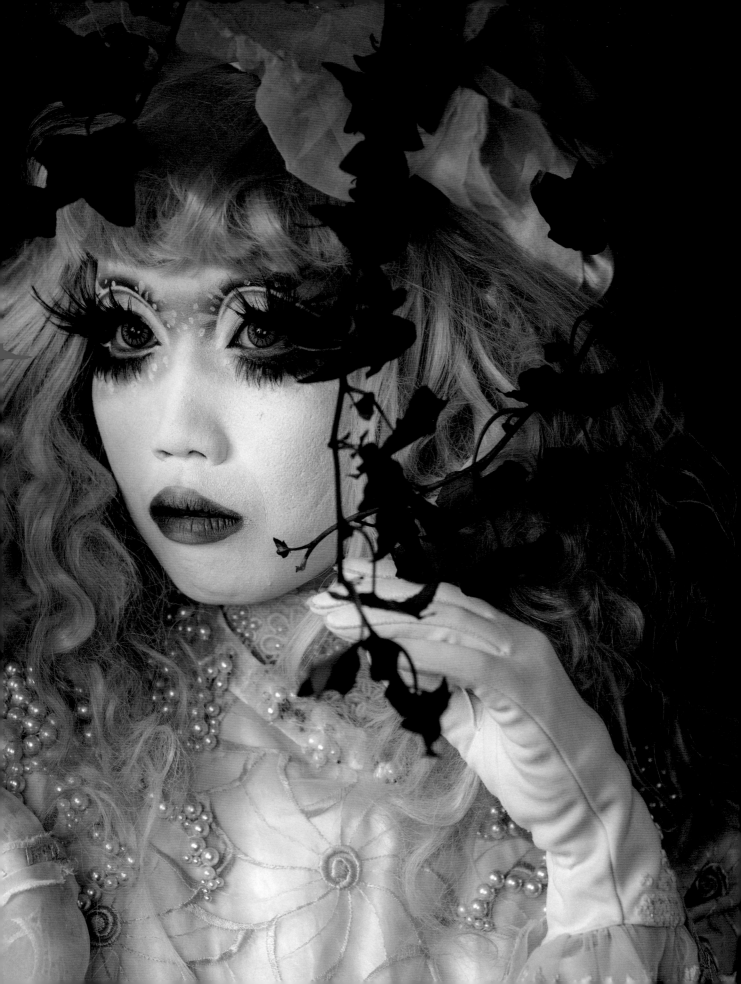

ガンダムカット

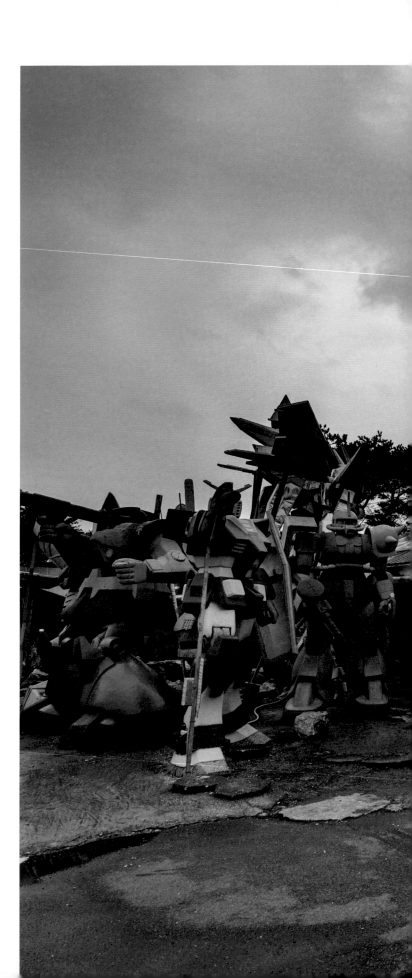

## GUNDAM CUT

A rural barbershop surrounded by gigantic
homemade Gundam statues.

Aomori prefecture is the northern-most
prefecture of the main island of Japan, far
removed from the buzzing subculture centers
of Tokyo and Osaka. One particular place,
however, has achieved a somewhat legendary
status in the wide world of Gundam fandom,
prompting pilgrimages from overseas and
local fans alike: Gundam Cut, a barbershop
complete with towering mecha statues.
      The owner, Suzuki Toshimi, now 77, was 60
when he first heard of Gundam, despite the
franchise beginning in 1979. "A high school
student told me about Gundam and I went to
the toy store to see what it looked like," he
says. "It looked cool, so I bought some model
kits immediately." Suzuki, who was already
an accomplished plaster sculptor, used the
plastic kits to calculate the dimensions,
and from there, created the molds for the
cement or plaster. As his collection grew, so
did the visitors in awe of the incongruous
towering figures surrounding this rural
barbershop building. Their charmingly
homemade feel combined with a meticulous
attention to detail has made Suzuki a
nationwide celebrity in the Gundam fan
community. "I love making them," he says.
"I'll be making new ones as long as my body is
able to move." As for the anime itself, Suzuki
confesses he is yet to see a single episode.
"I should probably get around to watching
it sometime," he says with a smile. "But my
visitors have told me all about it already."

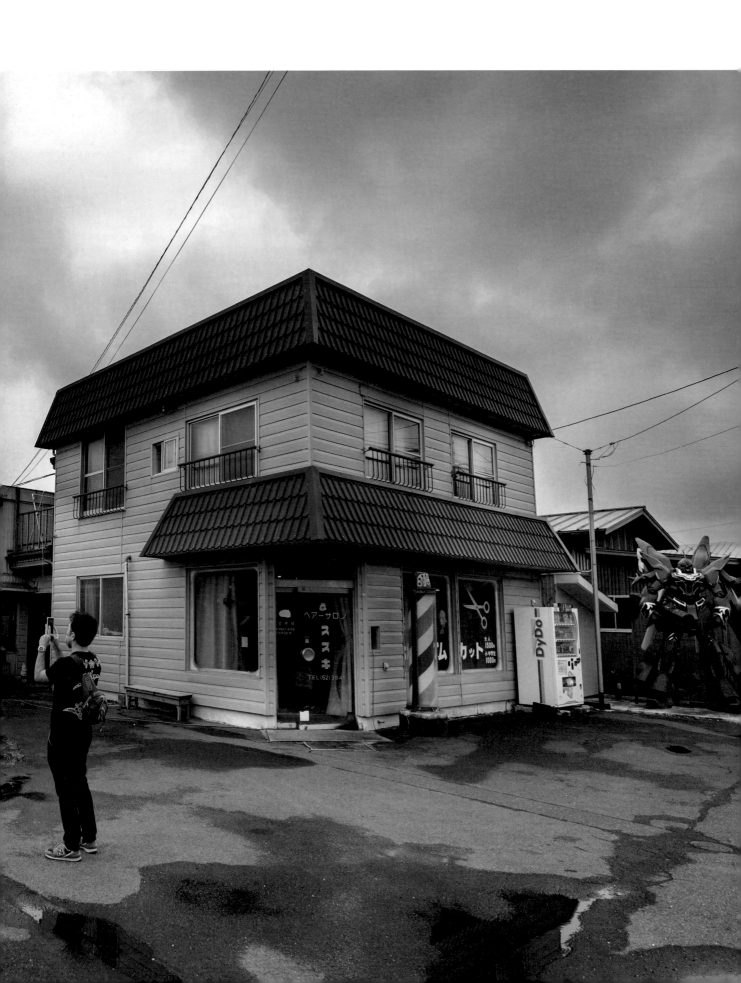

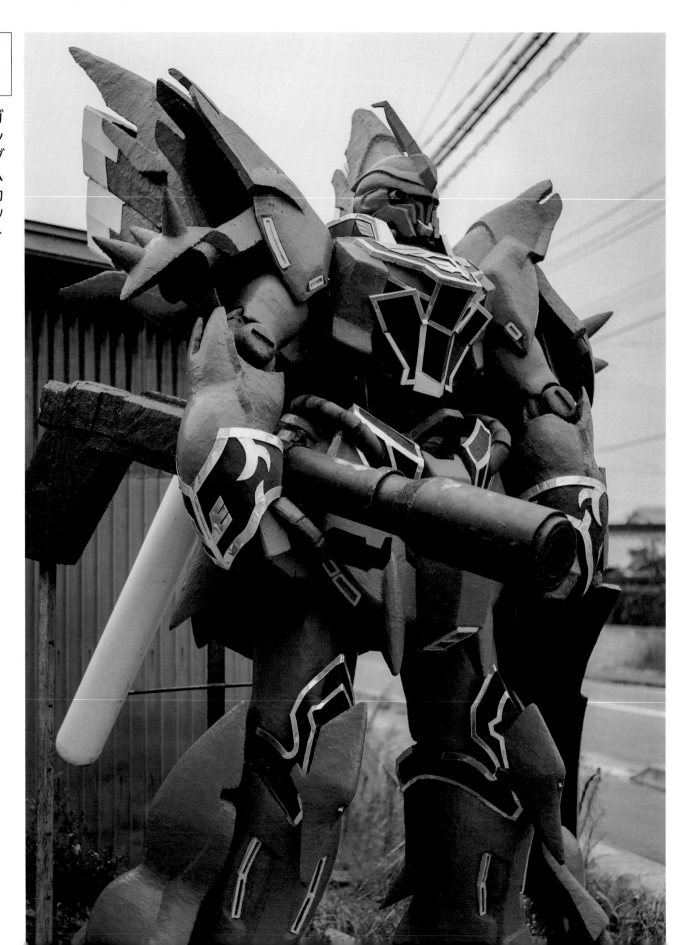

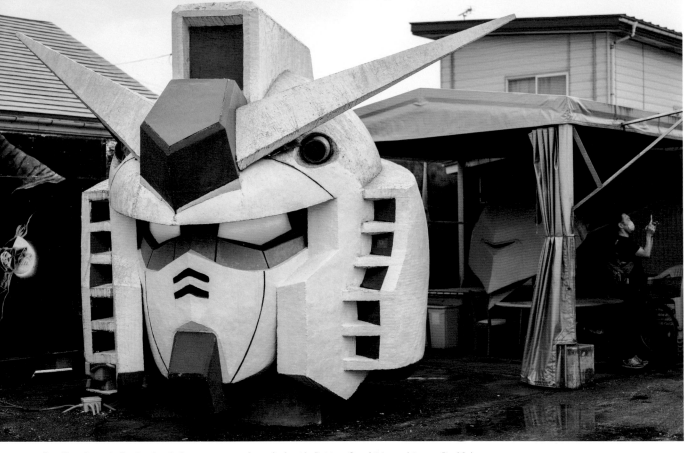

Top: The gigantic Gundam head also serves as a karaoke booth. Bottom: Suzuki is working on Bumblebee from the *Transformers* movie franchise. Opposite page: The Sazabi is one of Suzuki's favorite designs.

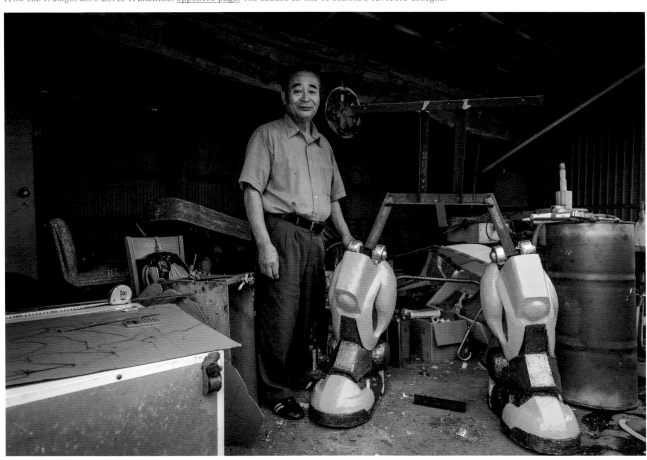

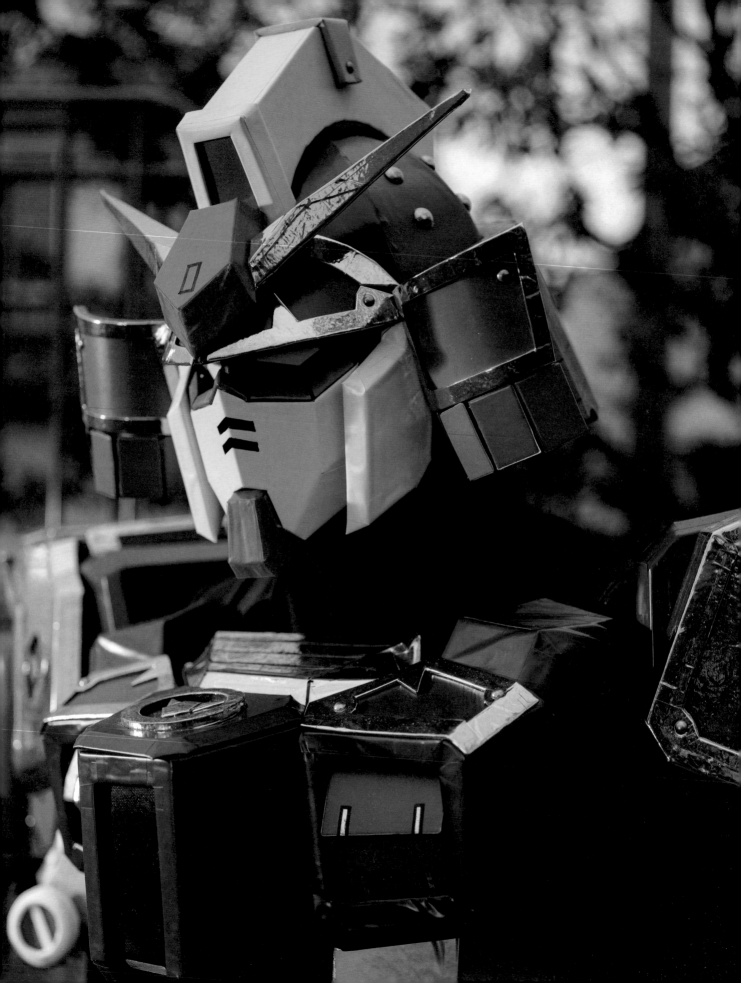

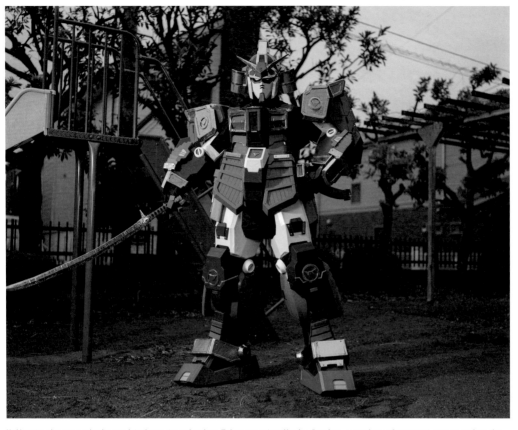

Valkyrie photographed near his home in suburban Tokyo wearing Musha Gundam, a mashup of samurai armor and mecha.

## ROBOT COSPLAYER VALKYRIE

A smaller subset of cosplayers dedicates themselves to creating full-body costumes based on popular mecha and robots from Japanese pop culture.

As a robot cosplayer with over 20 years of experience, Valkyrie credits himself as one of the first cosplayers to create full sets of robot or mecha costumes. Japan's pantheon of mecha and robots stretches back to the 1950s and has birthed some of the most memorable titles in anime fandom, including *Macross, Mobile Suit Gundam,* and *Neon Genesis Evangelion.* This vast swathe of popular culture is fertile ground for creators like Valkyrie, whose cosplaying career started out in high school, where he used to make robot figures out of paper and cardboard. "One day, I figured, 'I could wear this,'" he laughs. His first attempt was a Valkyrie from *Macross,* and he has since made close to 30 costumes over a two-decade stretch. Made of foam core and tape, with the attention to detail that mega-fans of the genre would appreciate, each takes an average of three months to complete. But as he puts it, "Changing into the costume is a form of stress reduction. Making a costume, going to events, and having people admire it, that's a much better feeling than making something for only yourself."

にょロボてぃくす

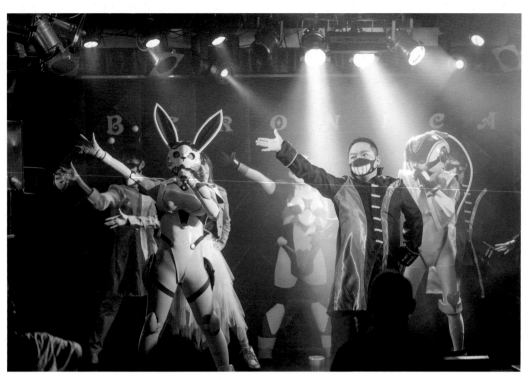

Above: NyoROBOtics perform jointly with other groups at Osaka live venue Beronica.
Opposite page: Brownie, Sagiri, and Prana are three of the eleven members of NyoROBOtics.

## NYOROBOTICS

This idol group stands apart for their beautiful robot costumes.

In the world of J-idols, groups must find a unique selling point to capture the hearts and minds of potential fans. Few stand out in this field as much as nyoROBOtics, an Osaka-based idol group dressed in full robot outfits. "When I was a kid, I used to love seeing female robots on the TV," says Nagata Tamotsu, the creator of nyoROBOtics. "Unfortunately, they were almost always relegated to supporting or guest roles and there were limited chances to see them." Taking matters into his own hands, Nagata began producing films with female robots as protagonists and eventually hit upon the idea of a robot idol group. The combination of lavish costumes and cute girlish performances proved to be a big hit with fans, and nyoROBOtics has expanded to 11 members. "The robots speak in Osaka dialect too, which is charming for the fans," says Nagata. Brownie, the robot with the bunny ears, hopes to perform for foreign audiences soon. "Since Covid-19, we've been doing live streams, so I hope people around the world will watch and invite us to overseas events!"

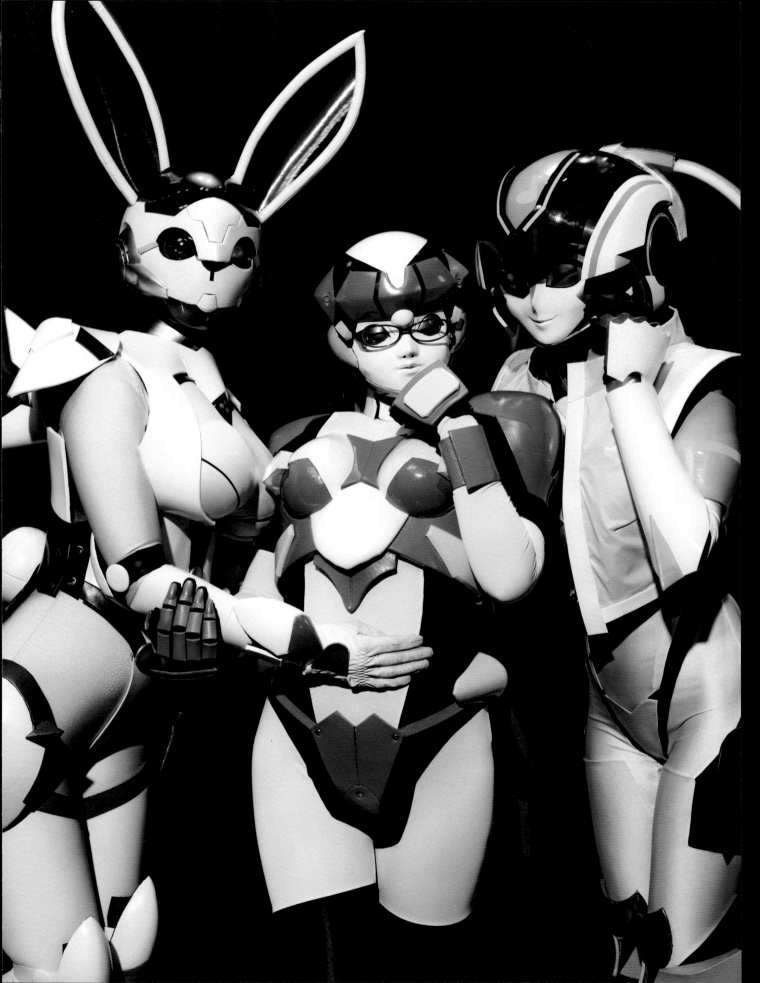

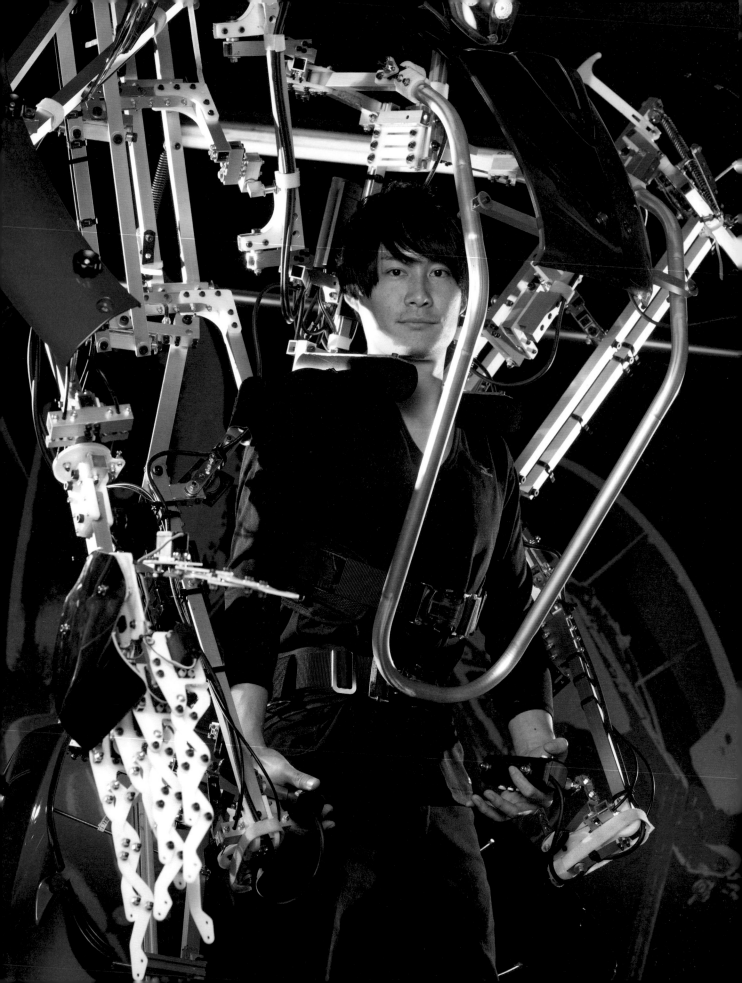

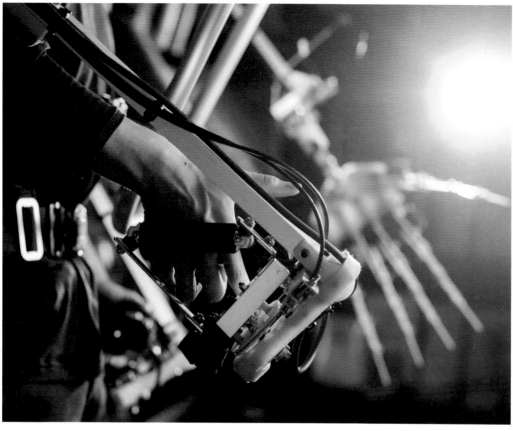

Above: The exoskeleton's hand grip contains controls for the articulation of each finger.
Opposite page: An employee of Skeletonics inside the nine-foot exoskeleton.

## SKELETONICS

This company builds wearable robot suits that run on the user's kinetic energy.

Japan's obsession with robotics may well have started back in the Edo period (1603-1867), with the development of *karakuri ningyō*, or mechanical dolls. These incredible handcrafted dolls were able to perform complex tasks like firing arrows from a bow, playing a koto, or writing calligraphy autonomously using a clockwork mechanism. The idea of a rideable robotic suit took the nation's fancy with the explosion of mecha anime such as *Gundam* and *Mazinger Z*. The conceit that a robot could be controlled with the thoughts and actions of a pilot became a staple in many works of fiction. These days that fiction is getting closer to reality with Skeletonics, a company that specializes in making rideable robots. "Skeletonics is an amplification of a human being's natural ability," says CEO and co-founder Aka Tomohiro. The nine-foot-tall exoskeleton requires no special training to use and no external power source is needed, aside from a small battery to power the finger actuators, "just like a bicycle," Aka says. His mission is to show how exoskeletons might expand the range of human capability. "When I control the skeletonics, I feel like an anime character come to life."

# BUILD BANG

A team of master cosplayers in Osaka,
each with their own specialty.

Disguises and masquerades have been a part of human history for centuries. Something about dressing up and letting your borrowed identity supplant your real one for a short while is an intoxicating thrill, and it's catching on, with cosplay exploding in popularity.

One such superfan is Izumi Shin, a cosplayer from Osaka who is being fitted for an MS Shojo Gundam cosplay in a small workshop in Nipponbashi–Osaka's center of otaku culture–when we speak. This workshop, called Atelier Chii, is operated by Chii and Kochi, two members of the Osaka-based crafting group Build Bang. Build Bang is a seven-member group whose cosplay creations are, to put it mildly, a level or two above what regular hobbyists might conjure up. Izumi, an anime diehard who has been cosplaying since he was 10 years old, is close to several members of Build Bang. "Chii and Kochi are a great team," he says. "They both have different ways of crafting so they complement each other's skills very well. The outfits they make are visually very balanced and highly detailed."

At 49, Chii is the oldest member of the group, and in addition to being a cosplay otaku, he is also a master artisan in the Senshuui pottery style. During the day, he crafts exquisite ceramic works for high-end department stores such as Takashimaya and Hankyu, and in the evenings, he opens his Nipponbashi atelier for cosplay-related activities. "Before Covid, I used to hold crafting workshops here," he says. "Hopefully I can start doing that again."

According to Chii, Build Bang formed during a drinking session with cosplayers who had met during Nipponbashi Street Festa, the premier cosplay event in Osaka. "We found the people who had the best cosplay and invited them to drink," he says. "We enjoyed swapping crafting stories and decided on a whim to form a group." Build Bang has since organized several cosplay events and parties aimed at stimulating the flow of crafting ideas within the Kansai cosplay community. While the demands of homelife, work, and the Covid-19 pandemic have prevented the group from getting together as often as they'd like, they stay connected through their love of crafting.

While Japan may have coined the term "cosplay," the hobby was originally an import from America. The idea of "fan costuming" sprang into being at the very first World Science Fiction Convention (shortened to WorldCon) in New York in 1939, when a couple of attendees wore futuristic costumes to the venue unprompted.

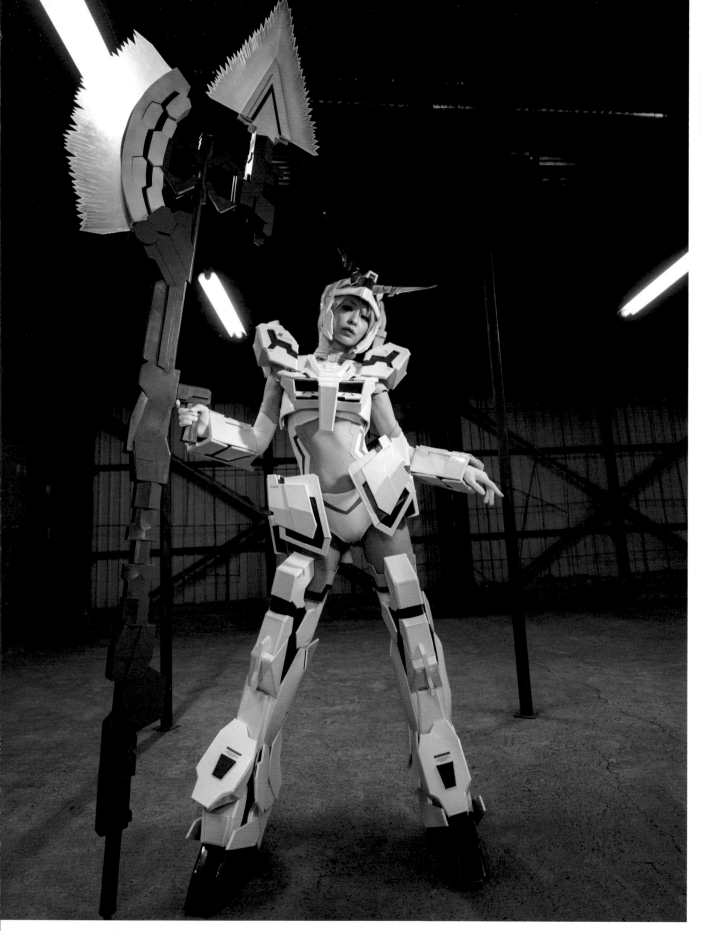

Izumi wears an MS Shojo Gundam Unicorn cosplay constructed by Chii and Kochi.

ビルドバン

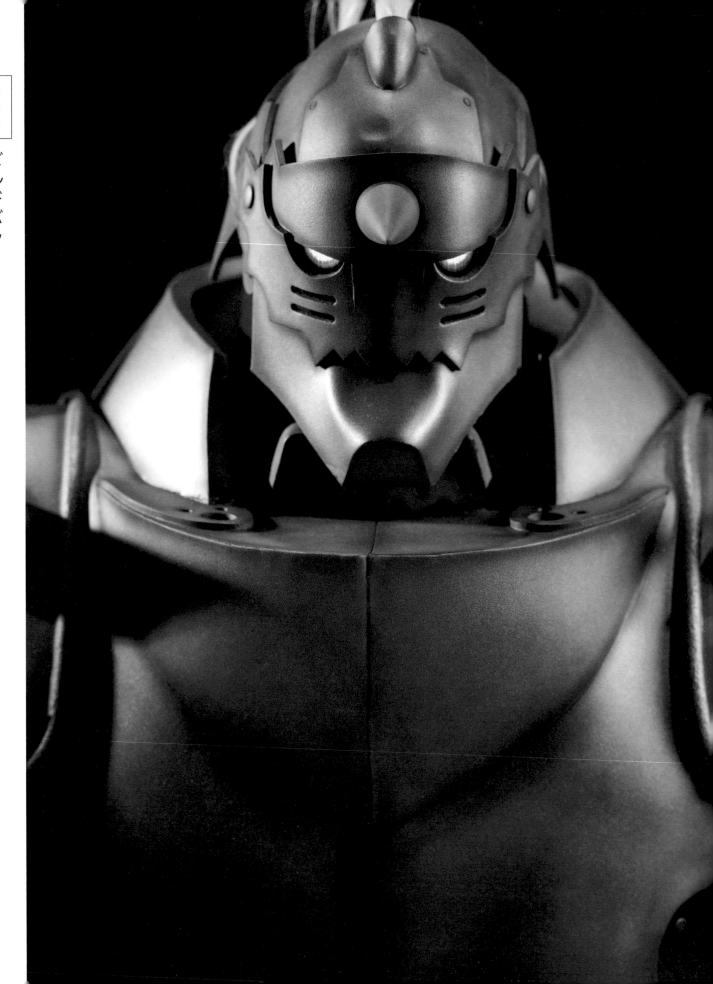

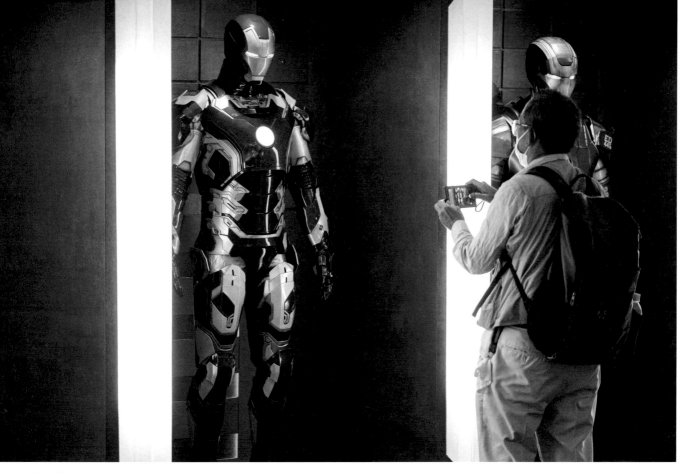

Top: The Ironman suit made by Chutaicho on display at a cosplay event. Bottom: Gyabaso in his signature Gyaban suit.
Opposite page: Chutaicho wears his Alphonse Elric cosplay.

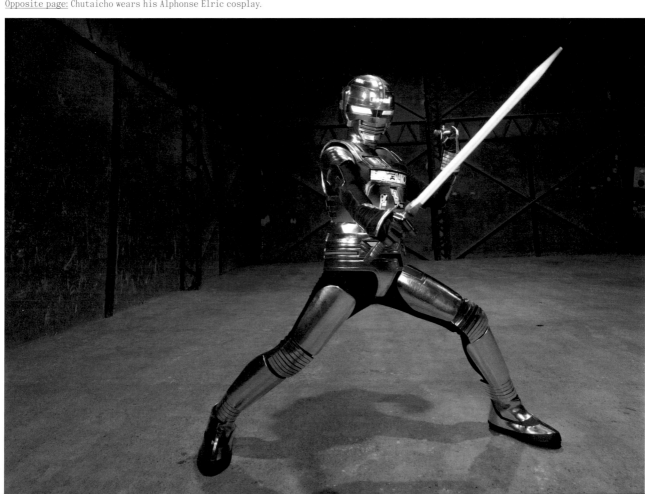

Subsequent WorldCons featured a masquerade segment in which costumed participants could strut their stuff to the admiration of attendees. Several risible incidents

**"There are some difficulties with cosplaying in Japan, you can't simply wear cosplay out in public without first getting permissions sorted out."**

led to the establishment of regulations for this masquerade—notably the banning of fully nude "costumes," the prohibition of any fire-shooting props, and a ban on food props, prompted by one gentleman who showed up covered in nothing but peanut butter. Nevertheless, the costuming fad caught on outside of New York and eventually gained traction with science fiction fans across the Atlantic in London during the 1950s.

Cosplaying in Japan also started before the term itself was coined. The first annual Comic Market convention in Tokyo in 1975 featured attendees dressed in costume, although it was described simply as *kasou*, the Japanese word for "fancy dress." Ironically, the word *kosupure*, a portmanteau of "costume" and "play" was born in an article written about the wonders of fan costuming in American conventions. The word wound its way into popular use in Japan and was then re-exported all over the world.

Chutaicho is another member of Build Bang, albeit a fairly new recruit. "I used to be a survival gamer," he says. "After I was injured in one session, I found myself stuck at home looking at cosplay online." An Ironman cosplay caught his eye: "I thought, I bet I can make one better than that." Employing his skills as a former indie filmmaker, the Ironman cosplay that Chutaicho ended up making

was so faithful to the original that he immediately got invited to a comic convention in Guangzhou, China. "I went, but I had just started cosplay so everything was completely new to me," he says. Not long after, he was asked to attend New York Comic Con and was struck by the differences in cosplay culture between his home country and overseas. "There are some difficulties with cosplaying in Japan," he explains. "For example, you can't simply wear cosplay out in public without first getting permissions sorted out. Regular people and others in the cosplay community will get mad at you." Conversely, in America, cosplayers can get dressed in their hotel room and walk or take the subway to the convention center without incident. "In Japan, you have to take your costume to the venue and get changed inside. It's a little more troublesome," he says. "It's neither a good or bad thing; it's just differences in culture."

Friends Naokiman and Gyabaso began their cosplay careers through marathon running. "I thought that if I wore something interesting while running, I'd be able to make some people laugh," explains Naokiman. Roping in his friend Gyabaso,

**"Everyone has such passion. As someone who gets to wear these costumes, I couldn't be happier."**

they both wore *Kamen Rider* helmets in one marathon, managing to finish despite the extra headgear. "At that time, we were more concerned about the ease of running while wearing it, so the helmets were somewhat shoddy," says Gyabaso. "But soon after that, we started taking crafting seriously." Gyabaso is particularly interested in using computer-aided modeling and 3D-printing to supplement traditional molding and sculpting techniques.

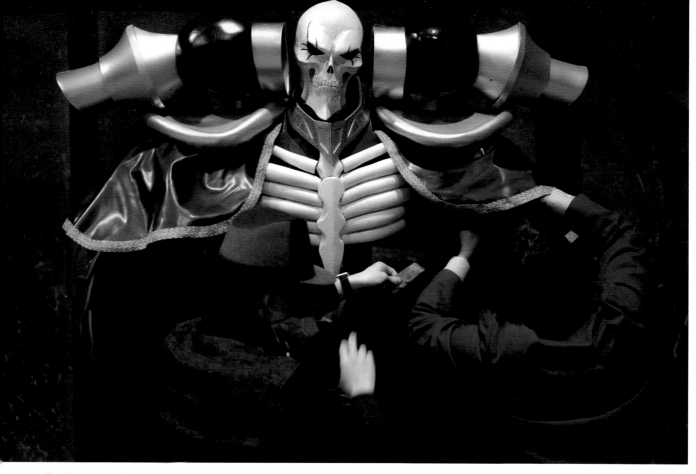

Top: Kassun wears his own Ainz Ooal Gown cosplay from the anime *Overlord*. Bottom: The elaborate costume involves articulated arms and lights.

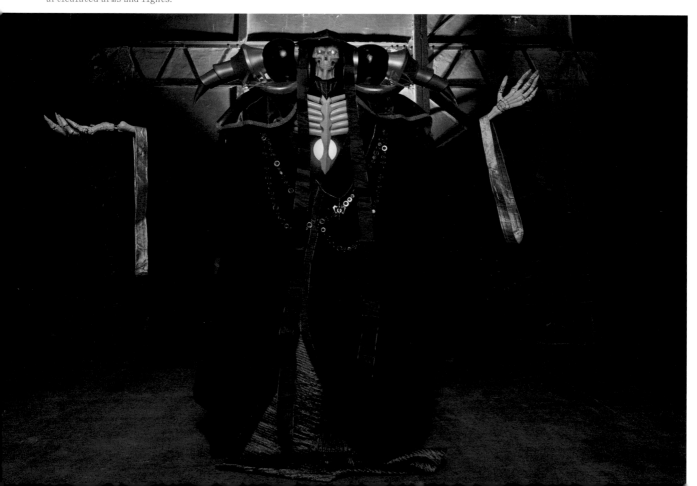

"It's important to use these tools so Japanese cosplayers don't fall behind overseas cosplayers."

Pochi is the only female member of Build Bang, but she is the most popular going by follower count. Cosplayer Izumi, who has worked with Pochi multiple times, is full of praise for Pochi's work. "It's like wearing the real thing," Izumi says. "Not only does it look good, but it's easy to wear and so precisely constructed that you feel spoiled." Pochi's approach to crafting places an emphasis not only on looks but practicality as well. "You have to consider situations in which the cosplayer has no one to help them get dressed, in addition to making it intuitive to wear," Pochi explains. "Also, ease of transportability is a factor in crafting. Japanese cosplayers often take public transport, so being able to break down the costumes into carry-able pieces is an important consideration."

The key consideration for all members of Build Bang though, is the question of balance. "When making a 3D costume from a 2D character, you always have to think about how that translates into the real world," says Chii. "Anime characters also have unrealistic body proportions some times, and that needs to be addressed so the cosplayer still looks stylized, like in the source material."

"Cosplay crafting is a question of how you allocate your limited time and re-sources," says Gyabaso. Adds Chutaicho: "Knowing when to move on from working on a piece is important. Otherwise, you'll end up working on something forever." And for cosplayers such as Izumi, the presence of such a talented group of crafters in Osaka is nothing short of inspiring. "Everyone has such passion," he says. "As someone who gets to wear these costumes, I couldn't be happier."

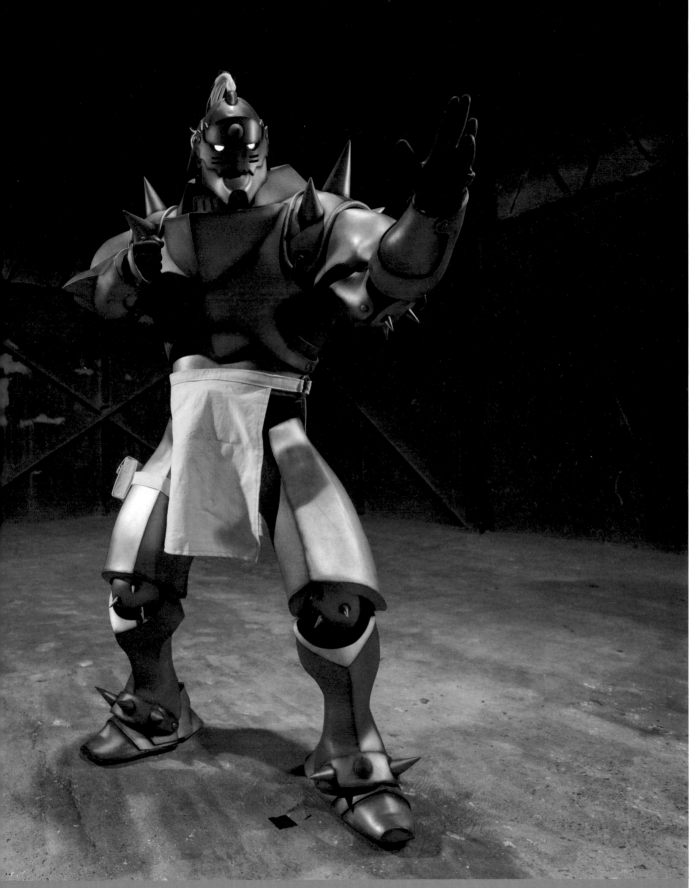

The full-body version of Chutaicho's Alphonse Elric cosplay.

らんまるぽむぽむ

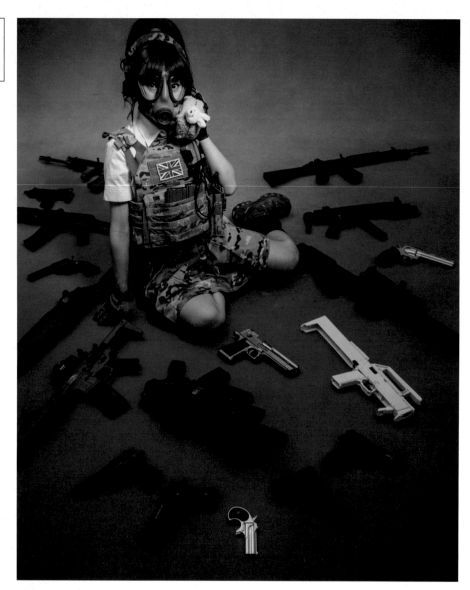

Ranmaru PomuPomu
shows off part of her
airsoft collection.

## GAS MASK IDOL
## RANMARU POMUPOMU

This idol mixes survivalist
know-how with a gas mask that
is never, ever removed.

Of the many idols active in Japan, few are as committed as Ranmaru
PomuPomu. The self-proclaimed "Gas Mask Idol" is a survivalist
and military otaku who writes and films YouTube videos about
wilderness survival techniques. Of course, this is all done with a
gas mask on, often adorned with cute accessories as befits an idol.
"One of my articles was about how to prepare and cook a crow. That
was a tough one," she laughs. Her YouTube channel contains numerous
videos showcasing survival techniques such as purifying water and
making fire from raw materials. "Bear Grylls is my inspiration," she
says. "I hope to one day be able to survive with just one knife in
the countryside." Her other interests include airsoft and military
goods, which she incorporates into her fashion with kawaii aplomb.
"Military technology is the culmination of a country's scientific
and engineering prowess," she says. "There's nothing cooler than
that." As for why she never takes her gas mask off: "It makes me look
cuter than anything else!"

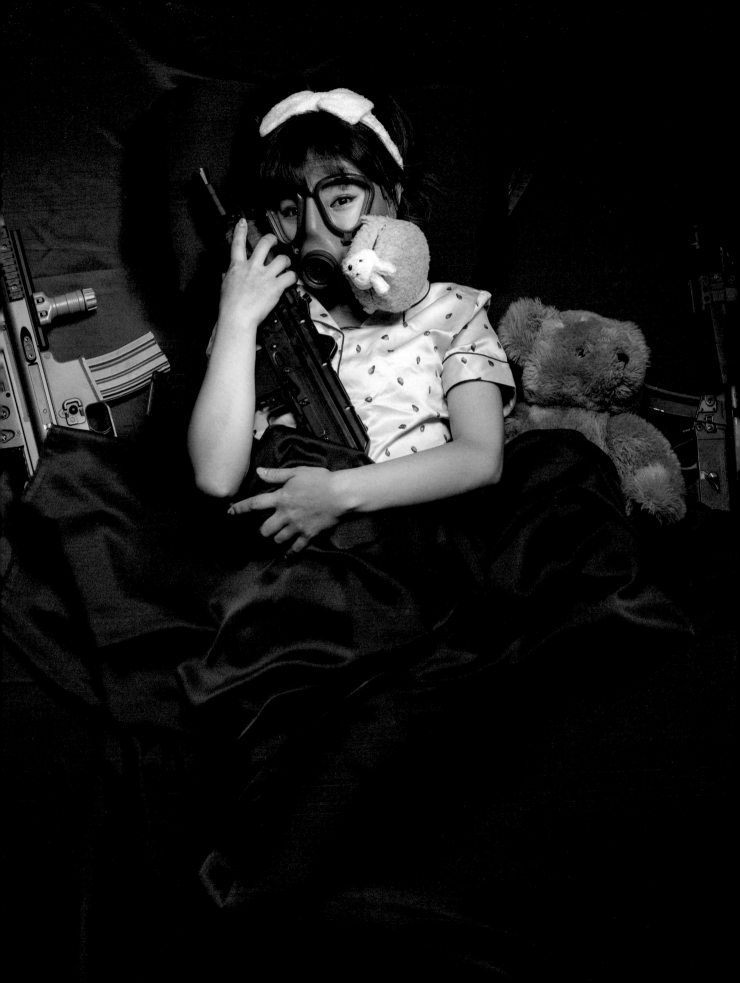

らんまるぽむぽむ

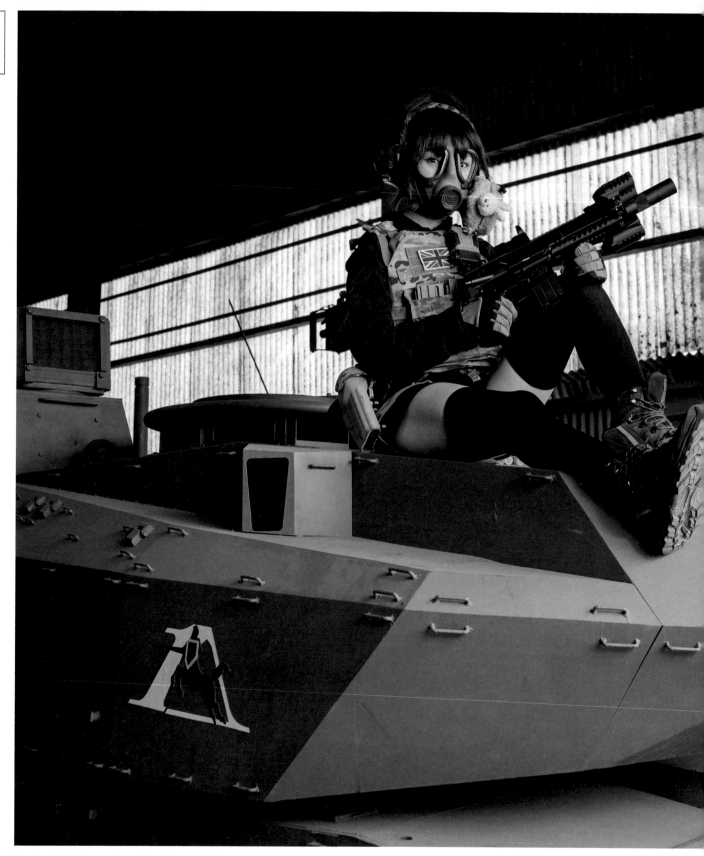

The airsoft field, complete with military vehicles, is Ranmaru's happy place.

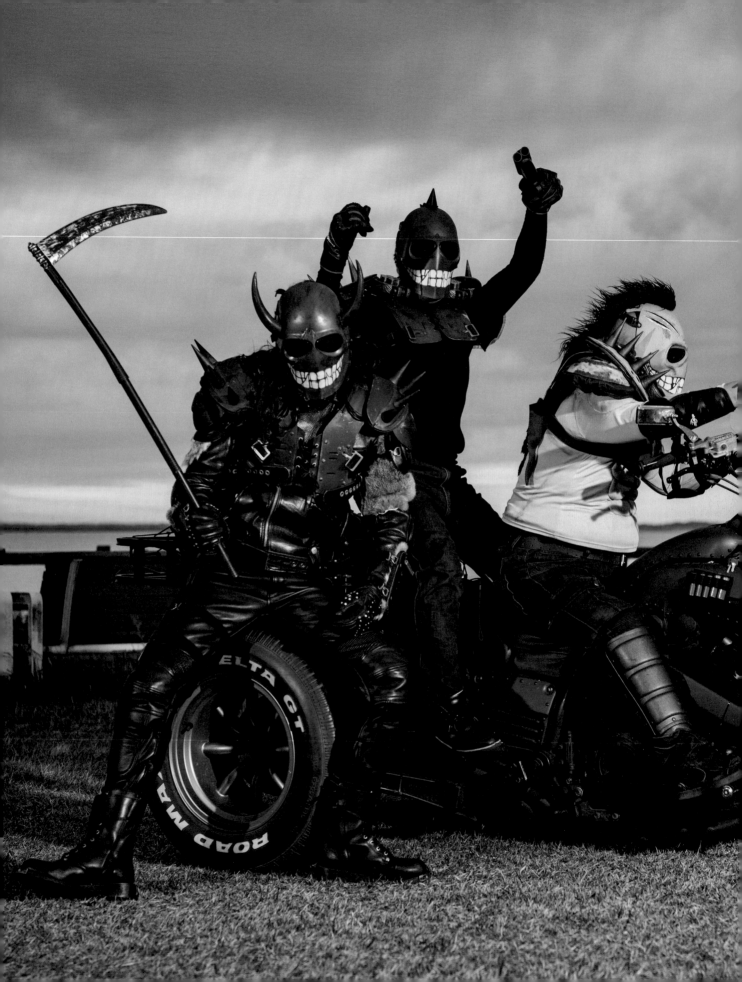

071

茨ジャギ

## IBARAKI JAGI

Just a few postapocalyptic riders out for a drive.

Cosplayers around the world are notorious for going
the extra mile to wow viewers with their creations. Few
go to the extent of modifying their vehicle into a Mad
Max-inspired street machine. "I don't consider myself
an otaku," says Ibaraki Jagi, or IbaJagi as he prefers
to be called. "I just don't like doing things by half
measures." IbaJagi's costume and vehicle are certainly
testaments to this; they would not look out of place
on a postapocalypse movie set. "Originally I started
out by customizing my bike with spikes, which people
said looked like something from *Hokuto no Ken*," he
says, referring to the famous manga and anime from the
1980s. "So I thought, why not make the costume as well?"
Using materials from 100-yen stores and home depots,
he modified his bike and costume, spending close to
400,000 yen on parts. "It's been three years since
I started, and now there's no more space on the bike,"
he laughs. It wasn't long before IbaJagi discovered
fellow riders who also found joy in dressing as post-
apocalyptic bikers, and now they tour the Ibaraki
countryside in full costume, enjoying the attention.

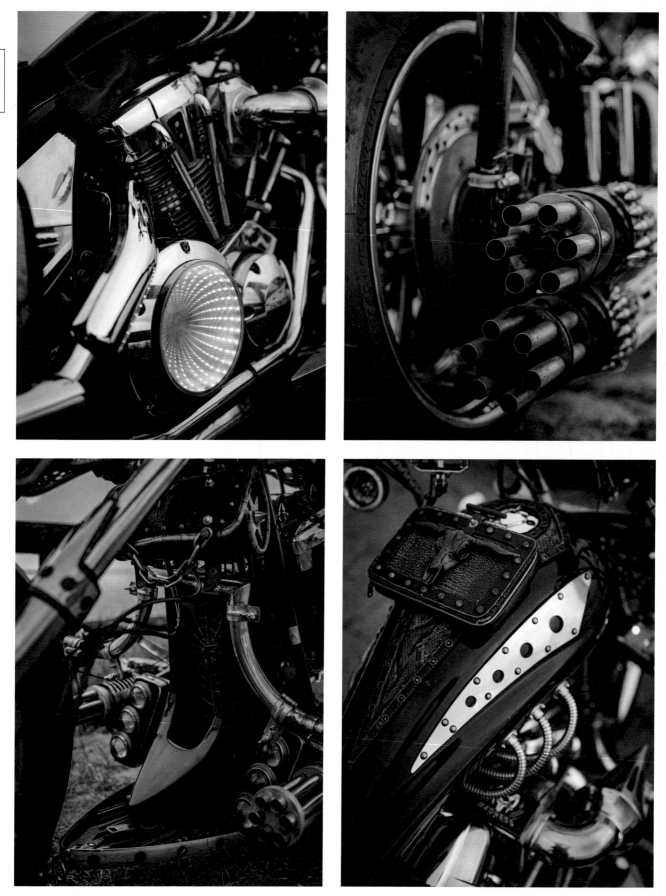

This page: Most of the custom parts on IbaJagi's bike were picked up at the hardware store. Opposite page: IbaJagi cosplays as Jagi, a villain from the *Fist of the North Star* manga series.

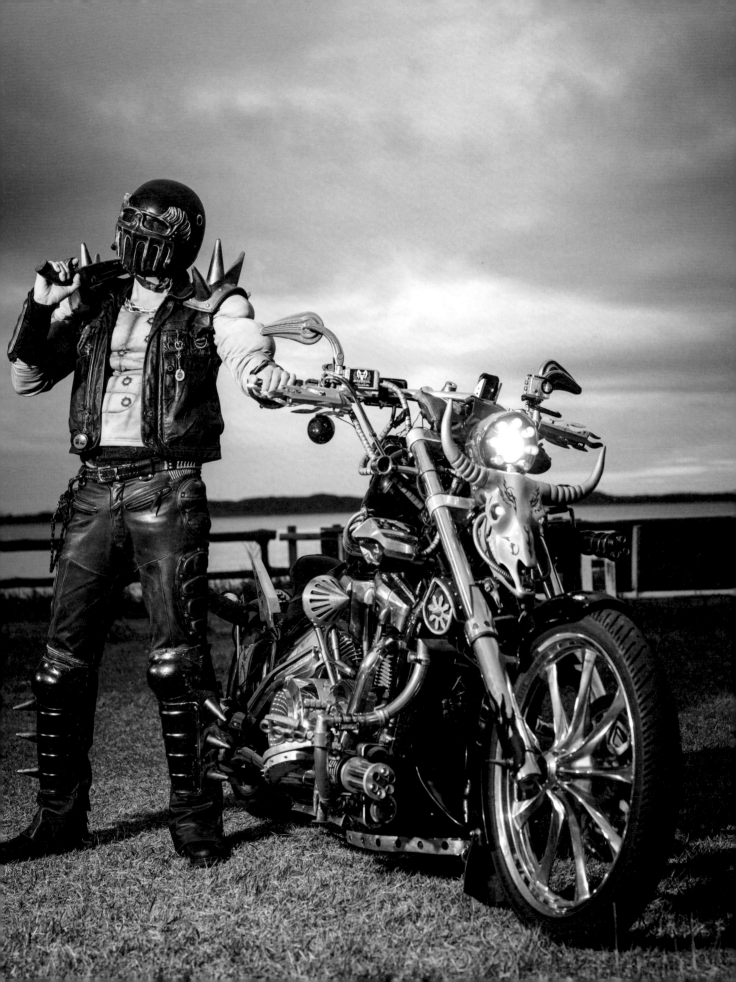

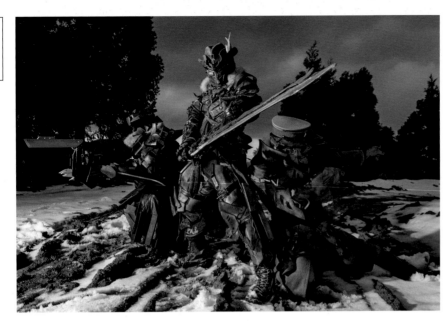

Left: Vadu (center) and several members of his Audo group at the Black Boar survival game site in Kanazawa. Opposite page: True to the spirit of all SF survival gamers, Kurohamu's outfit is an original creation borrowing influences from popular franchises.

# ARMOR FESTIVAL

A gathering of unique characters and costumes, united by their love of shooting each other.

In the world of airsoft survival gaming, a splinter subculture is gaining traction. Twice a year in a field in Chiba, hundreds of people in impressive sci-fi-inspired gear gather for Armor Festival, an anything-goes survival-game event organized by Moegami. "At first, I thought I was the only one dressing up like a space marine doing airsoft," he explains. "Then came SNS, and I found lots of like-minded people scattered all over the country." Expressing a desire to get together in order to share in their hobby, Moegami organized the first Armor Festival in 2016, which was attended by roughly 100 people. Since then, the event has grown in popularity, with 400 attendees in 2020, despite the country being in the grip of a pandemic. "This is a place where your creativity can be accepted and appreciated," says Moegami. "It's why so many people put so much effort into their gear." The quality and detail of many of the participants' creations certainly attest to this statement. "People who come here are overflowing with talent and potential. Creating this space as an outlet for that potential is probably my life's work."

Far north, in the city of Kanazawa, a cadre of former Armor Matsuri participants have their own tight-knit circle. Vadu, Kurohamu, and AP are members of Audo, a 12-member band of fantasy survival gamers. Vadu, the leader, is careful to draw a distinction between their original character designs and regular cosplay. "With cosplay, you are borrowing an intellectual property and are expected to act somewhat within the confines of that character. Making up your own character is much more fulfilling because you get to set your own ground rules and backstory." Kurohamu explains the appeal of their activities: "It reminds me of simpler times when we'd play heroes and villains as kids, emulating our favorite characters on TV. Of course, now it's leveled up because we have an adult's budget to spend," he laughs. Moegami shares the sentiment. "They say that as you grow up, you have to leave things behind, but if you hang on to the things you love, and find a place where you're accepted for it, I truly believe you can find happiness."

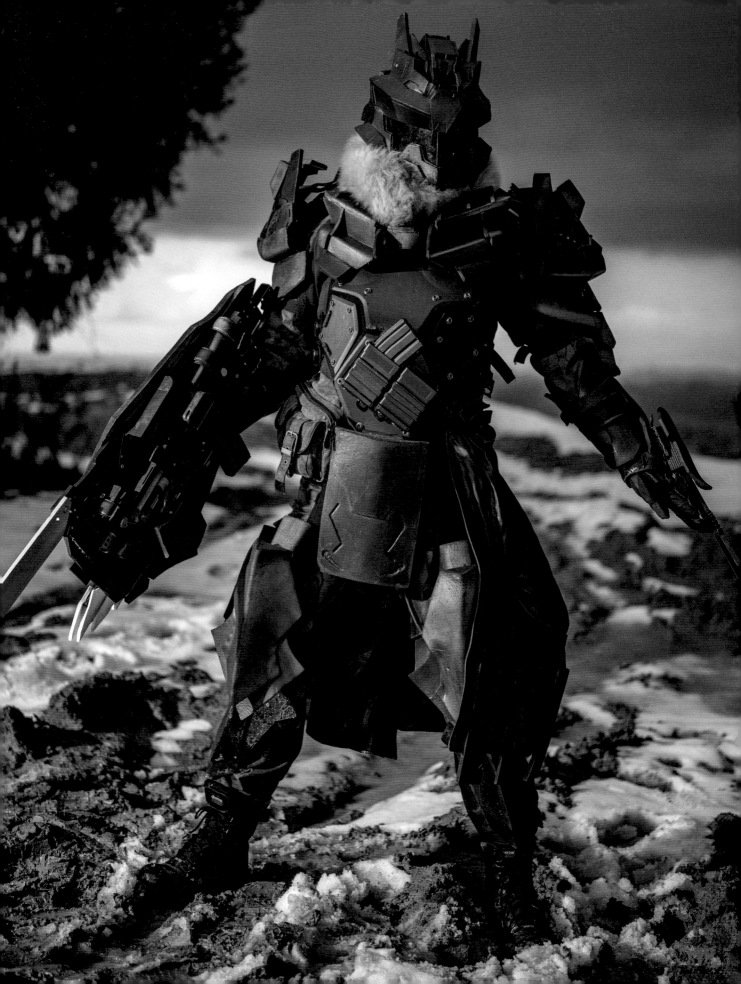

フィギュア コレクター

## FIGURINE COLLECTORS

An expensive and passionate love
for collecting figurines.

"These shelves are custom and cost one
million yen to make," says Ameshiba,
gesturing to the wall in her apartment
entirely dedicated to displaying over
500 anime figurines. "As far as the value
of the collection itself, it is probably
closer to four million yen." This impressive
accumulation of figures is the culmination
of over 10 years of collecting by Ameshiba
and Useda, a married couple obsessed with
figurines. While her husband predominantly
collects mecha and hero figures, the ma-
jority of the collection consists of *bishōjo*,
or "beautiful girl" figurines from various
anime and are mainly Ameshiba's purchases.
"The variation in hair, clothing, expressions,
and poses is stimulating, and the crafts-
manship is amazing too," she says. Indeed,
anime girl figurines show a staggering
degree of complexity and detail, often with
a price tag to match. "They used to cost
around 5,000 yen each but now demand for
quality has increased the price to around
15,000 to 20,000 yen each," laments Ameshiba.
Still, she has no intention of curtailing
her buying habits. "The only problem is
where to put the new figures," she laughs.
"It's like a jigsaw puzzle trying to fit
everything in."

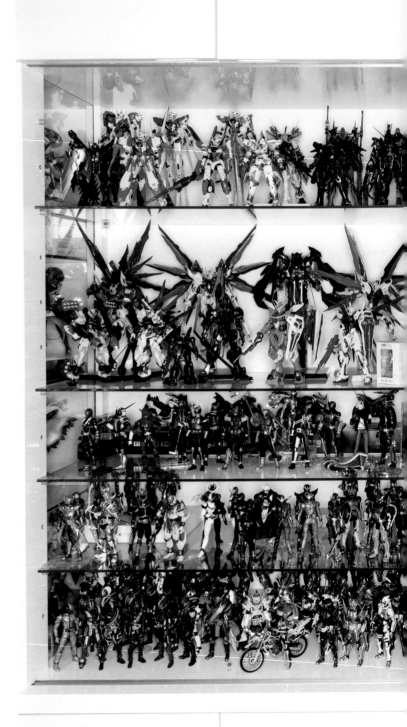

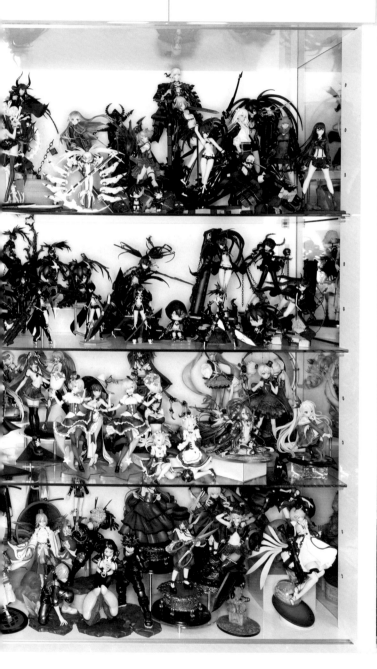
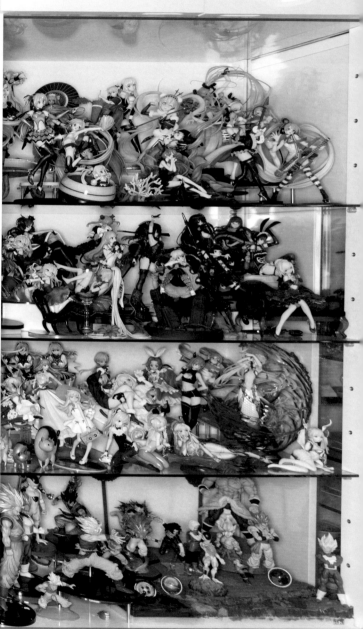

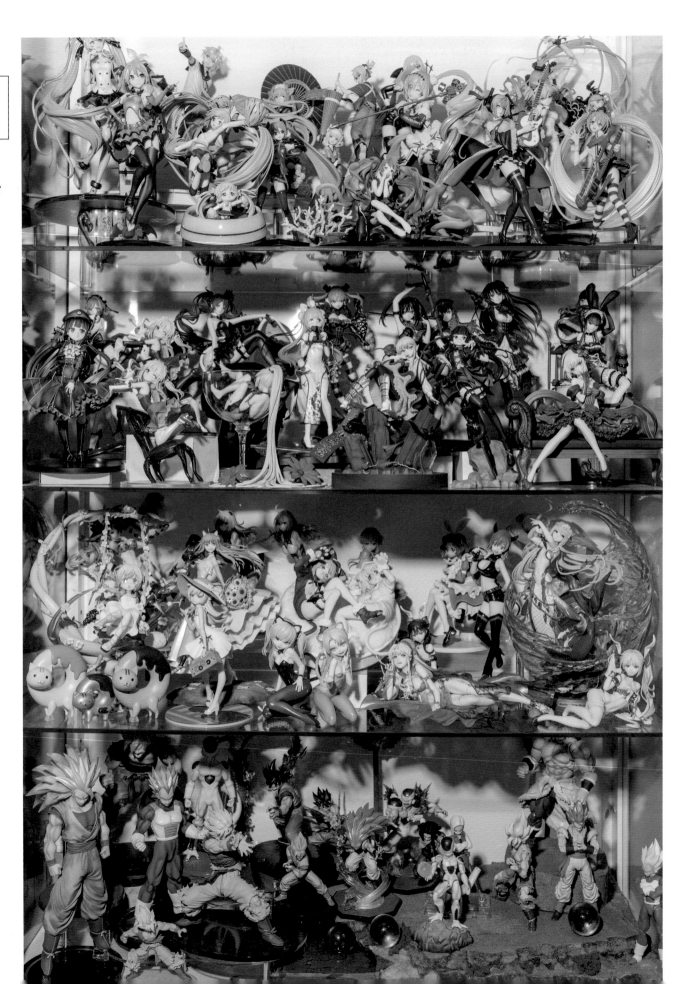

フィギュア コレクター

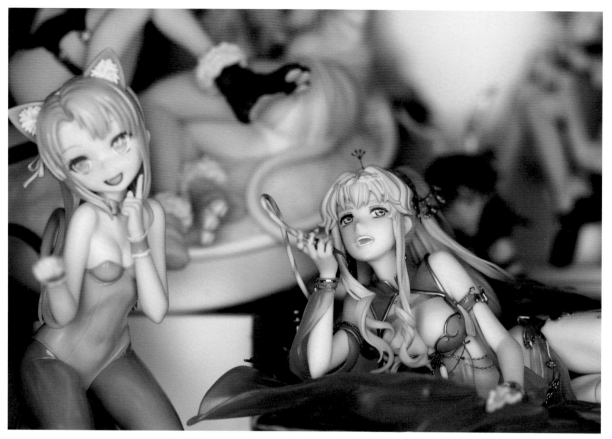

Top: Despite being highly sexualized, these figurines are popular amongst male and female otaku alike. Bottom: Poses are reproduced down to the finest detail. Opposite page: One entire wall of the apartment is devoted to cabinets squeezed to the brim with figurines.

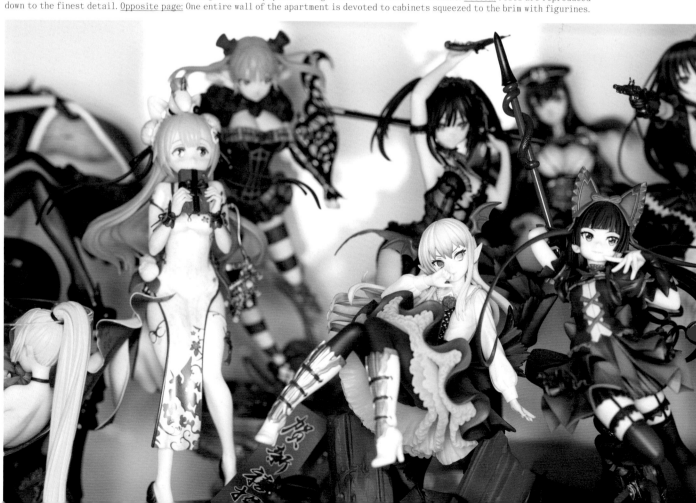

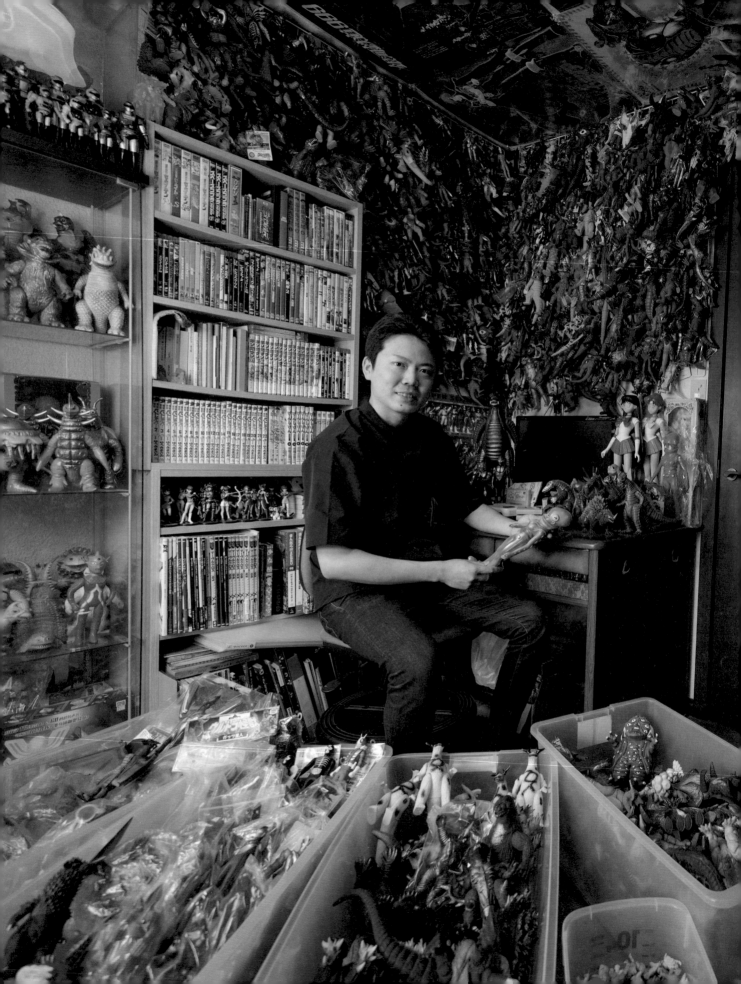

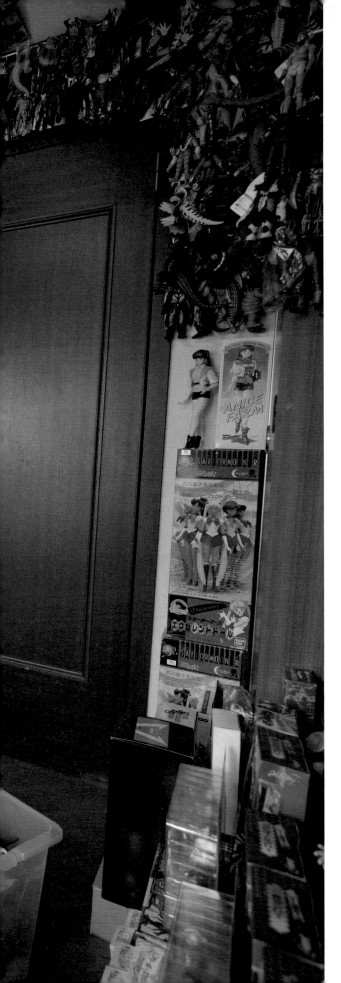

## SOFUBI TOYS

These squishy postwar Japanese toys are
as popular now as they were back then.

Japan's status as a superpower in the toy industry is
well known. From dolls to transformers to figurines,
the toy market here caters not just to the very young
but to adult collectors too—limited runs of popular
anime figurines or robots inspire as much fervor as the
latest sneaker drops from Nike or Adidas. Yet, no matter
how intricate and modern toys become, they will never
blunt the appeal of the humble *sofubi*.

Sofubi, a contraction of "soft vinyl," is a type of toy
that emerged in the 1960s. Made of polyurethane, these
figures are simple and often have no points of articu-
lation. Iconic series such as *Ultraman* and *Godzilla* were
some of the earliest sofubi produced and were amongst
Japan's first toy exports. The steady stream of new
heroes and villains from Japan's tokusatsu creators
gave rise to endless lines of sofubi toys, which now line
the shelves of stores such as Mandarake in Akihabara
for cashed-up collectors to peruse.

Kunkun Ojisan lives in Sendai, far north of the
otaku centers of Akihabara and Nippombashi. His room,
however, is a testament to the passion that sofubi
collectors share. They hang from every imaginable
surface and yet more are stored in chests hidden in
every nook and cranny. "I'd go to Tokyo a few times a
month with a budget and come home with a few boxes,"
he explains. He estimates his collection stretches
into the tens of thousands, though by now he has lost
count. Their appeal, Kunkun says, is twofold: "They're
extremely detailed, so you can admire them for a long
time. And the way they are a little squishy yet durable
is comforting. They remind you of when you were a child."

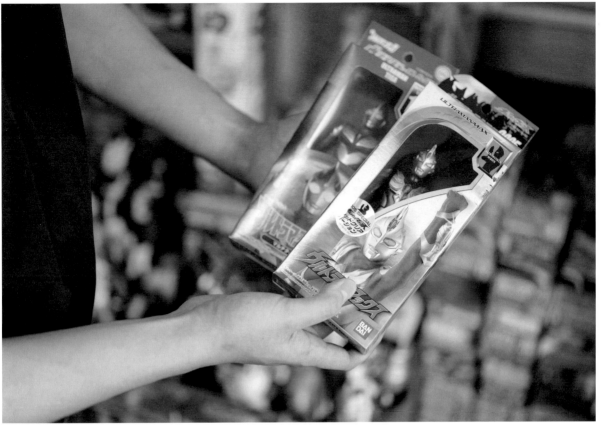

Top: Kunkun Ojisan holds the two Ultraman *sofubis* that started his obsession. Bottom: His display cases are lined deep with *sofubi* of every genre. Opposite page: Kunkun has to move house soon and hopes he can find enough space to display his collection.

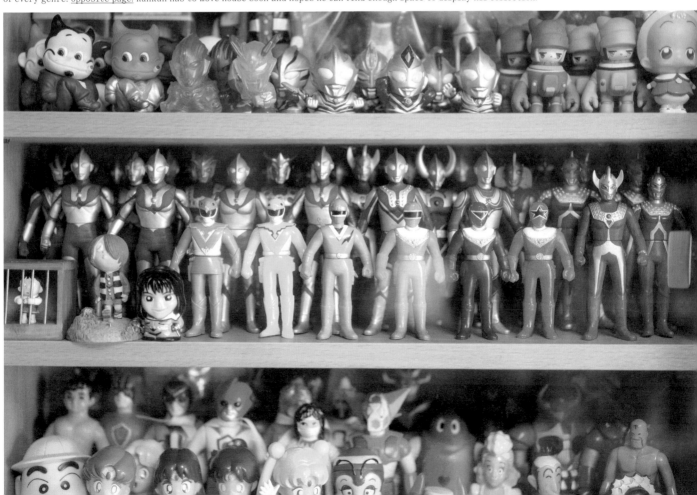

## TORIENA

A chiptune wizard who turned her Gameboy
into a musical instrument.

At the forefront of the chiptune music scene in Japan
is the artist known as Toriena. Chiptune is electronic
music typically composed by using the sound chips
in vintage video-game consoles, and Toriena's music
stands apart in its dizzying complexity and depth.
Born in Sapporo, she gained an appreciation of
electronic music in high school and began dabbling
in composing in university. Starting with computer
software, she eventually found her way to the classic
Nintendo Gameboy as a means of expression. "I modified
these Gameboys myself," she says. While the Gameboy
seems like an unlikely musical instrument with only
4-bit sound, to Toriena this restriction is no issue.
"I like the sound of the Gameboy music chip. A lot of
people say electronic music, being man-made, doesn't
express any soul. I think the Gameboy is very expressive."

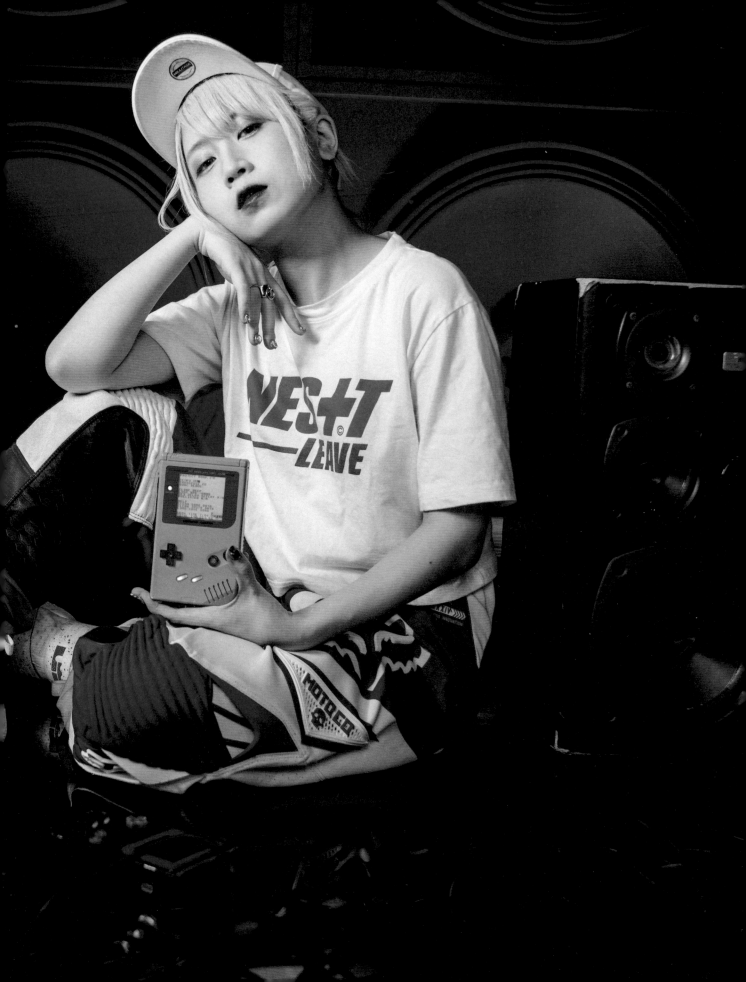

山崎
功

# YAMAZAKI ISAO

A legend in the Nintendo
collectibles world.

Yamazaki Isao's collection of video-game-
related memorabilia numbers into the
thousands. An avid collector of all things
Nintendo, he also has a huge array of
vintage, discontinued consoles from other
makers too. Neither his parents' home nor
his own home in Tokyo has enough space to
store it all. "Most of my collection is in
long-term storage or on loan to various
museums," he says. "It would be madness to
keep it in the house."

    The work Yamazaki is most well-known for
is his obsessive research and cataloging
of the long and storied history of the
video-game company Nintendo. "Ever since
I was a boy, I was always fascinated by
the way Nintendo games seemed much more
captivating and interesting than other

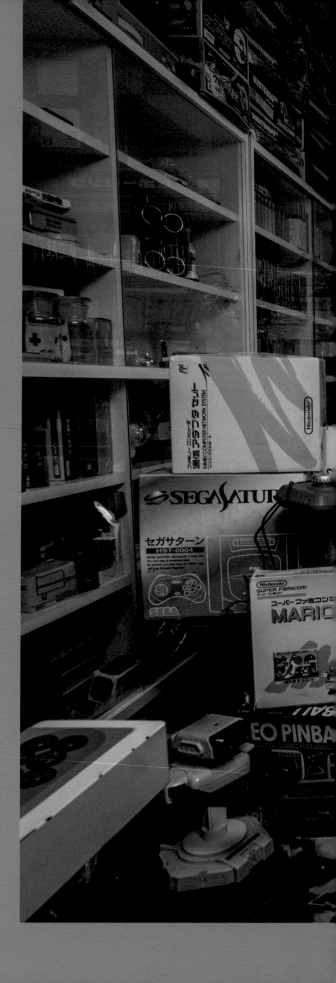

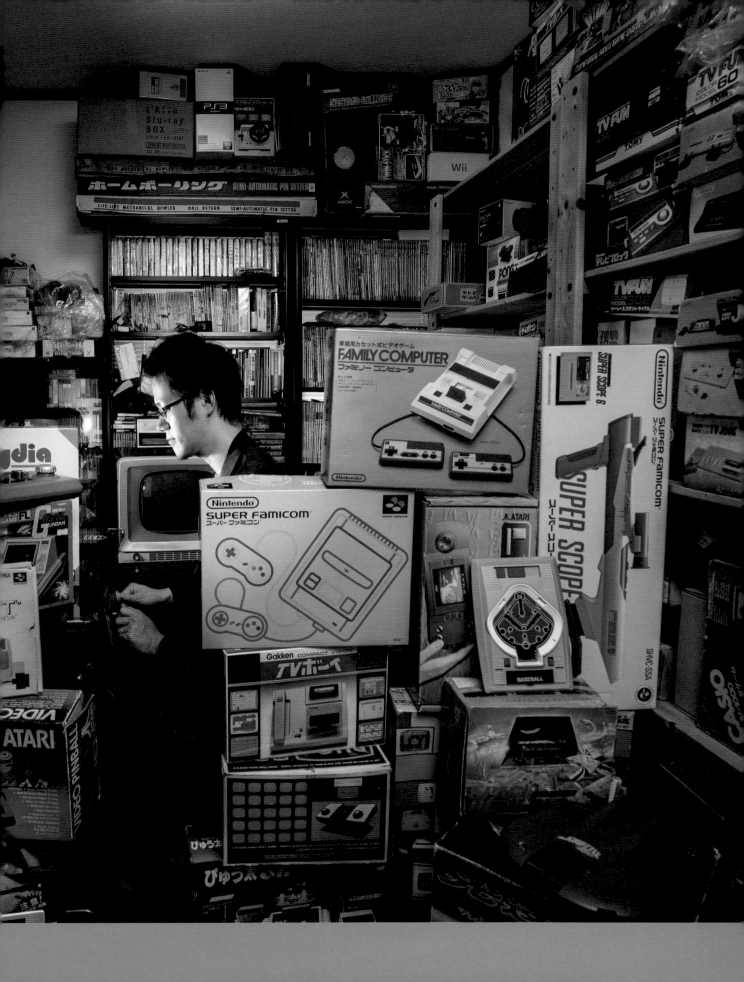

makers' games," he says. "Growing up, that fascination intensified, and I found myself digging into the history of the company." He describes sitting in Japan's largest library poring over books and articles for weeks on end, like an Indiana Jones of the video-game world. "I was surprised to find out many of the toys I played with as a child were products of Nintendo from their pre-video-game days," he says. "At the time,

**"Most of my collection is in long-term storage or on loan to various museums. It would be madness to keep it in the house."**

I had no idea that Nintendo's historical product range had been so large."

Nintendo was established in 1889, and was originally a maker of *karuta*, a type of Japanese card game. Card games were in fact banned until the late nineteenth century and the company was established by an avid cardplayer in response to the lifting of that ban. One of the most famous karuta designs ever sold by the company is the *daitouryou* deck, or president's deck, with each card emblazoned with an image of Napoleon. "I'm not sure why they decided to go with Napoleon," laughs Yamazaki. "After all, wasn't he the emperor of France, not the president?" Interestingly enough, this deck is still being officially produced and sold by Nintendo. The company soon expanded into Western-style playing cards and was at one point the biggest card-game manufacturer in Japan.

Following the Second World War and the influx of other popular Western entertainment pastimes, Nintendo found its card-game business falling behind. This was a time of extremely speculative experimentation for Nintendo, as they attempted to expand beyond toys into completely different industries including instant rice, taxi services, and even love hotels. None of these ventures stuck,

however, and in the late 60s, Nintendo pivoted back to what they knew best: toys.

It was around this time that Yokoi Gunpei joined Nintendo. Yamazaki owns every product that Yokoi had a hand in making and professes to be a superfan. "I read a biography about his design philosophy and knew I wanted to collect all of his Nintendo products," he says. The first product by Yokoi was the Ultra Hand, an extendable grabbing device that came with three colored balls, ostensibly for grabbing. "I don't think anyone knows what sort of game was to be played with those balls," says Yamazaki. "The goal was to pick them up and put them back down, as far as I could find out." Still, the Ultra Hand tickled Japanese society and sold 1.2 million units, a wild success for Nintendo at the time. Yokoi was given his own toy R&D division, and from there charted a new course, one that would eventually revolutionize entertainment for the entire world.

"One of Yokoi's philosophies was to use old technologies in new and interesting ways," says Yamazaki. One example was the Nintendo Love Tester, which at its core was a simple current-measuring device purporting to measure the "love" between two people. Two people would grip separate

**"In the 1960s, physical contact between the sexes in Japan was still quite taboo. This toy gave people an excuse to touch each other."**

metal sensors on each side of the toy, which would then produce a compatibility rating. "In the 1960s, physical contact between the sexes in Japan was still quite taboo. This toy gave people an excuse to touch each other," says Yamazaki. Predictably, the Love Tester was a runaway hit.

Not everything Yokoi touched was a success though. "Nintendo tried a lot of different things in the pre-video-game

A selection of the tabletop games Nintendo was famous for before going into video games.

山崎
功

era," explains Yamazaki. "Some of them made little sense and sold a lot, and some of them made little sense and sold little." One such item in Yamazaki's collection is the Chiritori, a remote-controlled vacuum cleaner. "It looks just like a Roomba doesn't it?" Unfortunately the Chiritori could only move in a forward direction and spun around in circles when left to its own devices. "Nintendo is one company you can count on to deliver a surprising product," says Yamazaki. "Whether or not they will be profitable is another matter entirely."

**"In the early days of video games, no one knew what the formula for success was, so companies tried all sorts of different things. That's why you have such an odd jumble of designs from the 80s."**

Of his enormous collection, Yamazaki is most excited by the Game & Watch product line of the 1980s. "This is where Nintendo's philosophy of using old technology in new ways really blossomed," says Yamazaki. "They took two things that were already very common–an alarm clock and an LCD screen–and made a smash-hit product." In the 80s, Nintendo began to make inroads into video-game making. The Game & Watch, of which there are 60 variations, were addictive minigames on a pocket-sized tablet. "The ability to walk around with a game in your pocket–this was an unprecedented luxury in the 1980s!" says Yamazaki. The double LCD Donkey Kong Game & Watch was released shortly after–the first game machine of any kind to feature the cross-shaped D-pad, which would become a staple of video-game controllers and the most enduring of Yokoi's many innovations. When Yamazaki is not digging out rare video-game artifacts, he is writing books about his passion. His favorite, *The Nintendo Complete Guide*, was completed

with little assistance from the company itself. "They say Nintendo is a company that doesn't look back, and that was definitely the case when trying to contact them about their history," he says. The company declined to answer any questions about their past because they did not preserve any of their records. Yamazaki was left to piece together what he could from magazines and articles going back decades, like an archeologist sifting through a forgotten civilization. Then in 2007, he was asked to lend some of his extensive collection to the official Nintendo retrospective museum at Hankyu department store in Osaka. "Working directly with Nintendo was a dream come true, and I got to meet Iwata Satoru!" he says, referring to the late president of Nintendo, who steered the company through the early 2000s and oversaw the development of the DS and Wii systems. "He was like a hero to me."

**"Many of the toys I played with as a child were products of Nintendo from their pre-video-game days. At the time, I had no idea that Nintendo's historical product range had been so large."**

As for why Yamazaki finds old video-game systems so fascinating, he says: "In the early days of video games, no one knew what the formula for success was, so companies tried all sorts of different things. That's why you have such an odd jumble of designs from the 80s. Some of them were truly terrible, and it's interesting to look at these as the jumping-off point for the gaming culture we love today." Yamazaki is still searching for several elusive items of Nintendo merchandise before he can call his collection complete. "There are some things that I really regret not bidding for," he says. "Maybe if I'm lucky enough, I'll come across them again."

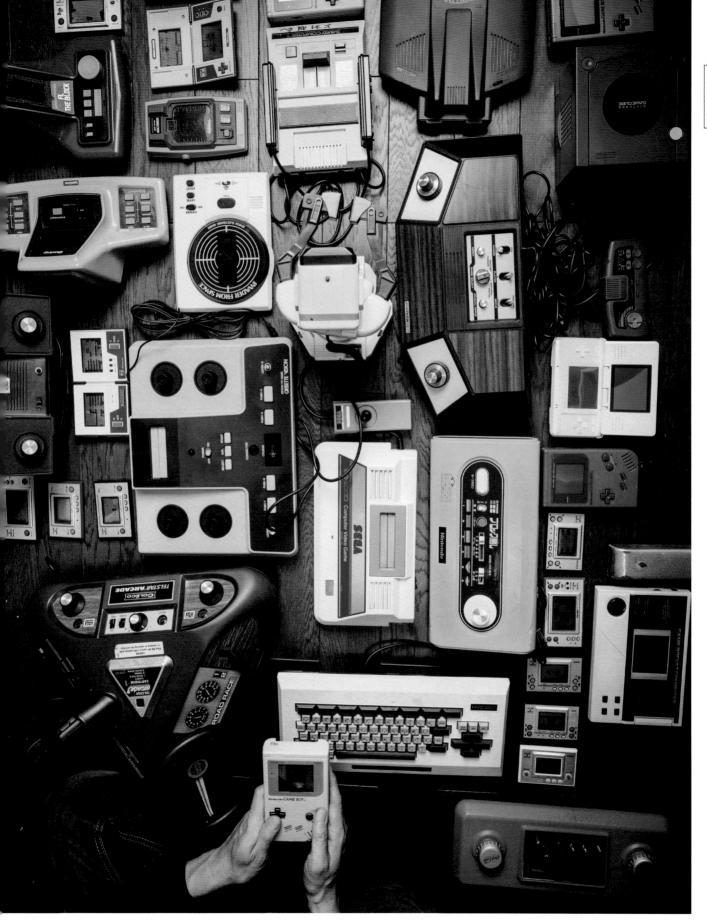

Only the smallest hint of the vastness of Yamazaki's collection, most of which is held in long-term storage or on loan to exhibitions.

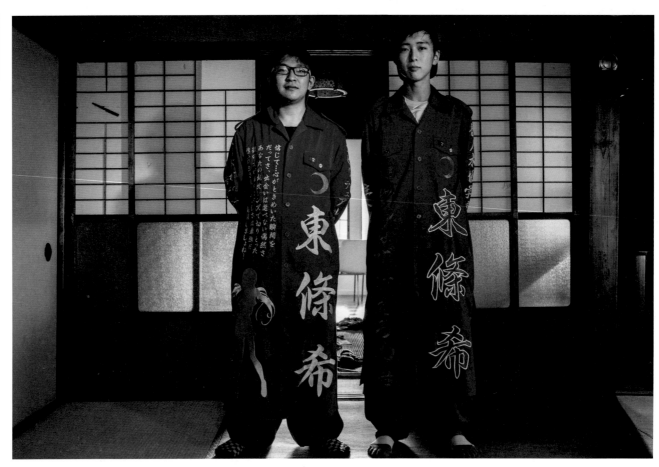

Embroidered *gakuran* were once the domain of delinquents, but are becoming more popular amongst otaku. The more merchandise sold, the more popular that character is considered. Superfans are known to buy everything available, multiple times.

## BUSO LIVERS

An overabundance of love results in extreme wardrobe choices.

The anime *Love Live! School Idol Project* has been a smash hit with both male and female anime fans alike. In it, various fictional schools form idol groups who perform song and dance choreographies at music events. The culmination of each series is the *Love Live!* concert, and only schools that have amassed enough fans in the real world are allowed to participate. This has resulted in passionate "Love Livers" (as fans of the franchise are known) competing in an ever-escalating race to outperform each other's displays of devotion and have their favorite groups advance. The embroidered *gakuran* has been adopted as a sign of such superfandom. For some fans, however, this was not nearly enough, and so the "Buso Liver" was born. Translating to "Armored Liver," these obsessives coat themselves in as much merchandise as they can fit on their body– and then some. Their bulky displays are reminiscent of samurai armor and are a sight to behold at *Love Live!* events. One superfan was even ejected from an event for being too over-encumbered. Loving something too much can be tough sometimes.

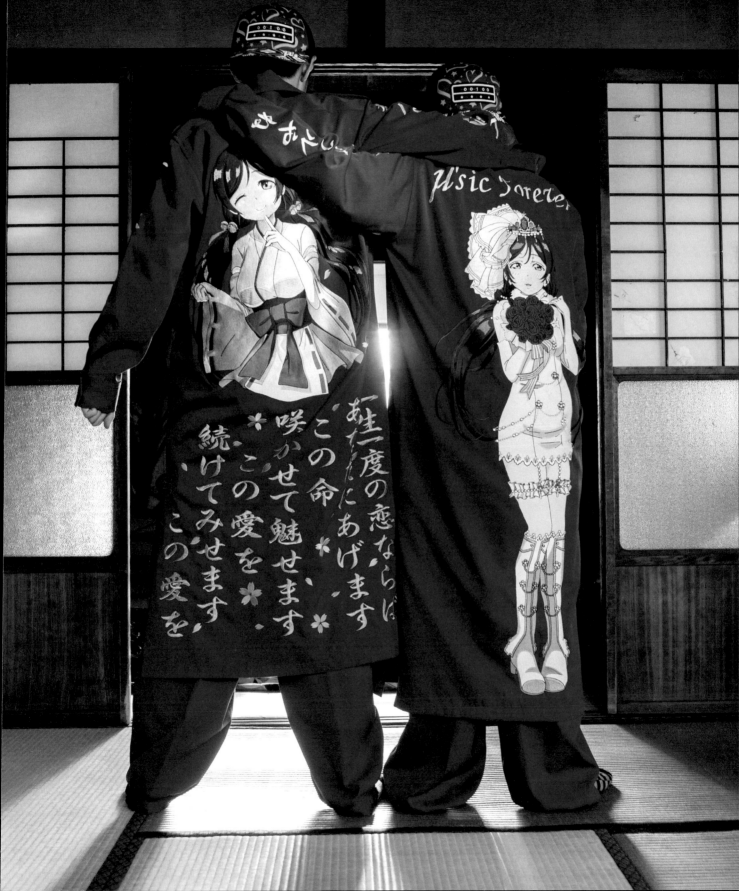

武装ライバー

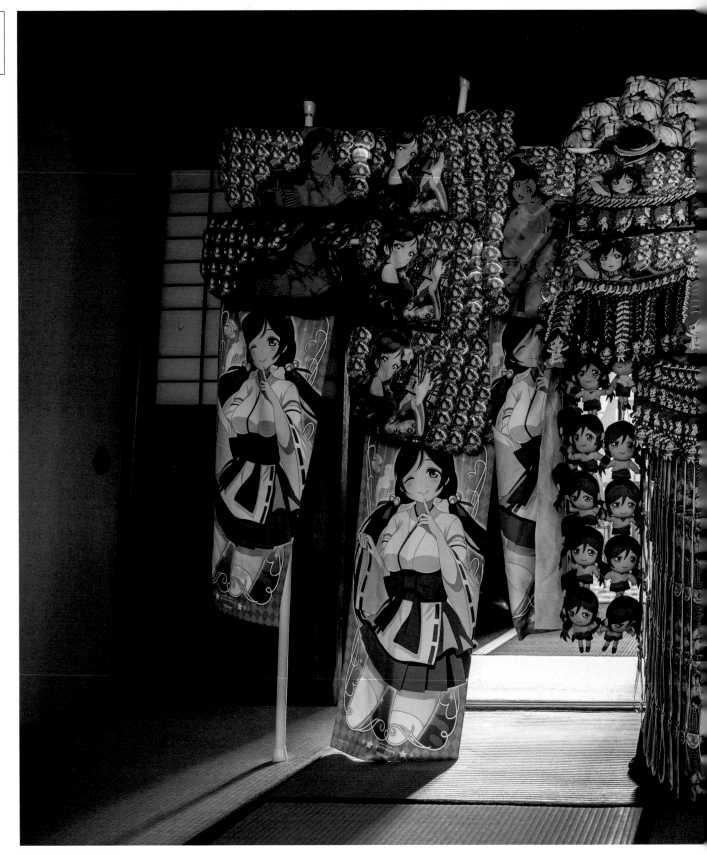

The full glory of the Buso Liver is one to behold, at least until they get kicked out for disrupting other patrons.

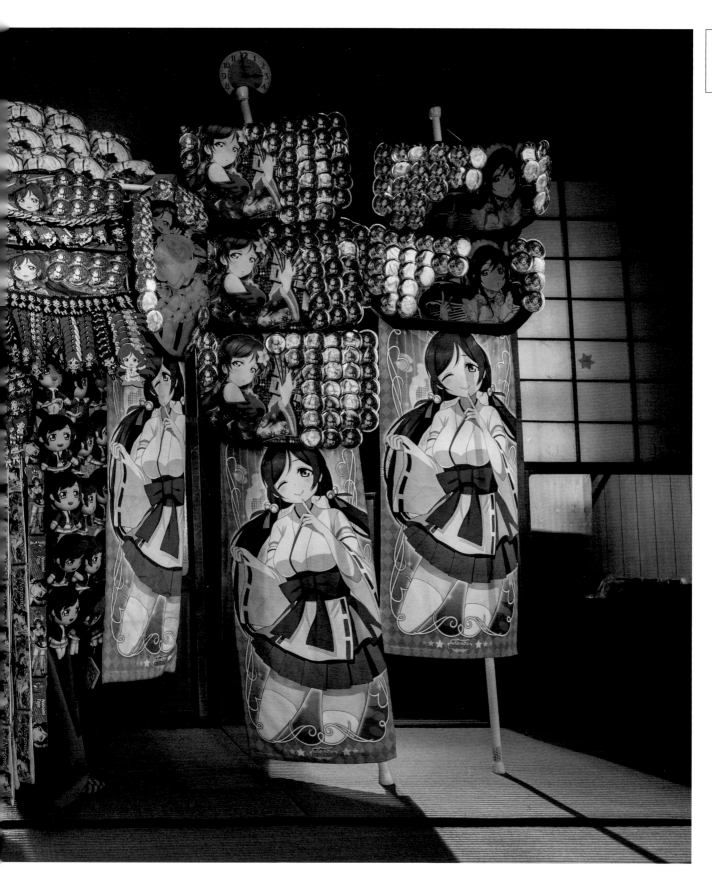

刺繍マニア

# SHISHUMANIA

A skilled embroiderer fusing tradition
and pop culture into a new subculture.

Fukumori Takuma is Shishumania, a young
embroidery artisan who has gained recog-
nition for his vivid and intricate artwork.
Amongst many things, Fukumori's work
greatly contributed to the emergence of
the subculture in which tokko fuku were
co-opted by otaku to wear at idol concerts.

Tokko fuku are jumpsuits that orig-
inated in the 70s as the uniform of the
disaffected youths belonging to bosozoku.
These jumpsuits were themselves co-opted
from the workwear of mechanics and manual
laborers, and meant to be representative
of their wearers' working-class origins.
Tokko fuku were often covered in embroidery
denoting gang names, logos, flags, and even
poetry, in order to make the individuality
of each wearer known. The gang members
were reverential to their tokko fuku, never
washing them and allowing the dirt and
blood from their adventures to become part
of the story of their clothes. For the rest
of Japan, however, the tokko fuku became
a symbol of delinquency and intimidation,
with an image inextricably entwined with
lawlessness. To wear a tokko fuku in public
was to brand yourself an outsider. Despite
this, the tokko fuku was undeniably stylish
and wormed its way into popular culture–
superfans of bad-boy rocker Yazawa Eikichi
were known to wear tokku fuku embroidered
with his name and likeness to his concerts.

The embroidery adorning tokko fuku
was a huge part of its identity. True to
the spirit of Japanese craftsmanship,
these designs were intricate and metic-
ulously executed and a point of pride for
bosozoku members who would often pour
thousands of dollars into decorating
their garments. Artisans skilled enough
to satisfy these demands were few enough;
fewer still were willing to accept jobs
embroidering clothing so closely linked
with criminality. Over time, bosozoku num-
bers dwindled and the scourge of delin-
quent joyriders became less commonplace.
Despite this, the iconic tokko fuku was
firmly stamped into the Japanese zeitgeist
as a symbol of youthful zeal and rebellion.

Fukumori was born in 1990, just after
the bosozoku wave peaked and gang numbers
were decreasing. He grew up removed from
that world, entering a JASDF (Japan Air
Self-Defense Force) high school with hopes
of becoming a pilot. It was there that
he developed an interest in embroidery
through sewing rank insignias. "I'd kill
time in the dorm by embroidering with
leftover threads. It was so interesting
it made the time fly." On graduating, he
pursued embroidery by apprenticing to
a master embroiderer in Kiryu, Gunma, a
place famous for a style of embroidery
called *yokoburi shishu*. A difficult art
that forgoes the use of a Jacquard loom,
it affords greater flexibility when
creating designs. "My master is truly
the best in his field," says Fukumori. "But
we never had work. When we were featured
on TV, we'd make it look like we were busy,
but in all honesty, there were no jobs."

After six years of training while
working three part-time jobs, and some-
what fed-up with the stuffy, unthinking

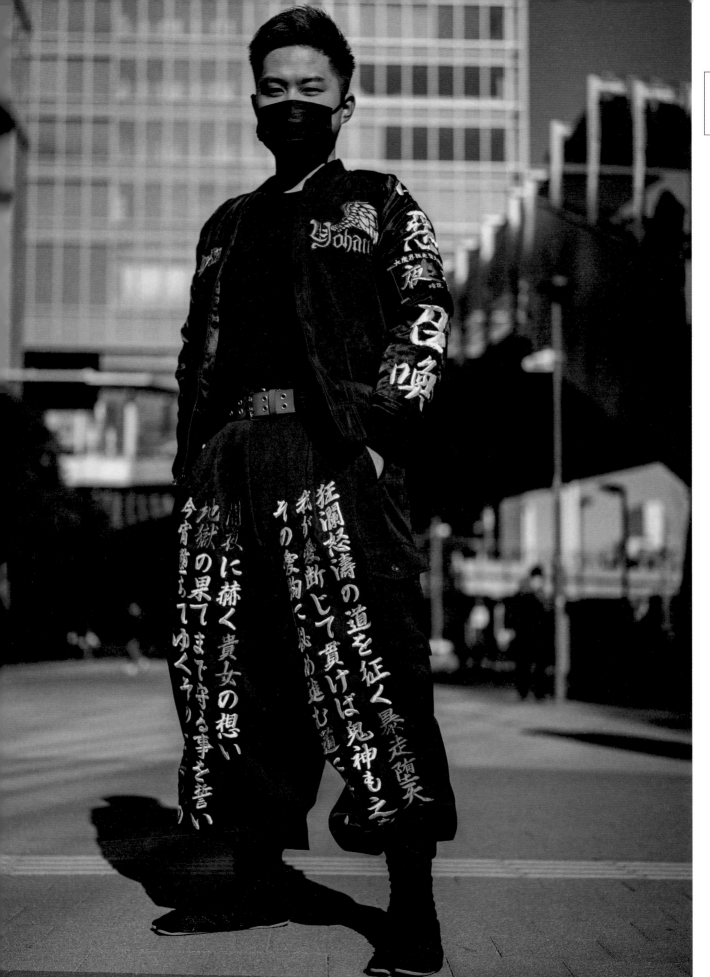

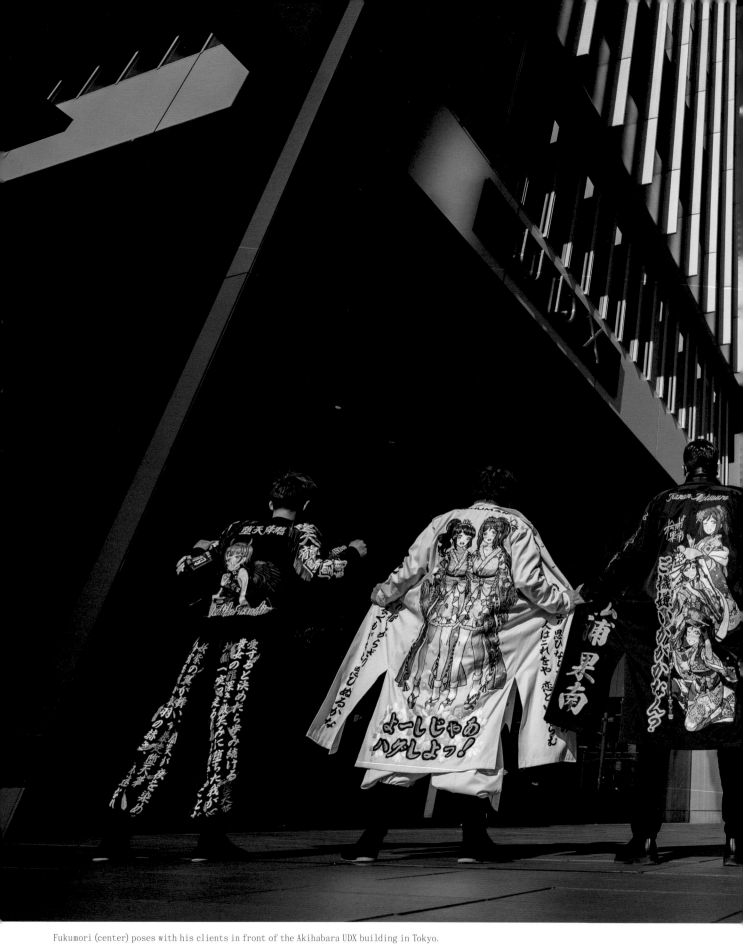

Fukumori (center) poses with his clients in front of the Akihabara UDX building in Tokyo.

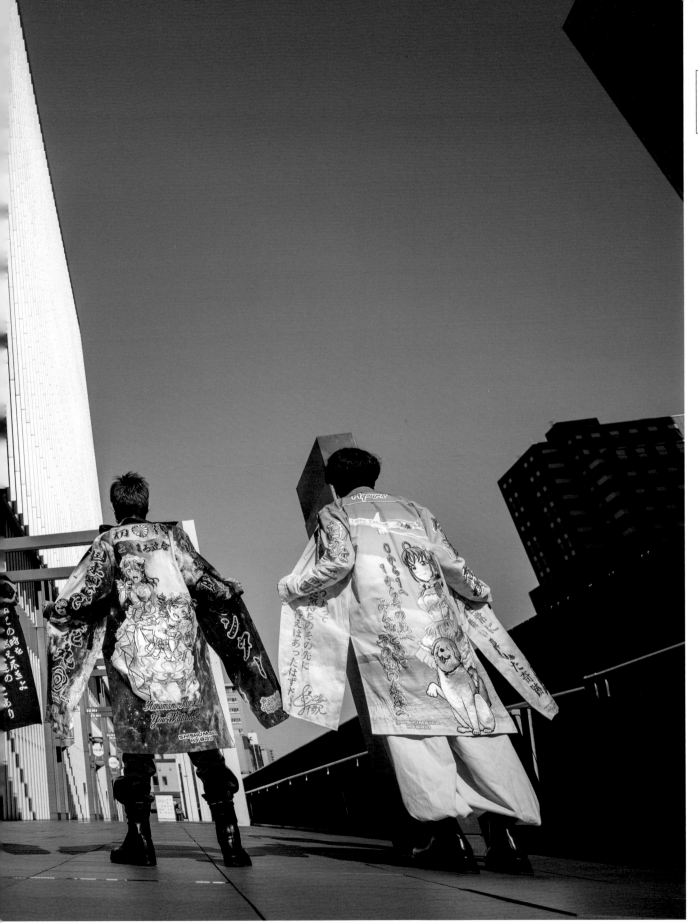

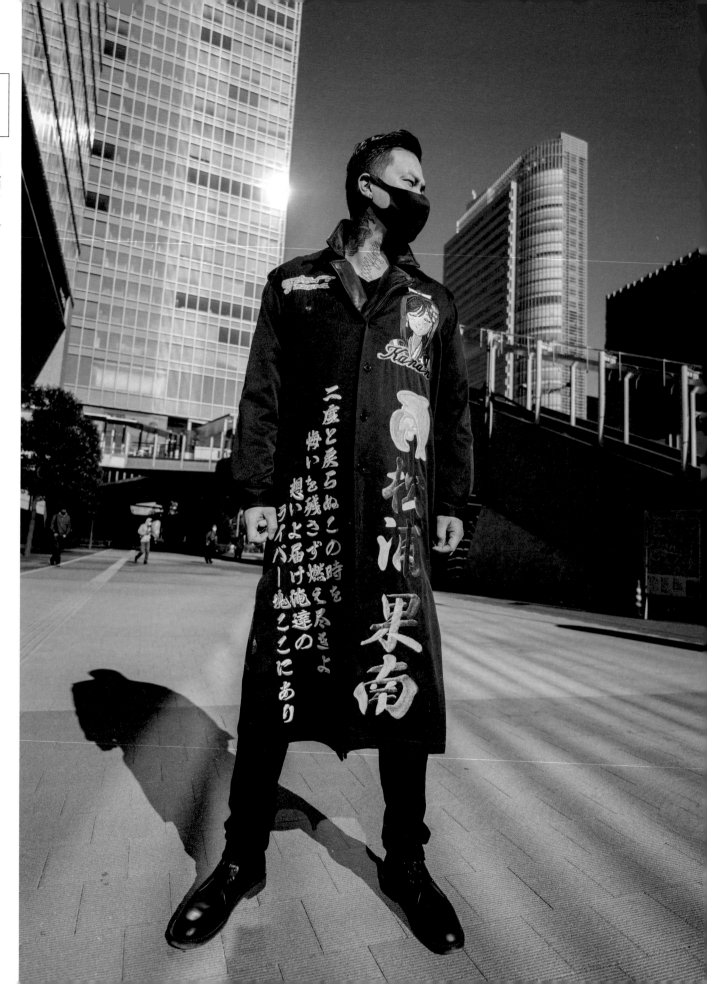

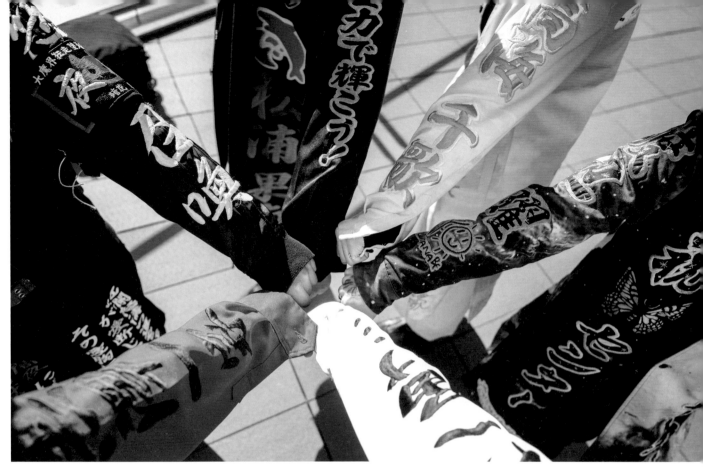

Top: No patch of fabric escapes being adorned with devotions to fans' favorite idols. Bottom: Fukumori maintains the traditional techniques of *yokoburi* embroidery to this day. Opposite page: Fukumori wears one of his elaborate creations.

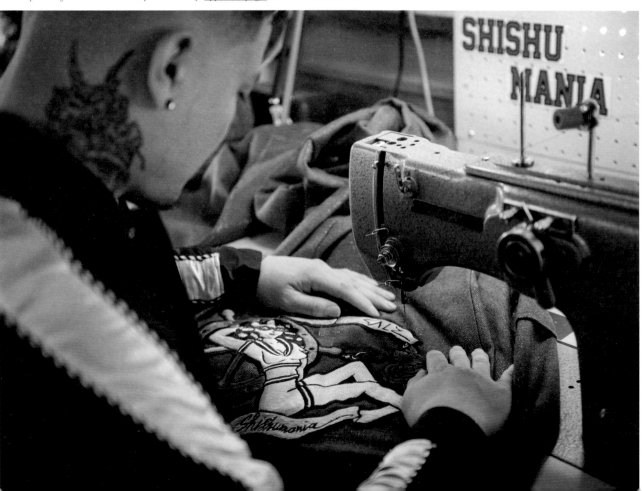

adherence to tradition that the shrinking embroidery industry of Kiryu offered, Fukumori struck out on his own. He moved back to Saitama, a prefecture neighboring Tokyo, and set up shop. "I had no jobs, no money, and I had to figure out a way to pay the rent somehow. That was a time when I was at my lowest, and the anime otaku who respected me and gave me jobs embroidering their jackets really saved me and made me who I am today."

**"I found it hard to understand how garments decorated with cute girls and lyrics about love could be intimidating."**

The articles of clothing that Fukumori worked on were, of all things, tokko fuku, this time co-opted by anime idol fans to show their undying devotion to their *oshi*, or beloved character. Megafans would get their favorite anime character emblazoned on the backs of their jackets, along with choice kanji or poetry in the style of the old bosozoku riders. This time, however, the kanji weren't of nationalistic slogans but lyrics from love songs and pop ditties. The immensely difficult task of rendering these characters in the vivid detail that otaku desired was one Fukumori was uniquely suited to, having undergone the arduous training under a master.

Wanting to show off his work, Fukumori went along to concerts with a group of his customers, all proudly wearing their anime tokko fuku. Not all the concert goers were impressed. "Some reactions were very extreme," says Fukumori. "I received messages from people on Twitter and 2ch telling me to 'die,' and 'get lost.'" Fukumori wanted to hear directly from his critics but however long he waited at concerts fully clad in tokko fuku, no one came to talk to him. So he started reading the comments people were leaving. "The main reason people didn't like it was that they found tokko fuku intimidating," he says. "I found it hard to understand how garments decorated with cute girls and lyrics about love could be intimidating just because they were on tokko fuku, but I felt that I could change their minds."

The deep-seated rejection of bosozoku culture from mainstream society was rearing its head. On the other hand, for many otaku the allure of having their own tokko fuku custom designed with their favorite anime character was enough to overcome their bias. Orders for Fukumori's work gained steam. "I saw Fukumori-san and his people wearing them at a concert and I wanted one too," says Ka-kun, a former customer of Fukumori. Otaku were not shy about the cost either–each embroidered tokko fuku ran between 50,000 to 300,000 yen, depending on the surface area covered.

It wasn't long before tokko fuku-clad anime fans were a staple at anime and idol concerts. Fukumori's big break arrived when he was asked to embroider the costumes of the pop duo KinKi Kids for their performance in the Kohaku singing competition, the biggest television event of the year. He has since worked in the movie,

**"The anime otaku who respected me and gave me jobs embroidering their jackets really saved me and made me who I am today."**

television, and music-video industry. The credit goes, he says, to the legions of otaku who trusted him. "They raised me up when I was lowest. I would not be here without them." One of his proudest achievements is normalizing tokko fuku at anime concerts. "The era of young rebels wearing gang names on their back and risking their lives joyriding has changed into a culture of kids enjoying concerts with the character they love on their back. I am proud to have been able to spread this culture alongside my customers."

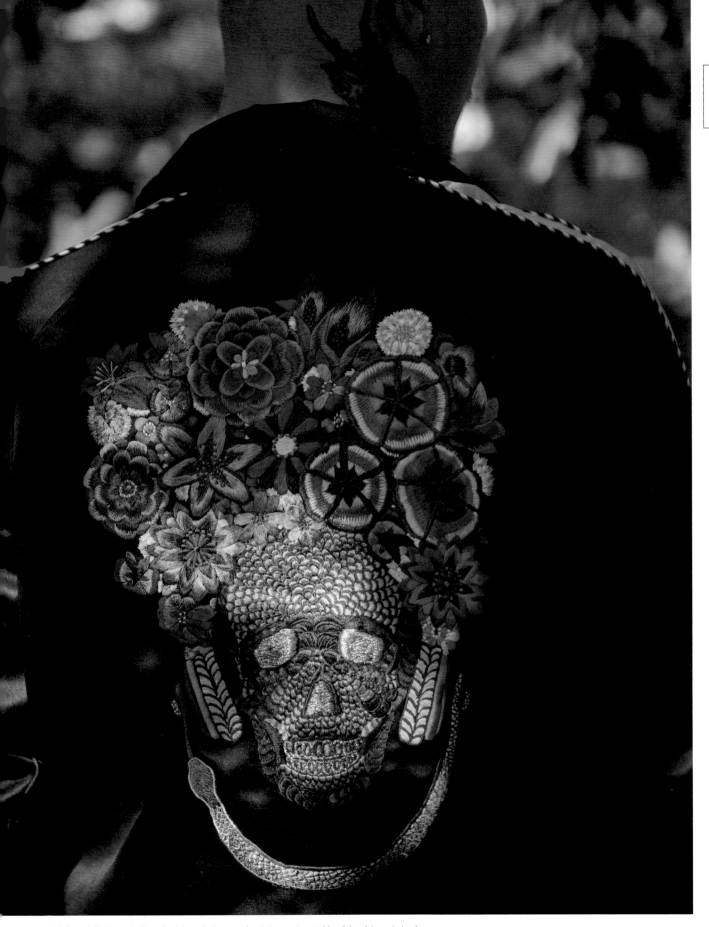

Although Fukumori played a big role in popularizing anime tokko fuku, his original designs also speak to his creativity and virtuosity as an embroiderer.

<u>Above:</u> The Strangers are the most active group in the Harajuku area. <u>Opposite page:</u> Two members of the Fairlady group, one (left) sporting a classic regent hairdo.

## ROLLER-ZOKU

The famous rockabilly dancers outside Yoyogi Park aren't performing–they're continuing a tradition.

The Harajuku rock-and-roller tradition stretches back to the 1980s. In this period, the pedestrian paradise affectionately known as the Hokoten had recently been established and fashionistas of all sorts were gathering there, creating the melting pot that would lead to the explosion of fashion variety Harajuku is now known for. Of these, the rock-and-roller group The Strangers are amongst the most well-known. Every Sunday they gather in front of the entrance to Yoyogi Park with their denim-on-denim outfits and bouffant hairdos to dance to classic 1950s rockabilly music. The group is a gathering of enthusiasts rather than performers; their goal is not to play for tips from passersby, but simply to "be cool," according to one member who preferred to remain unnamed. The Strangers were started in 1982 by Jess Yamada, but there were many other similar groups at the time who have since disbanded or don't meet regularly. The Strangers' longevity has paid off, however–the group has performed at a Paris fashion show and appeared in a commercial for Apple Beats.

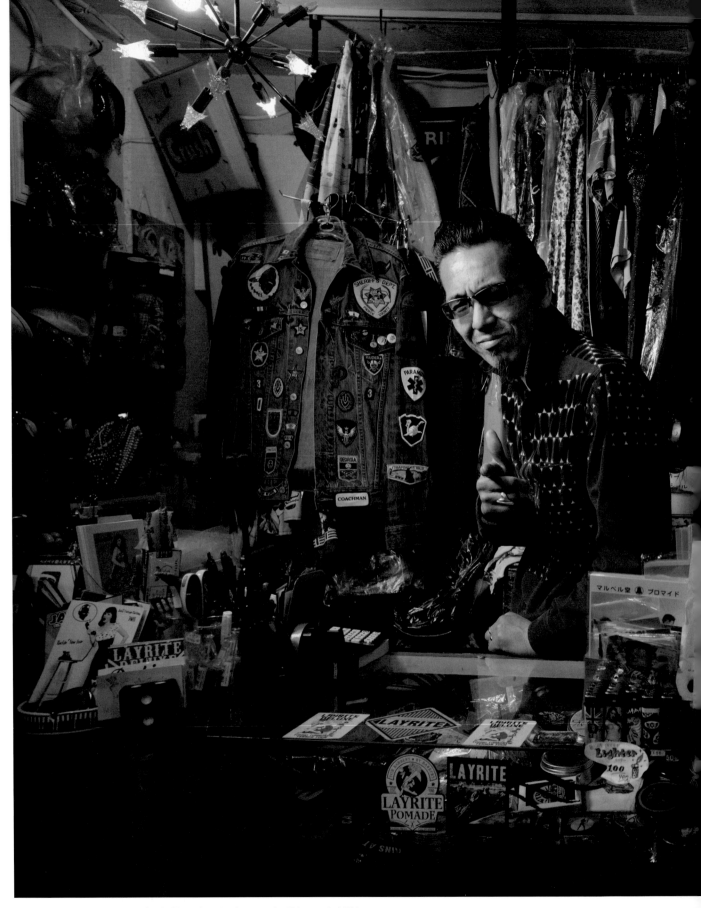

Elvis Sato in his store, Harajuku Jack's, a favorite hangout for Tokyo rockabillies.



岩室純子

## DJ SUMIROCK

The oldest DJ in the world.

In the college district of Takadanobaba, there is a hole-in-the-wall gyoza restaurant called Muro, which was founded in 1954. If you visit, you might see an elderly woman stir-frying vegetables behind the counter, a common sight in such family-owned businesses. What you might not expect, however, is that same old woman heading out to the clubs in the evening to spin tracks for partygoers until sunrise. This is DJ Sumirock, a Tokyo club icon and, as of 2021, the oldest DJ in the world at 86 years old. "It all started when a French lad stayed at my place about 10 years ago," she says. "He wanted to hold a dance party in my gyoza shop and I said, 'why not?'" She enrolled in DJ school soon after. "I must have been a weird sight," she laughs. DJ Sumirock, who originally liked chanson and jazz, now lists her inspirations as Deadmau5, David Guetta, and Kraftwerk. As her fame spreads, she has found herself playing gigs overseas: "My New Zealand show sold out in 14 minutes." Although she sometimes feels tired, Sumirock says she has many years left in her. "I was a child during the war," she says. "My goal is to spread love and peace whether it be through food or music."

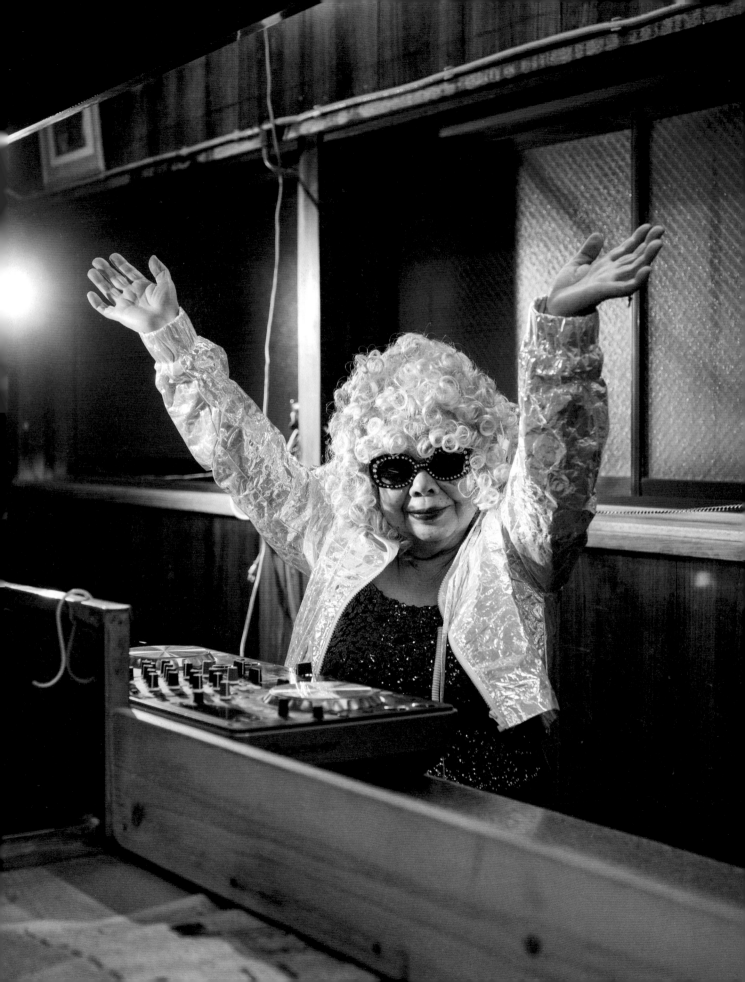

# GYARU FASHION

The rebellion of Japanese high school
girls changed fashion around the world.

A person familiar with *gyaru* fashion will
likely be picturing it with Shibuya as a
backdrop. Indeed, the history of gyaru cul-
ture has been entwined with Shibuya since
the 1980s and remains ingrained to this
day. The gyaru phenomenon grew so large
in the 1990s and 2000s that it permeated
every aspect of pop culture from language
to media and, of course, fashion. Since
then, however, gyaru culture has shrunk,
almost as though a bubble was popped,
and a once-colorful element of Shibuya's
fashion scene is becoming an increasingly
rare sight these days.

On the stormy north coast of Japan, in
an isolated city called Fukui, one woman
is doing her bit to make sure gyaru culture
remains alive and well. "I'd never been to
Shibuya until last year," says Konasuke,
who was born in 1994. "By the time I was a
teenager, there were fewer and fewer people
wearing gyaru fashion." Nevertheless,
the flamboyant, flashy subculture had
resonated with her since she was a child,
and she found herself unconsciously
imitating the fashion stylings of gyaru
that were predominant in the Heisei era.
The office of her custom-car workshop is
also decorated in the style of late-90s
to 00s Japanese pop culture. "I like stuff
from that era; it was always flashier and
more colorful. Nowadays things are too
plain," she says.

Gyaru fashion began in the 1990s, when
rebellious schoolgirls began hiking up
their skirts, wearing loose socks and car-
digans, and dyeing their hair. They would
also tan their skin to step away from the
traditional Japanese perception of pale
skin equating to beauty. This trend set

off a fashion subculture that could loosely
fit under the umbrella term "gyaru," but
in reality, it has been evolving constantly
since its inception and birthed many
splinter styles.

"There are no rules to gyaru fashion,"
says Eri Moccori. "You just wear what
gives you confidence." Eri was once a
member of Black Diamond, a group of gyaru
fashionistas who until recently operated
a gyaru cafe in Shibuya. Her fashion can
be broadly described as *ganguro*, a style
known for its excessively dark tanning,
bright makeup, and hair dye. Eri's three-
inch, jewel-studded acrylic nails and
peacock-like fake eyelashes add to this
head-turning ensemble, which is extreme
even for Shibuya standards. The style
emerged in the late 90s as a counter to
the typical cute fashion that appealed
to men's tastes.

"Japanese people are brought up to be
very aware of how they are seen in society,"
says Konasuke. "Everyone's always looking
at each other and putting on pressure
to conform and be normal." The ganguro
movement rejected the demands of society
to be prim and pretty girls. "We didn't
like being told what to do. If someone
told you it was attractive to wear less
makeup, we'd put on more makeup. If someone
said that dyed hair is ugly, we'd dye our
hair in even louder colors. We weren't
dressing up for men anymore. We were dress-
ing for ourselves."

This trend to put one's own fashion
identity ahead of what was deemed
attractive and cute by society was in-
deed hugely empowering for many teenage
girls who had suffered abuse or felt lost

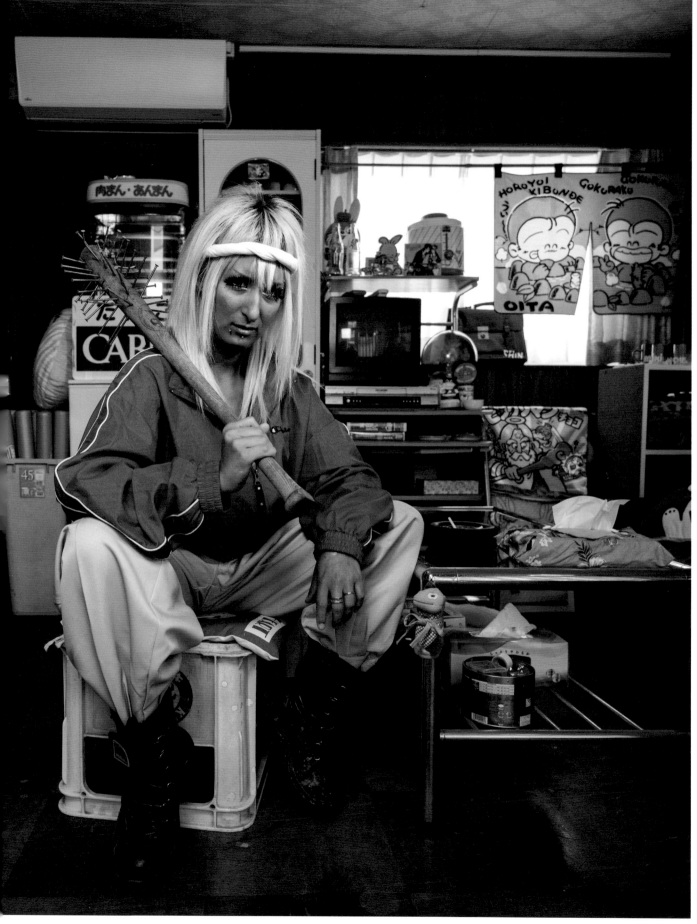

Konasuke's welding shop office is also a shrine to Showa-era Japanese cute.

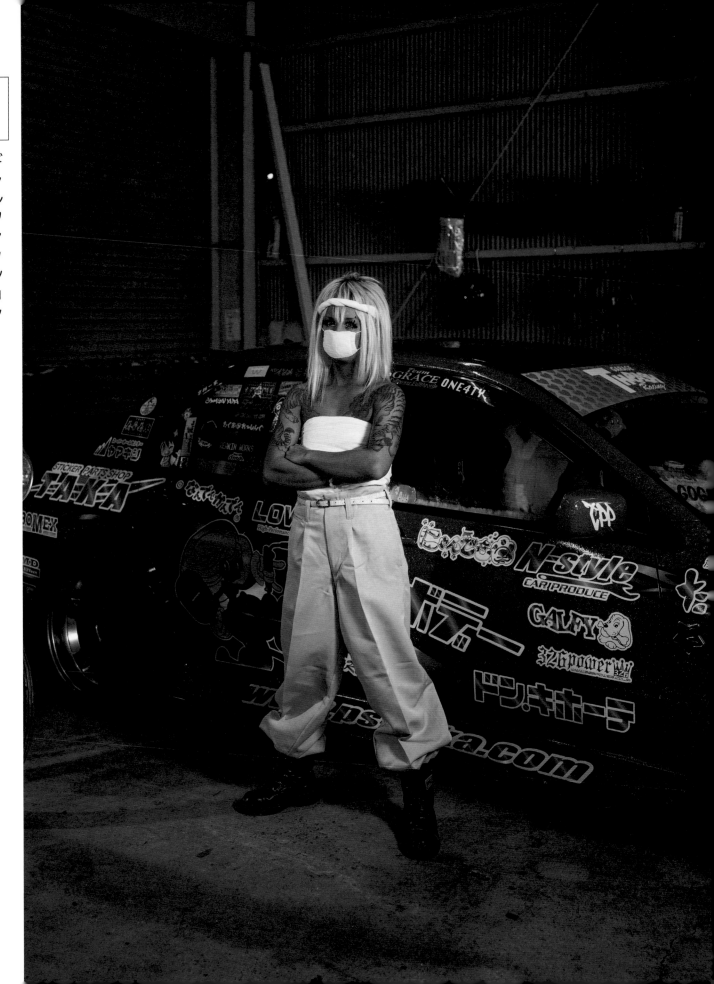

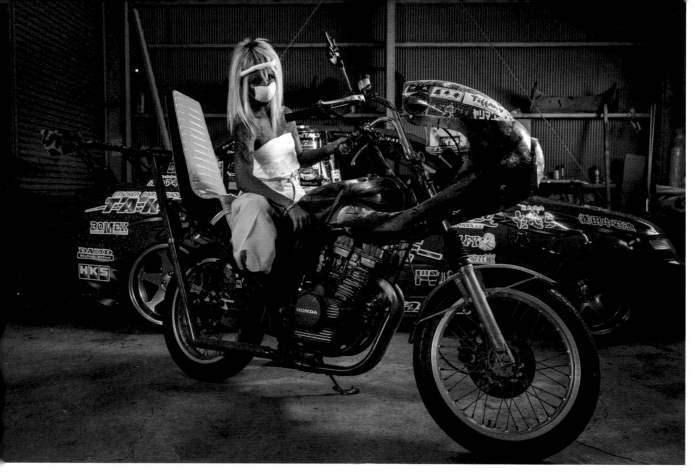

Top and opposite page: Gyaru fashion is only part of Konasuke's identity; she is also a skilled mechanic and auto enthusiast. Bottom: The pink-heavy interior of her Mitsubishi Lancer Evo.

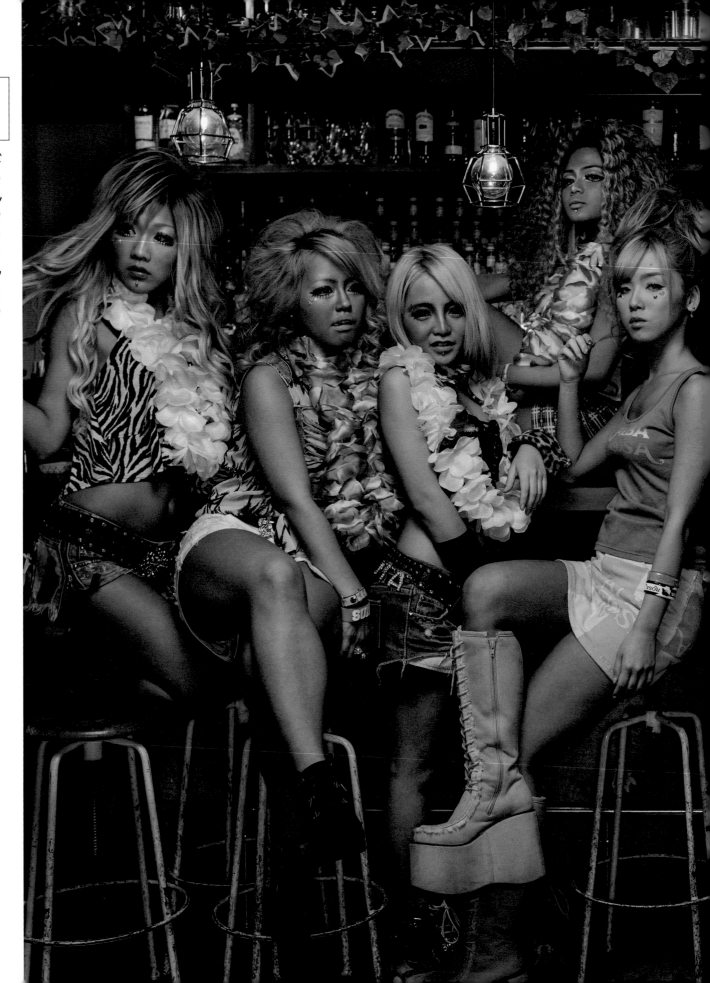

ギャルファッション

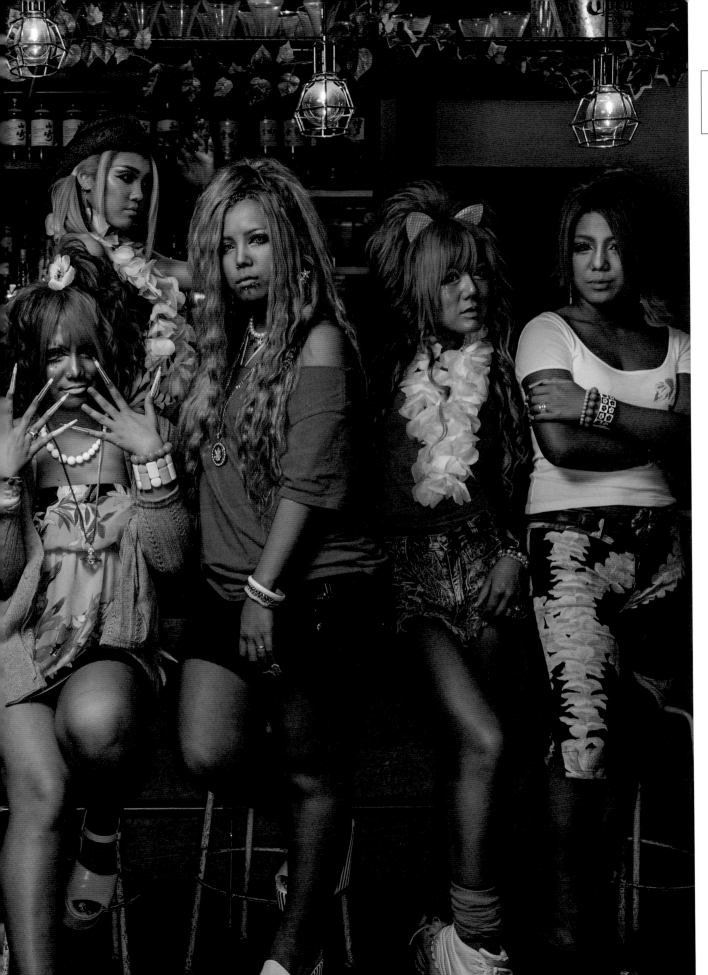

and without a voice. "I have always been mentally fragile," says Konasuke. "But when I wear bright colors and makeup it helps me feel strong and confident." According to Konasuke, the wild fashion choices and makeup served a dual purpose: The crazier each girl dressed, the more respect they had for each other within respective gyaru circles. At the same time, the ganguro style, which expressly subverted the male gaze, was effective at creating a safe space for these women to be without fear of being pestered by men looking to hook up. "In the end, men started copying gyaru style to be accepted by us," Konasuke laughs. These men who adopted the scorched tanned look, neon eyeliner, and streaked, dyed hairstyles of their female friends were called *gyaru-o*, or "girl man."

Ganguro might be the most recognizable form of gyaru fashion in Japan, but it is, in fact, one of the later stages in the evolution of this fashion movement. The precursor to ganguro was called *kogyaru*, which translates roughly to "little girl." This style was generally much more centered around dressing attractively to please the opposite sex, often with a school uniform as the central motif. In the 90s, the uniforms of upscale schools underwent something of a fashion facelift in order to attract more prospective students. Wearing uniforms outside of school hours surged in popularity and Shibuya, which was already known as a fashion and clubbing center for youths, became a de-facto gathering point for these fashion-conscious and slightly rebellious teen girls. Modifications to uniforms became the norm, most commonly loose knee-high socks and an extremely short skirt.

Retail shops in Shibuya were quick to realize that these delinquent yet relatively well-off teens were a huge potential market, and adapted their products to cater to them. The department store Shibuya 109 became home to some of the most popular kogyaru fashion outlets, including Me Jane and Alba Rosa, making 109 (known in the parlance as *marukyu*) the default place for trendy young girls to shop. The style evolved beyond schoolgirl uniforms and started incorporating American beach culture, starting with leis, midriff tops, and cut-off denim shorts. Eventually, more extreme fashion choices emerged such as large platform shoes, a phenomenon helped along by iconic gyaru popstar Amuro Namie.

Gyaru fashion had undergone incredible changes from its roots as kogyaru in the mid-90s to the rapidly escalating individualism of ganguro in the 2000s. "Kogyaru wore clothes and makeup to be admired by the opposite sex. Ganguro were different," Konasuke explains. "There were no fashion icons for them to copy so they were dressing to impress each other." Eventually, the style choices of these girls became so shocking that a new moniker emerged to describe their appearance: *yamanba*, which means "mountain witch." These girls were typically heavily tanned to the point of almost being black, with bright neon makeup to contrast starkly with the skin. "Yamanba was the peak of that style," says Konasuke. "There wasn't a way to dress crazier than that." Soon after, trends reversed, leading to the emergence of *shiro* (white) gyaru and *hime* (princess) gyaru, a strikingly more feminine approach than ganguro and yamanba.

"It's still evolving," says Konasuke. "There isn't any one way to be a gyaru. It's more about being able to dress how you like." Indeed, Konasuke's path to becoming a gyaru has been one of evolution as well, having dabbled in almost every fashion and subculture before settling on gyaru as the most comfortable. "I've tried Lolita fashion, cosplay, owned an itasha, been a Love Live fan, been a yankii, everything!" she laughs. "Being a gyaru fits my personality best for now, but who knows, I might change my mind in the future!"

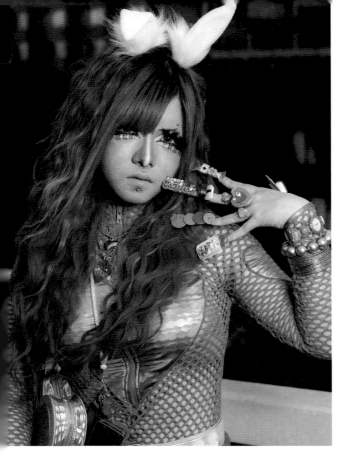

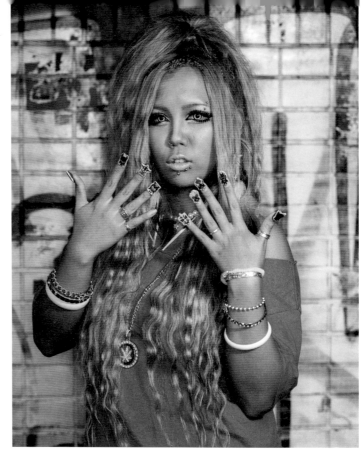

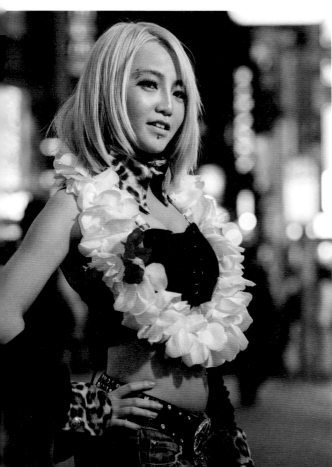

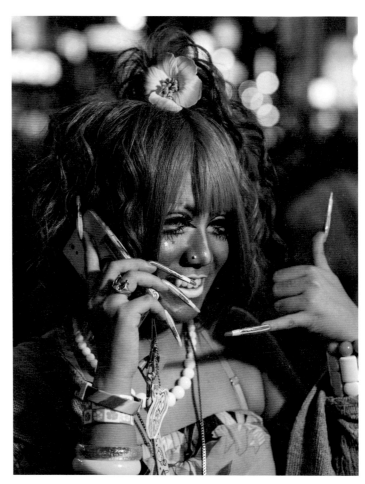

Gyaru come in all varieties, from cyber-gyaru to ganguro to the most extreme: yamanba.

# BOSOZOKU

A scourge of the roads in the 1980s and 90s,
the biker gangs of Japan have grown up.

Seuchi Tetsuhiko's construction company
occupies a lot of space in the rural town
of Oyama in Tochigi prefecture. The middle-
aged man is stocky and solid looking,
with a nasty jagged scar that runs down
the middle of his forehead between his
eyes, perhaps indicative of a youth spent
getting into fights. A photo of him in his
teens shows him clad in a red jumpsuit
and straddling a modified bike with an
extremely tall fairing. Even in the grainy
photo, he has an intimidating presence
most 17-year-olds would struggle to
muster. That's because Seuchi was once the
sub-leader of a *bosozoku*—a Japanese biker
gang made up of delinquent teenagers
who found their place with each other.

   Bosozoku translates roughly as
"berserk tribe," and was a term that
emerged in the media to describe the
roving bands of teenagers who rode

customized bikes in large numbers, blocking
traffic on roads and getting into fights.
"We fought a lot," says Seuchi. "Sometimes
you had to fight even though you didn't
want to. We didn't want our gang to be
looked down on." At its peak, Seuchi's native
Tochigi prefecture had nine bosozoku
teams, with Seuchi's own gang membership
numbering in the 60s. "Local teams who
hadn't met each other before often got
into fights," says Seuchi. "But as long as
we didn't back down and let them know we
weren't screwing around, we would gain
respect for each other." Indeed, Seuchi
describes times when multiple gangs would
gather for a joyride, in which more than
200 bikes would ride slowly down the roads,
swerving into both lanes, revving their
engines, and blocking traffic. "The sound
when we all gathered was out of this world.
Everyone was trying to outdo each other

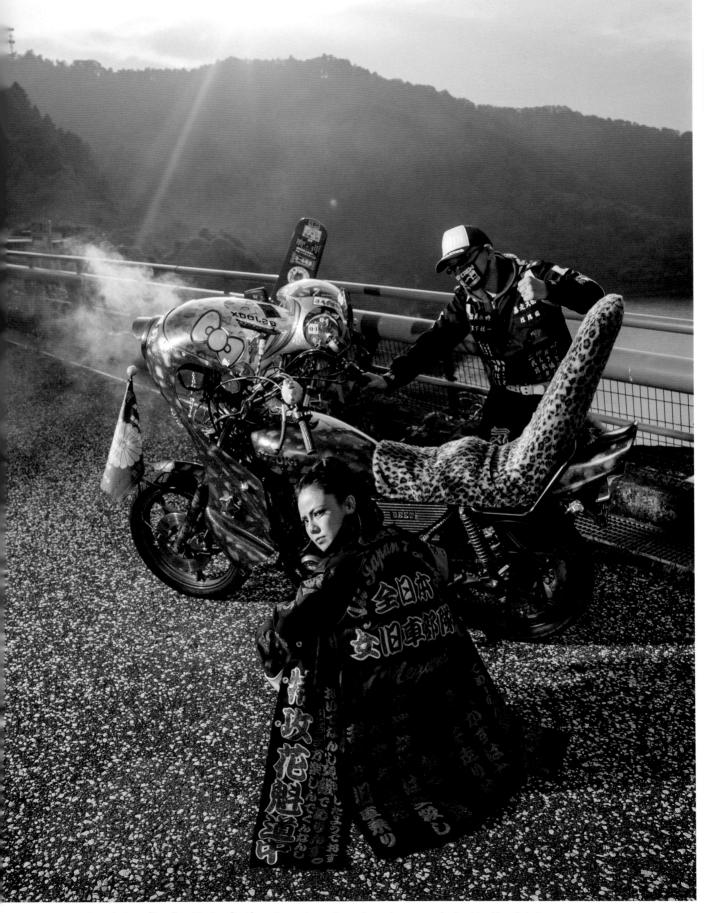

Married couple Megu (front) and Yuuken (back) are former bosozoku members who now regularly attend kyushakai.

by being the loudest. Everyone wanted to stand out."

The bikes characteristic of bosozoku, colloquially known as *tansha*, are modified to be extremely loud. When groups took to the tarmac, they would not necessarily

**"We fought a lot. Sometimes you had to fight even though you didn't want to. We didn't want our gang to be looked down on."**

drive extremely fast but cruise down the road revving their engines in order to make as much noise as possible. This cacophony could be heard from blocks away and announced a group was in the area–which was just how they wanted it. "We were *furyou*," says Seuchi. "This was a way to remind society that we exist, that we weren't going away." Furyou translates as "not good," and is a catchall term for the delinquents who joined bosozoku. The term, which is also used to describe defective or inferior products, served to further alienate troubled kids who failed at school and struggled to integrate socially. Pushed to the fringes and made to feel invisible, these teens made their furyou status a point of pride, using the loud engines of their bikes to reaffirm their identity with each other and society. The distinctive revving sound of bosozoku machines is known as the "call," and has now become something of an art form amongst former gang members at bike meetups. "If you want to win in a 'call' competition, you have to rev the bike consistently and with good tempo. And, of course, it has to be loud," says Seuchi.

Another defining characteristic of bosozoku bikes are their eye-catching modifications and paint jobs. There are

no rules for how to modify one's bike, but the general consensus is the flashier the better, each rider customizing their vehicle according to their own tastes. Impractically oversized fairings, multicolored lights, trumpet horns, and ostentatious paint schemes are some of the hallmarks of tansha. The most common modification, however, is the addition of an oversized rear seat called a *sandan* seat. "The sandan seat isn't just for show– it has many functions as well," explains Seuchi. "The seat is tall so that when you crash, the bike doesn't roll over and crush you. It also supports a second rider who would often be flying a team flag." In Seuchi's bosozoku days, a tertiary function of the sandan seat was to make it difficult for police to see who was driving and, of course, it provided more surface area for decoration. Another common modification, *shiborihan*, is to squeeze the handlebars inwards. "We made the width of the handlebars narrower so we could get away from police cars down narrow alleyways," explains Seuchi. The result of these modifications made tansha into a colorful subculture often romanticized in manga and film.

**"The sound when we all gathered was out of this world. Everyone was trying to outdo each other by being the loudest. Everyone wanted to stand out."**

The reality, however, was somewhat grimmer. Seuchi's path to becoming an outlaw biker was more or less decided in his elementary school days. "My older brother was six years ahead of me and had already joined a team," he recalls. "I always looked up to him and wanted to be just like him."

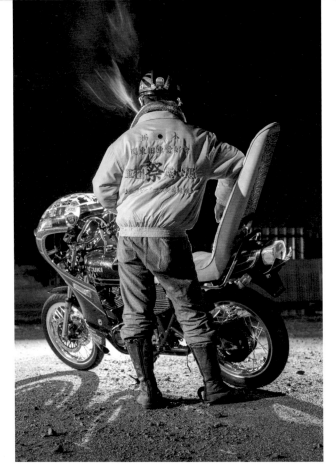
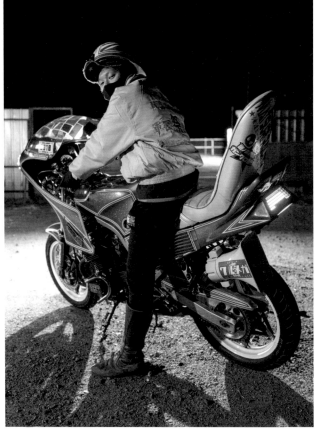

Top: Although bosozoku typically scoffed at helmets, modern tansha riders are more likely to try to avoid confrontation with police. Bottom: Megu's ride is a blend of kawaii and biker cool, and she is a popular personality at many kyushakai.

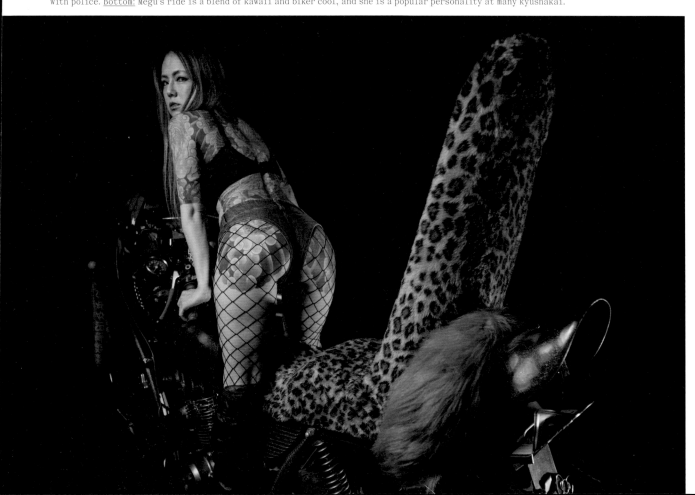

Seuchi (middle left) is on the straight and narrow now but still enjoys the automotive aspect of his wilder days.

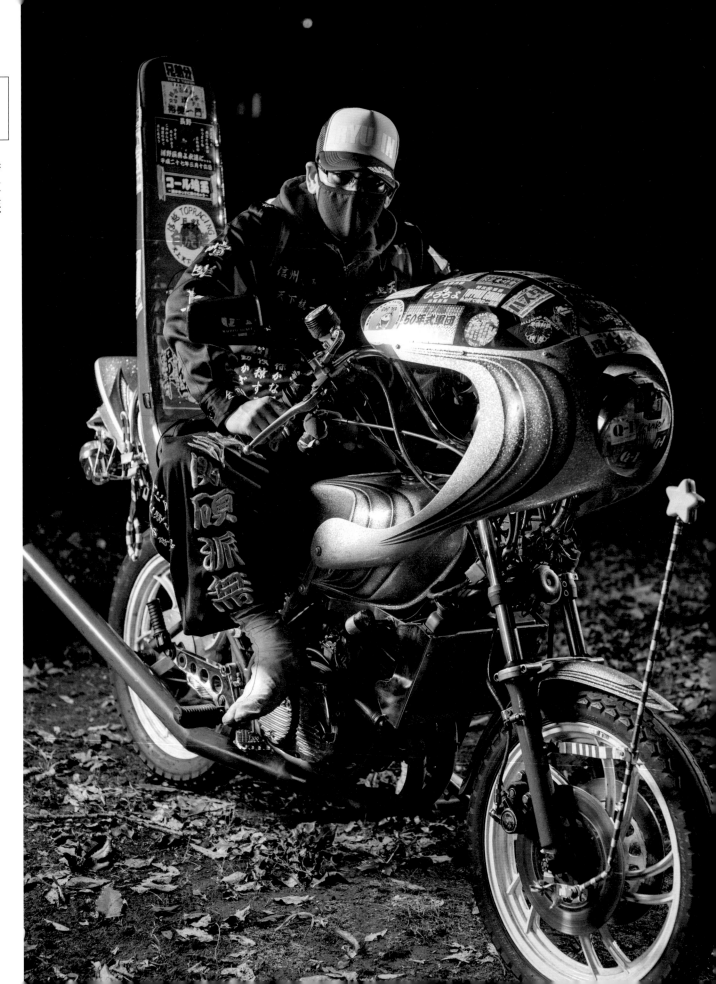

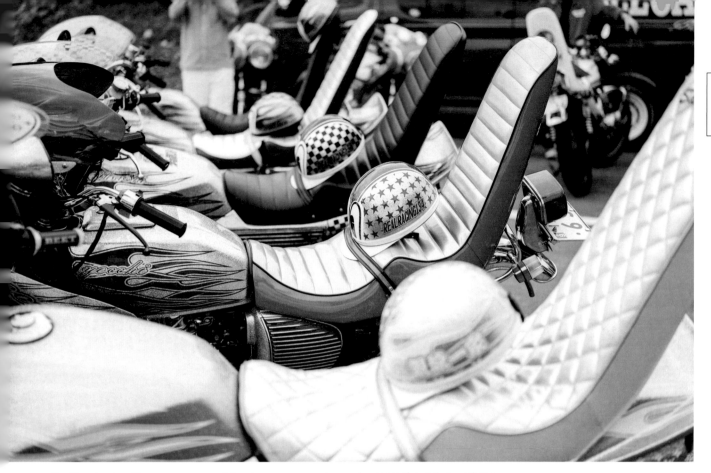

Top: When tansha riders grow up, many of them have more money to spend on beautifying their machines.
Bottom: Kyushakai attendees rev their engines before a turn on the track. Opposite page: Yuuken sits astride his bike adorned with stickers from other tansha groups.

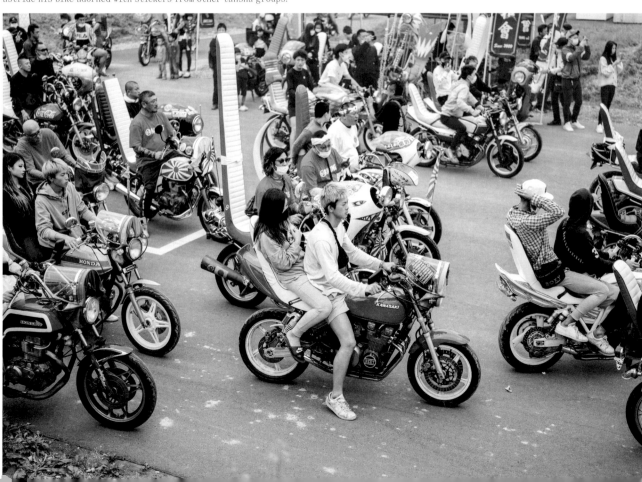

暴走族

He often got into fights in middle school, which led to an incident in which he had lit cigarettes put out on his skin–a hazing ritual called *konjyouyaki* which

"People might have been looking at me wondering what I was doing with my life, but it taught me a lot of things, and I made some lifelong friends. I have no regrets."

was supposed to toughen up the victims. "It hurt like hell, but I knew that if I suffered through it, they would accept me," he says. From there, he joined his brother's bosozoku group before breaking off with several friends to form his own tribe called *Bakushin*. Seuchi remembers the time with mixed emotions. "You had to have absolute respect for your *senpai*," he says. "Whatever they said was law, even if you didn't agree with it." A common part of bosozoku life was *shimekai*, punishing other members of the group for not following instructions or failing to show up for the weekly cruises around town. "We'd beat them up because that was our way of teaching respect to each other." To this day, the strictly instilled respect for bosozoku authority exists in former members, partly due to the memories of such shimekai.

Respect for police, however, was a different matter entirely. "It was a different world in the 80s," recalls Seuchi. "The police couldn't stop us. We did pretty much as we pleased." This included smearing mayonnaise on the windshields of patrol cars and in extreme cases smashing in the windows. "We were still teens so we were treated as kids," Seuchi says. Nowadays, the crackdowns are so severe that police have the authority to arrest whole groups of joyriders and confiscate their bikes.

"I was sent to juvenile detention twice in my life," says Seuchi, "but that was only after being arrested dozens of times. Now, it's one strike and you're out." Bosozoku rider numbers plummeted after these changes took place, but the tansha culture lives on in the *kyushakai*, or "old bike gatherings" held at various places throughout the year.

Seuchi started organizing kyushakai 20 years ago. His event, Kyutochi, attracts on average 500 bikes every year. These events are held in rented rural racetracks and have a set of stringent rules to avoid unwanted attention from the police. Attendees truck their bikes into the racetrack and engines are not allowed to be started before a certain time. Fights are dealt with by immediate expulsion. The former rebels follow the restrictions to the letter, perhaps because of the discipline beaten into them in their bosozoku days. Once the event starts, the bikers take to the racetrack to make as much noise as they can, or swap old battle tales and check out each other's bikes. This maturing of the bosozoku culture is a testament to the love they have for their bikes and to the nostalgia they harbor for the old days, however fraught they might have been. Although the nights of fighting

"It was a different world in the 80s. The police couldn't stop us. We did pretty much as we pleased. We were still teens so we were treated as kids."

and being a menace on the streets are over, Seuchi looks back with fondness. "People might have been looking at me wondering what I was doing with my life, but it taught me a lot of things, and I made some lifelong friends. I have no regrets."

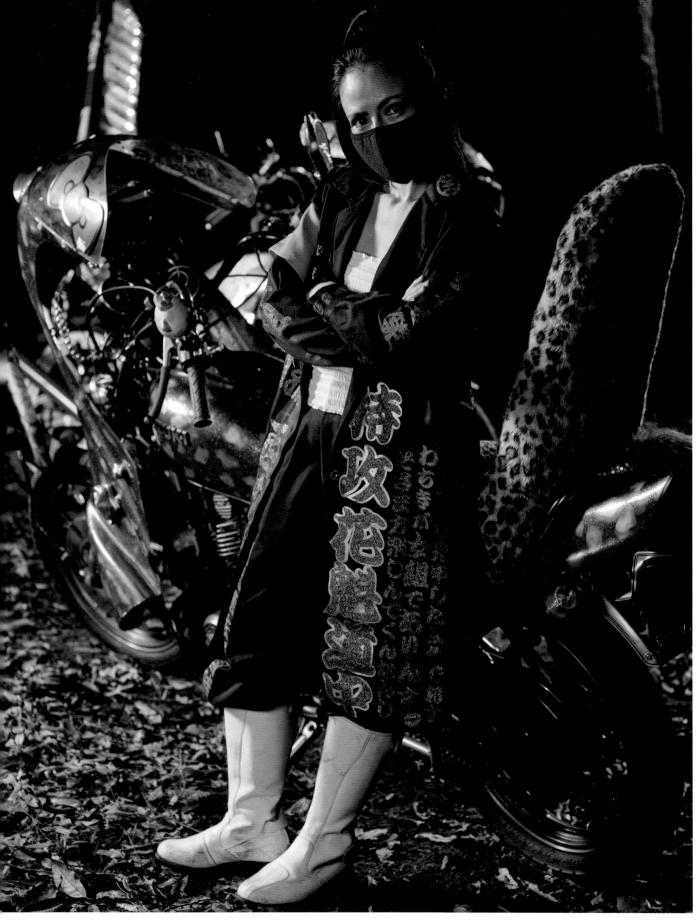

Megu is technically a "lady," a term for female bosozoku riders.

彫
連

# HORIREN

The story of a fearless wabori artist
who became a Buddhist monk.

Getting inked may seem like an innocuous pastime for many who have grown up in the Western world, but in Japan it is still a culture burdened with hundreds of years of stigma. Even today, a large proportion of bathhouses and hot springs explicitly deny entrance to anyone with a tattoo. "The overwhelming majority of my customers are people on the fringes of society," says Horiren. "Prostitutes, runaways, people with ties to organized crime, and so on. For these people, getting *irezumi* is an indelible statement that says 'I am setting myself apart from society.' The tattoo is itself the mark of the outcast. Making the decision to get a tattoo in Japan takes guts."

Horiren herself is tattooed from head to toe. Her distinctive bald pate, freshly shaven since her induction as a Buddhist monk, is strikingly adorned with beautifully graded black ink in the shape of roiling clouds and lightning. Horiren too has made her decision to live outside the norms of conventional Japanese society.

The history of tattooing in Japan stretches back as far as 10,000 BCE in the Jomon period, but its links to criminality may have begun in the eighth century CE, when it is said that criminals convicted of the most serious crimes were branded on their foreheads with the kanji for the crime they committed. Fast-forward to the Edo period and views toward tattoos softened a little, especially upon the release of the wildly popular novel from China, the *Suikoden*, which introduced woodblock prints of heroic figures covered with full-body tattoos of dragons, phoenixes, and blossoms. Youths wanting to emulate the stories would ask to be tattooed in the same manner, and the motifs of these designs are still popular today. During this time, irezumi flourished, influenced by other emerging arts such as *ukiyo-e* (woodblock printing).

During the early days of the Meiji period, which coincided with the opening of Japan's borders, the government issued an ordinance outlawing tattooing. Instead of stamping it out, however, the practice moved underground, and around this time the term irezumi started to become inextricably linked with yakuza. Although irezumi was legalized postwar by the occupying forces in 1948, its image never rebounded, and a spate of movies in the 1960s that romanticized the life of the yakuza only cemented the links between tattoos and criminality.

Horiren herself was a runaway, fleeing an ultraserious family who had her life mapped out for her. "They wanted me to become a kimono dresser, which I had no interest in," she says with a laugh.

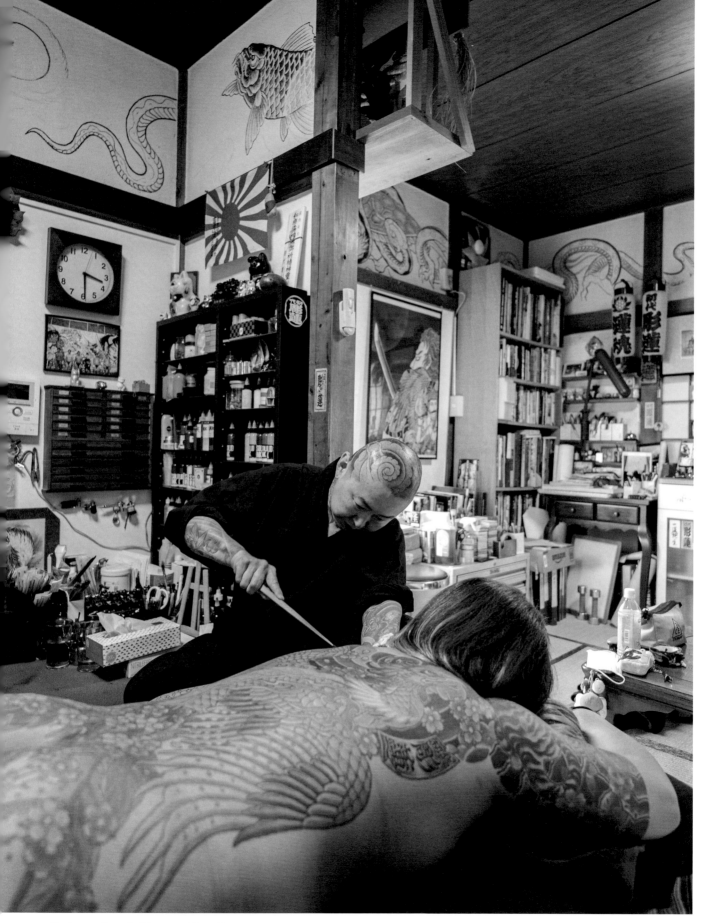

Horiren works on Yoshino, one of her clients.

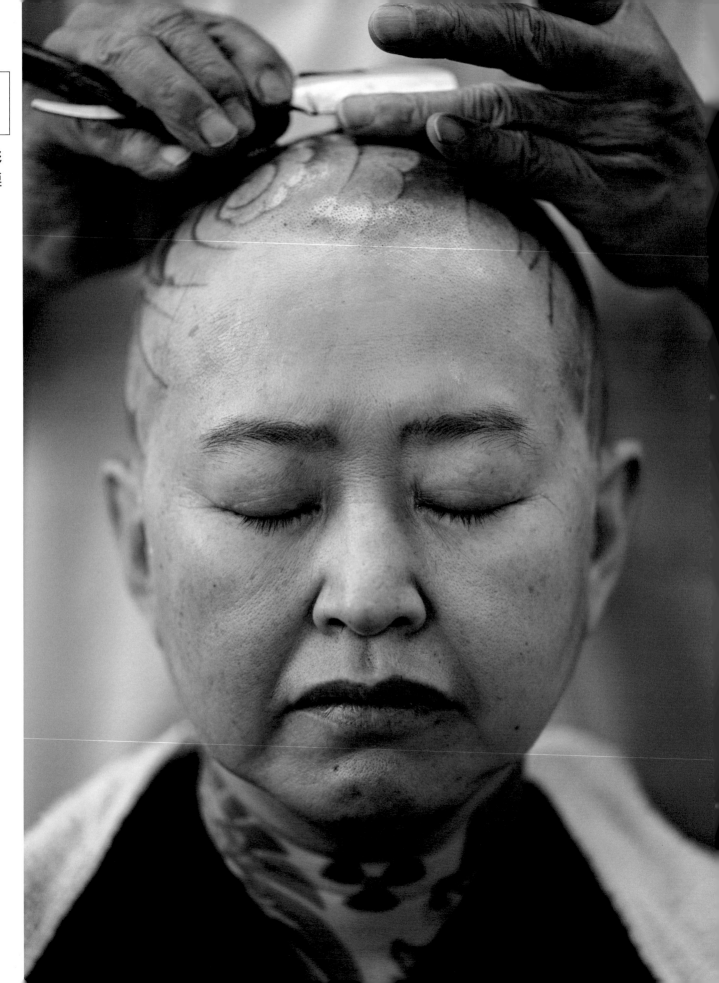

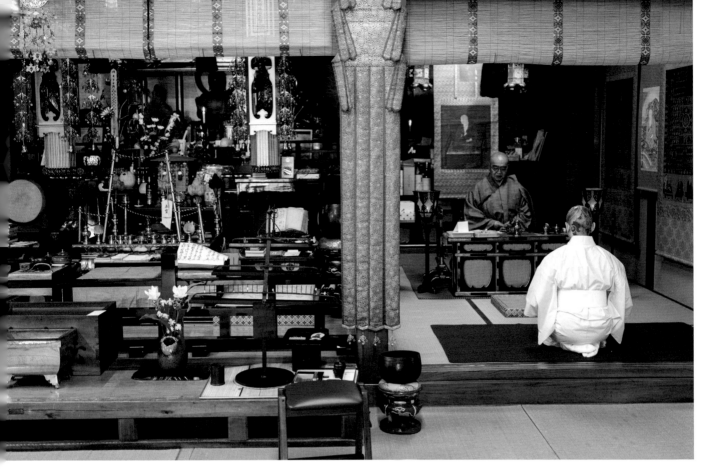

Top and bottom: After affirming her desire to do good for her community, Horiren is anointed as a monk.
Opposite page: Prior to her induction as a Buddhist monk, Horiren has her head shaved.

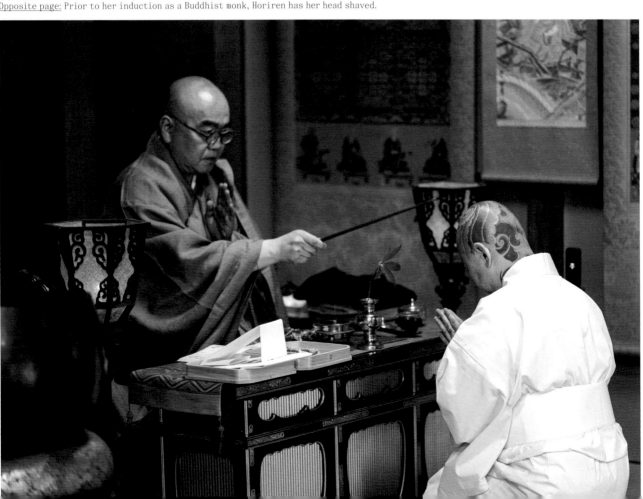

"So when I was 18, I left without a word."
Gifted with a talent for drawing, she ended
up at a design school in Shibuya but was
kicked out of her dorm almost immediately
for breaking curfew. "I had to work nights
to support myself," she explains. "It turns
out art supplies are extremely expensive!"
With no home and no contact with her family,
Horiren ended up sleeping on the streets
while she bartended at night and attended
school during the day. She eventually
found herself a bed at the bar she worked
at, although this didn't mark the end of
her troubles. "The entire place got raided
by cops because it was a hotspot for
marijuana dealing," she says. "Everyone
there got arrested except me because
I was still underage. It was a crazy time."

Somehow, through all of this, Horiren
graduated from her school and got a
job making pixel art in a video-game
company called D&D. "I got the job from
a customer at the bar I worked at," she
says. "He challenged me to draw something
on a napkin and apparently that was
good enough." This stint didn't last long,
however, and she was soon back bartending
when another one of her customers scouted
her into the world of mural painting.
"I just kind of fell into these jobs," she
explains. "To be honest, I was perfectly
happy bartending."

Horiren's love for tattoos did not
begin in Japan but on a trip to Australia.
"I went to visit my friend there, but
she immediately ditched me for a guy," she
laughs. "Horrible, right?" Left to her own
devices, she found herself in King's Cross
in Sydney and on a whim decided to get
a tattoo. After becoming good friends
with the tattoo-shop owner, she stayed
there while helping him with odds and
ends. "At that time, a lot of people wanted
kanji characters as tattoos, so I helped
make sure they weren't getting anything
weird tattooed on their body." After that,

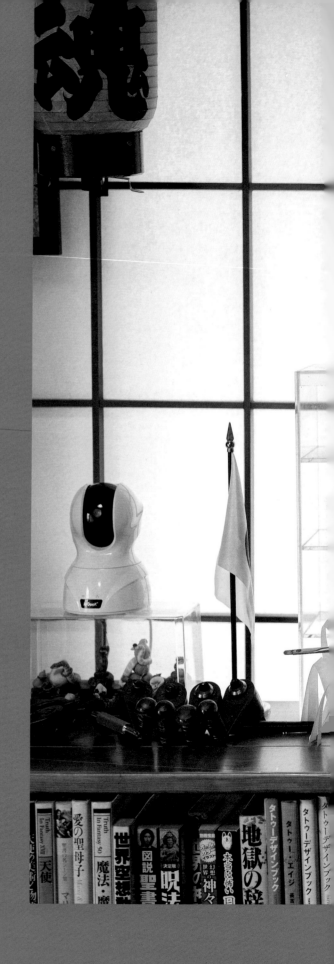

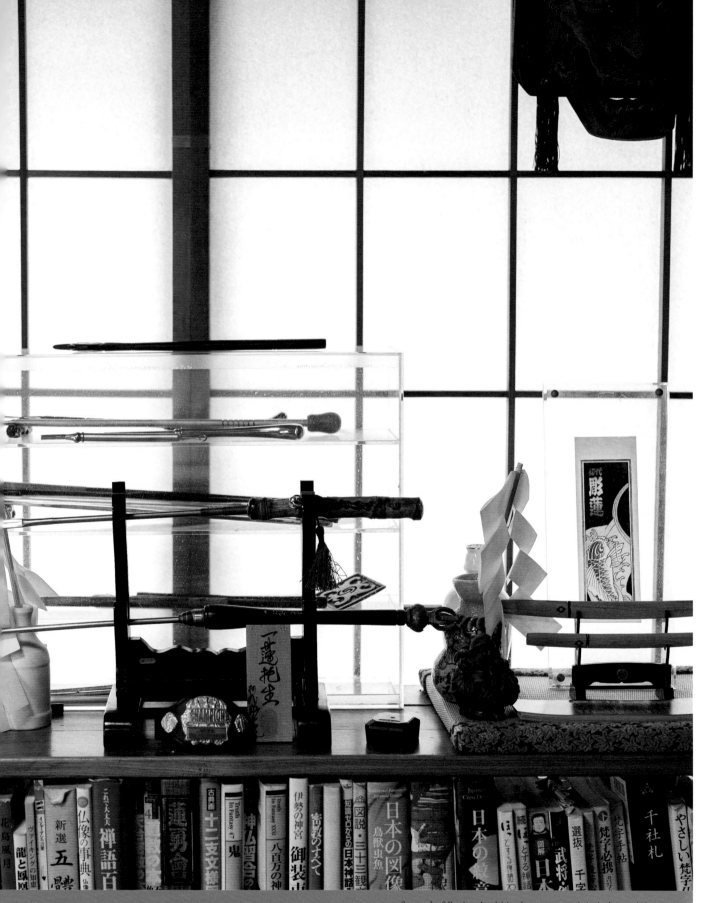

Several of Horiren's old implements on a dais in her waiting room.

彫
連

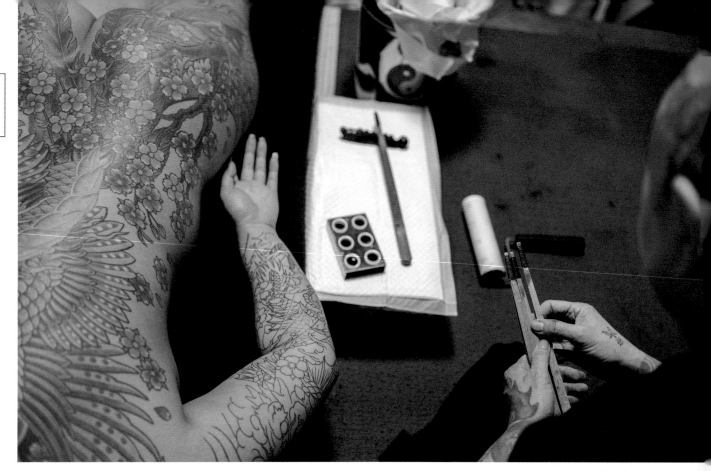

<u>Top:</u> There are 36 needles on each of Horiren's tattooing implements–nine is the standard for machines. <u>Bottom:</u> The tebori technique is used to fill in the outlines. <u>Opposite page:</u> Horiren tattooing a bokashi into her client's back.

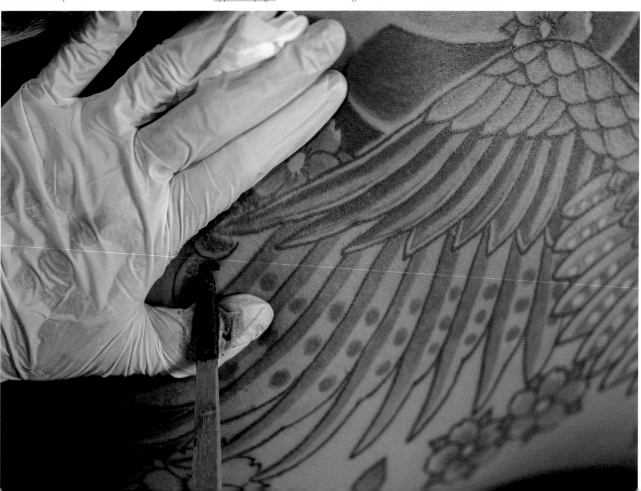

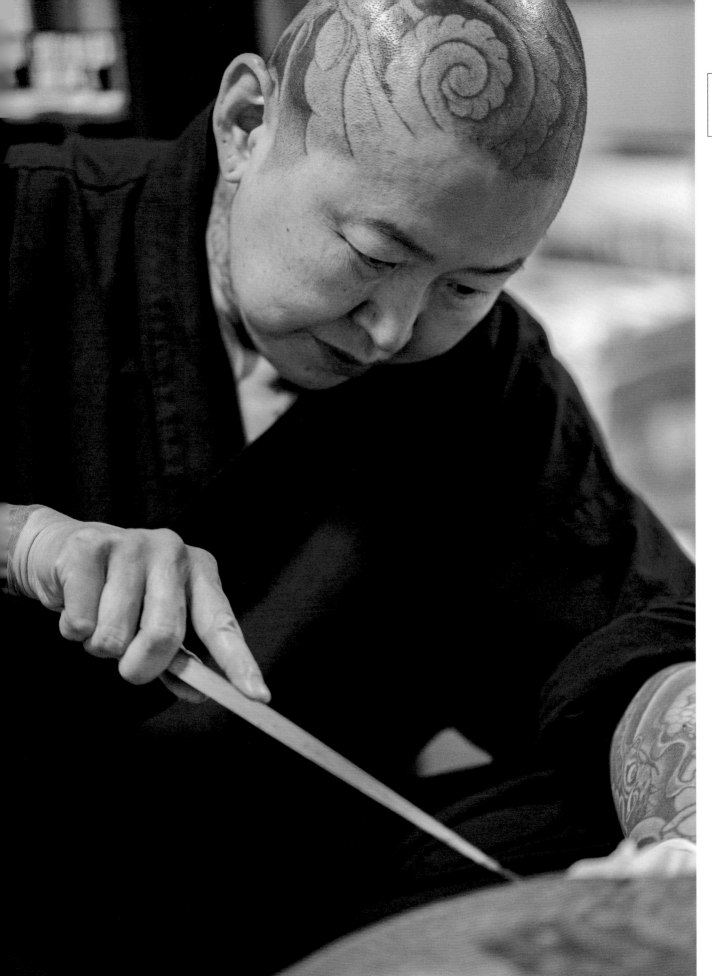

The studio is located in a quiet suburb in northwestern Tokyo.

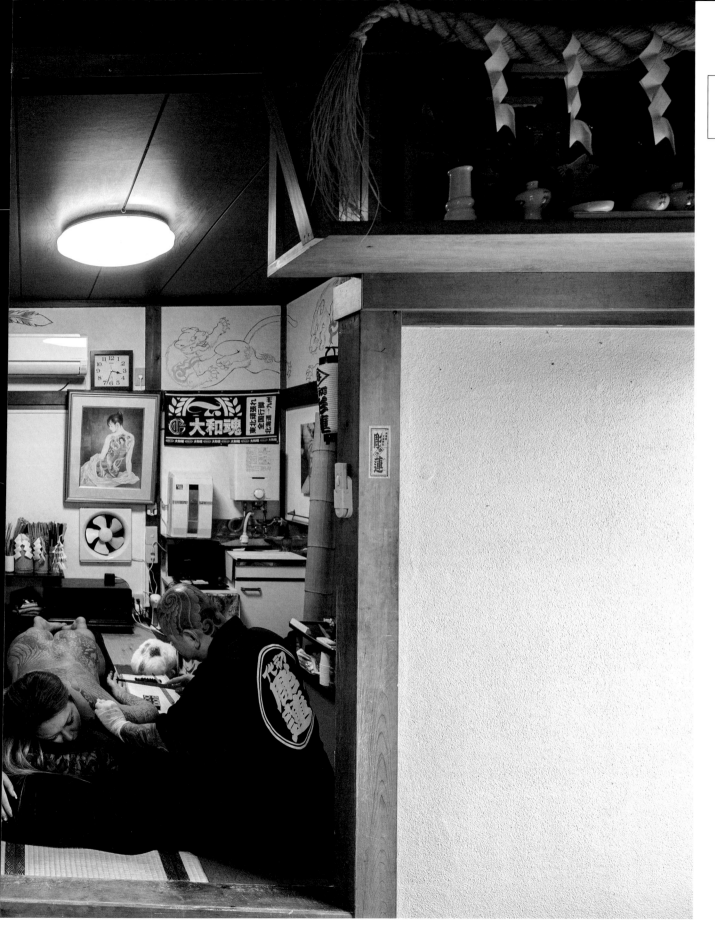

彫
連

she backpacked and hitchhiked around Australia, getting a new tattoo at every town she visited. "Looking back, they were pretty hodgepodge things," she says. "But I was caught up in the moment, it was all just a bit of fun." Her epiphany came at the point when she was out of money and ready to fly back to Japan. "I was drinking at a pub and a guy came up to me. He said, 'Hey mate, looks like we have the same tattoo!'

**"They wanted me to become a kimono dresser, which I had no interest in. So when I was 18, I left without a word."**

And he was right." She spent the flight back to Japan thinking she should have drawn her own unique designs for the tattoo artists she visited, and the idea of becoming a *horishi* took shape. "I was obsessed from that moment. I knew what I wanted to do for the first time."

That career change took a back seat when her mother was diagnosed with brain cancer. "In those days, brain cancer was pretty much a death sentence. Our only hope was a new acute radiation therapy that wasn't covered by insurance." The price for the treatment: 10,000,000 yen. Determined to pay for the therapy, Horiren threw herself into her mural-painting job. "I worked like a demon. Took any job. Even painted some murals in the newly opened Tokyo Disneyland." Against all odds, the therapy worked, and finally, Horiren was free to quit her mural job and pursue her dream. She is in the minority as a horishi who never formally learned the art under the instruction of a master. Instead, Horiren went to get tattooed by prominent horishi and absorbed as much as possible by watching them work on her. "Even so, I needed the practice," she says. "So I'd go up to shady-looking gangs hanging outside convenience stores and say, 'Hey would any of you like a free tattoo?' A surprising

amount took me up on the offer." After a while, word began to spread, and finally, at the age of 30, irezumi artist Horiren was born.

Today, 53 years old and diagnosed with advanced stomach cancer, she reflects upon her time as a tattoo artist wistfully. "It's a lot like bartending, in that you're a sponge for your customers' problems," she says. "And unlike bartending, there's a lot of physical contact. It's very intimate, for hours at a time. I have to be a bulwark for whatever is troubling my customer at the time." Her role as a tattoo artist serves as a kind of therapy for the dispossessed and lost clientele who find their way to her. It is difficult work and sometimes heartbreaking. "A lot of my clients have problems with society of some kind or another. And that leads them to have bad or lonely deaths." She recalls a client whom she became close to–the wife of a yakuza member–who was lost to alcoholism. "I did my best to check in with her, but she didn't make it. She died alone. Her body had decomposed by the time anyone found her. I still can't get over the fact that I

**"There's a lot of physical contact. It's very intimate, for hours at a time. I have to be a bulwark for whatever is troubling my customer at the time."**

couldn't save her. What good does a tattoo do when you're dead? It just turns to ash with the rest of you." Feeling an overwhelming need to do something for all the lonely souls with no one to mourn them, Horiren decided she could at least help their spirits reach the afterlife. In 2021, she had her *tokudoshiki*, or advancement into the Buddhist priesthood. Reborn as the priest Rensho, she now guides the departed souls of the strayed, lonely, and dispossessed, just as she has done for the living as a tattoo artist.

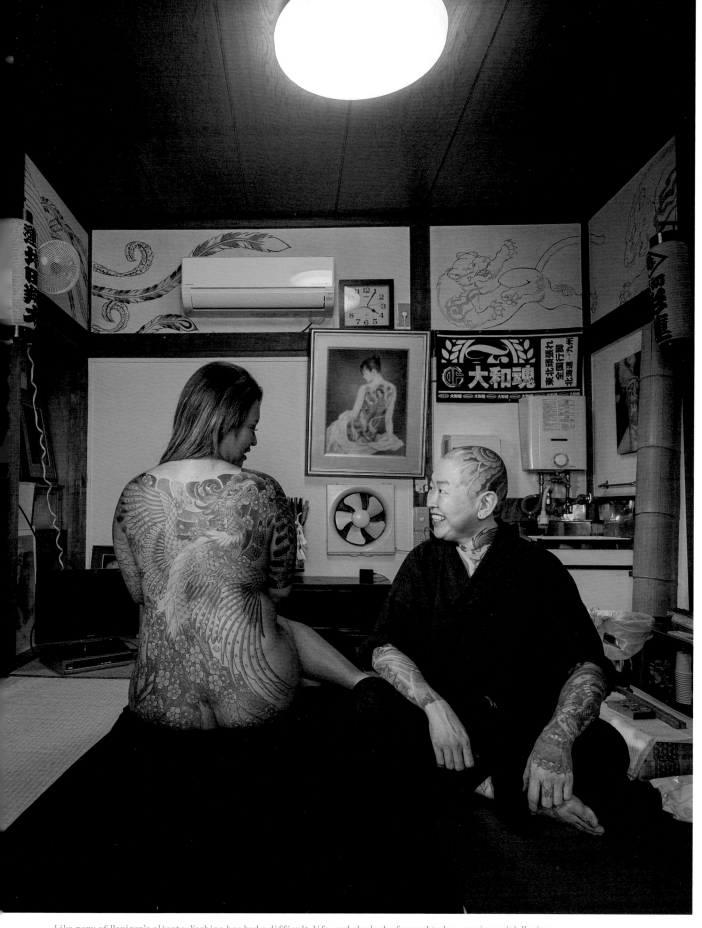

Like many of Horiren's clients, Yoshino has had a difficult life, and she looks forward to her sessions with Horiren.

# JAPAN'S OBSESSION WITH CARS

Car culture in Japan is a vehicle for experimentation and flamboyant self-expression.

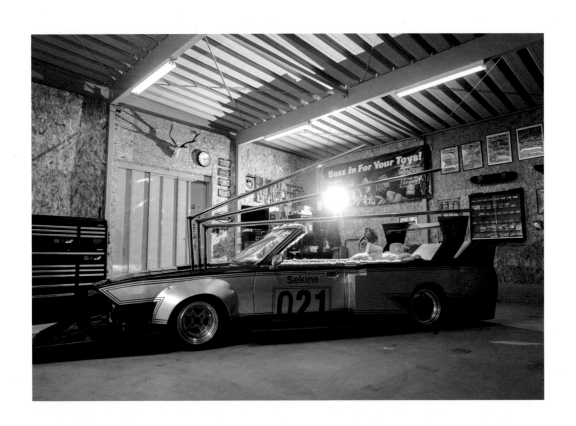

<u>Above:</u> Dekotora on display at a charity event in Gifu.
<u>Opposite page:</u> A classic zokusha.

In Japan, technology grows and is adapted into people's lives at a blistering pace, yet at the same time, the country remains one of the most conservative societies in the world. It may be at the forefront of telecommunications, for example, but using a fax in the workplace continues to be a must. Traditions are revered and dictate the way people should behave, whether socially or in the workplace. As the Japanese saying goes, "The nail that sticks out gets hammered down." From the earliest school days and throughout professional life, the idea of standing out is frowned upon in Japanese society. Stick with the system, work as one with your peers, and you will be rewarded with retirement and a comfortable life.

But Japan is a country of contrasts, and car culture is one way for the Japanese to take a love—in this case for their cars—and build on it in a way that only they know how. Away from the responsibilities and constraints of the daily grind, weekends are a space for transformation. The drab gray suits are banished and colorful self-expression flourishes. It is here that the inner otaku is set free.

Japanese car culture has cemented itself as one of the most diverse and unique in the world, which may have a lot to do with the way society has forced people to conform—when the time comes for a car obsessive to enjoy their passion, you can bet it will be embraced to the fullest. Car culture allows freedom of expression in a space where nobody criticizes. The deep passions and extensive knowledge of these car-crazy enthusiasts are a true contrast to the way Japanese society wants everyone to be. And it's precisely this that has edged car guys and girls on, to expand their interests, to dig deeper, to appreciate, and ultimately to evolve. That's why Japan offers up the best of every facet of car culture to the discerning outsider looking in.

The domestic automotive scene has flowered over the decades to create a colorful subculture that spans every possible type of vehicle Japan has ever produced or imported, from the old race car-inspired *Kaido Racers* of the 1970s to the wildly decorated *dekotora* trucks and *bōsōzoku* bikes. A strong natural pride ties all of these together, an inner style that originated, for the most part, from the working class as they strived to personalize the cars they could afford in the wildest

愛車へのこだわり

This jacket, produced under the Black Flame brand, is an example of a growing Japanese fascination with Chicano culture.

ways possible, whether tuning and extracting more power from their engines, customizing their exteriors, or replicating the race cars that used to battle it out in touring car series at Fuji Speedway. Today, these styles still exist, kept alive by a mix of nostalgia and love for the old styles, fuelling a strong movement around classic cars that has blossomed over the last decade. Two very evident schools of thought have emerged: those who prefer to stick to the original look of the car as it came out of the factory, and those who still believe that a Japanese car isn't quite perfect until it has been heavily modified. Whichever camp you belong in, there are plenty of shows, events, and local gatherings, from JCCA (Japan Classic Car Association) yearly meetings to the Nostalgic 2 Days show in Yokohama that brings the entire classic car–or *kyusha*–world together under one roof.

It is impossible to talk about Japanese car culture without referencing drifting, the biggest automotive style to have been exported to the rest of the world. With roots tracing back to the small *touge* or mountain passes of the country, the style of driving emerged from the need to fine-tune one's trajectory through tight hairpins, sliding the rear of the car while setting up for the corner ahead much like a rally car, then using the power to exit sideways, in the process tackling the corner in the fastest way possible. Drifting was adopted by street tuners or *hashiriya* to show off and earn the kudos of their peers in the scene, but it wasn't until the emerging professional driver Keiichi Tsuchiya started to use this technique in motor racing, sliding his Nissan Skyline GT-R Gr.A around corners to win an advantage over his competitors, that the style exploded. Keiichi was dubbed the Drift King, and 20 years ago drifting evolved into a professional series in Japan: the D1 Grand Prix. It has since spread all over the world, giving birth to similar championships such as the American Formula Drift. But while the professional side of the sport grows and evolves, true enthusiasts continue to pursue it at a grassroots level, persistently pushing the boundaries of both style and driving. Japan remains the place drifters around the world look to for inspiration, not only in the cars themselves but also the driving techniques.

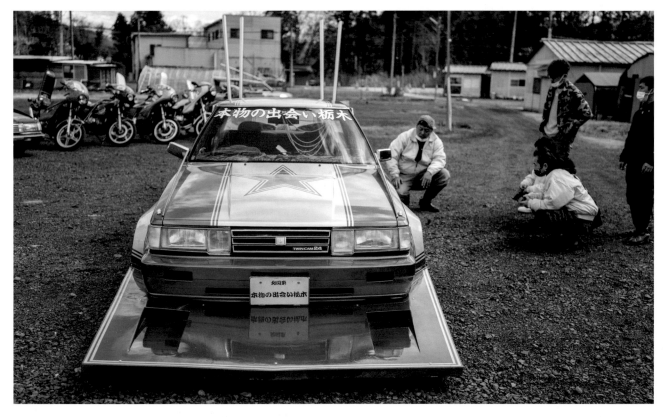

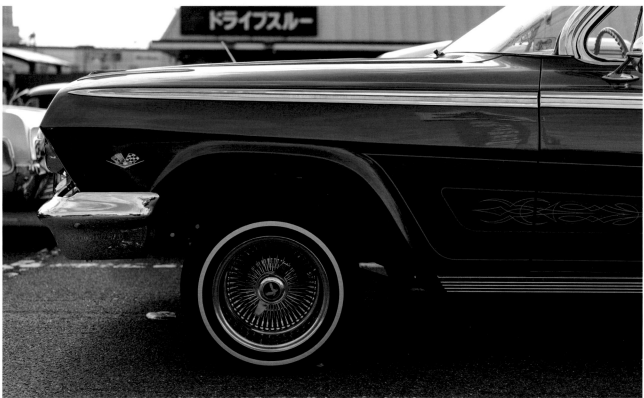

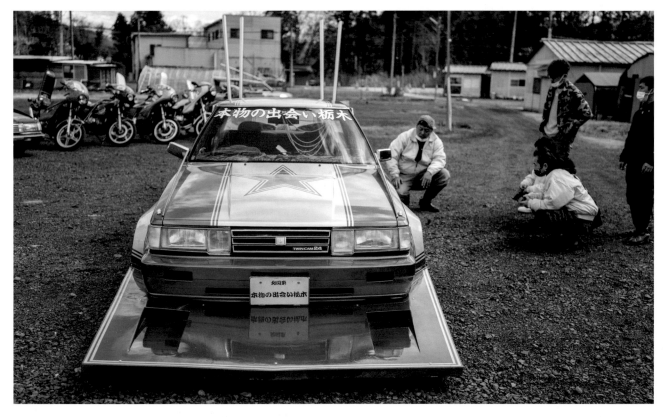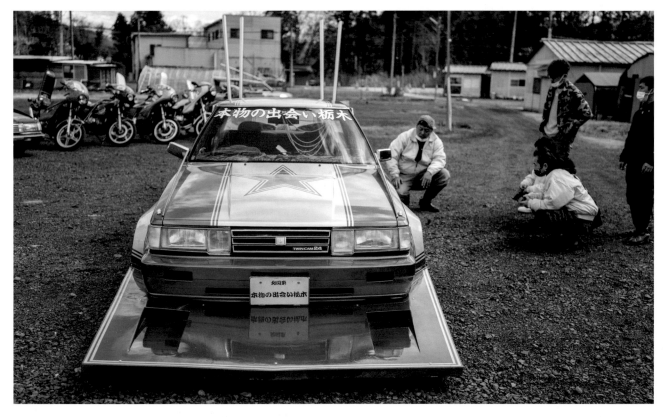

The contrast between homegrown Japanese classic car style (top) and Amesha (bottom).

愛車へのこだわり

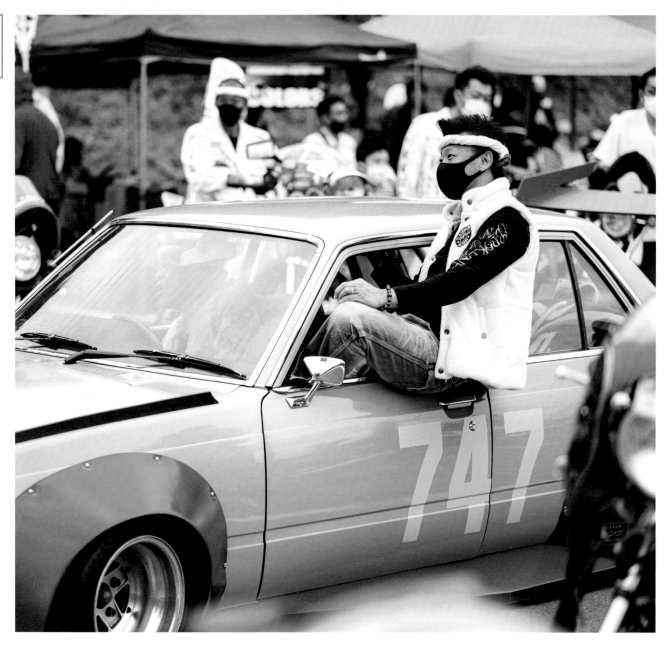

Zokusha, also known as Kaido Racers ,
enter a *kyushakai* event in Tochigi.

One period is still the most defining in Japan's
obsession with cars: the 1990s. This was the decade that
Japan asserted its fascination with power and speed,
when the local tuning shops dotted around the country
were the focus of a love for cars that was incredibly
widespread. From drag racing to street racing and
eventually to time attack, every sports car that Jap-
anese manufacturers churned out was getting highly
modified and raced on the weekend. Street racing ran
rampant in this decade, when legendary cars like the
Skyline GT-R and Toyota Supra were king, with tuning

While not widely advertised, *kyushakai* events are great places to see homegrown custom styling.

shops building their own interpretations of the perfect model. Twenty-five years later, the cars that defined that slice of modern automotive history have become today's sought-after collectibles while tuners continue to apply their black magic to the latest crop of performance cars, extracting even crazier levels of power and performance.

Ever since the country opened up to the West in 1853, the Japanese have practiced the art of looking outwards, carefully observing, and then perfecting whatever it is one has learned about. In the case of cars, Japanese car enthusiasts have an uncanny ability to take any foreign vehicle, be it an American muscle car or a European supercar, and make it look and perform just right. This can be done in a variety of ways through aesthetic modifications, but more often than not, a simple handling package and a well-matched set of wheels and tires nail the stance. They may be emulating styles found in the countries these cars originate from, but the application of Japanese attention to detail perfects the result. The otaku approach can truly generate some gems—as with the adoption of Chicano culture, where shops build and custom-paint lowriders for guys and girls who have possibly embraced the Mexican gangster look more fully than the people they emulate. Once an otaku finds the passion that drives them, it truly becomes their life calling. This level of obsession is precisely what fuels Japan's car culture, what sets it apart, and what makes it the focus for enthusiasts around the world to derive inspiration from. Which somehow brings us full circle, since this car culture originates from the Japanese looking outward for inspiration in the first place. In essence, it all comes down to an international exchange of ideas— initially at least. All would come to nothing if it wasn't for the obsessive nature to perfect that the otaku possesses, coupled with a way of standing out from the crowd through what they have created.

Dino Dalle Carbonare is a car photojournalist based in Tokyo. He has covered every angle of Japan's car culture for 20 years, reporting for global publications and working as a consultant to car manufacturers and TV productions. He is editor-at-large for Speedhunters.com, a car culture blog created from the *Need For Speed* video game franchise.

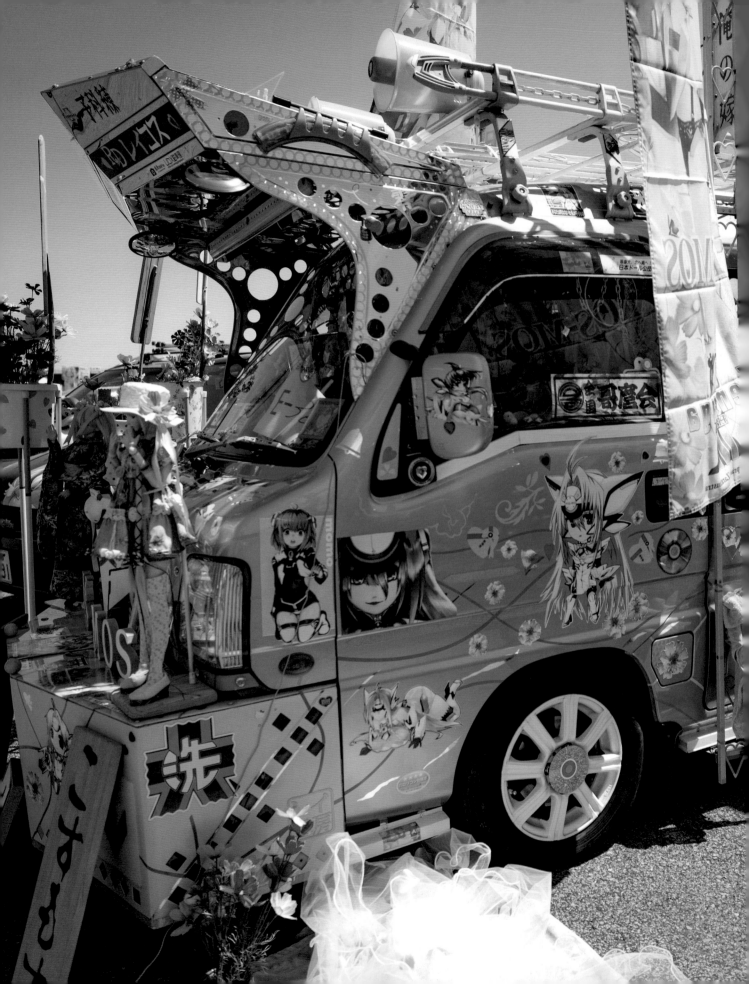

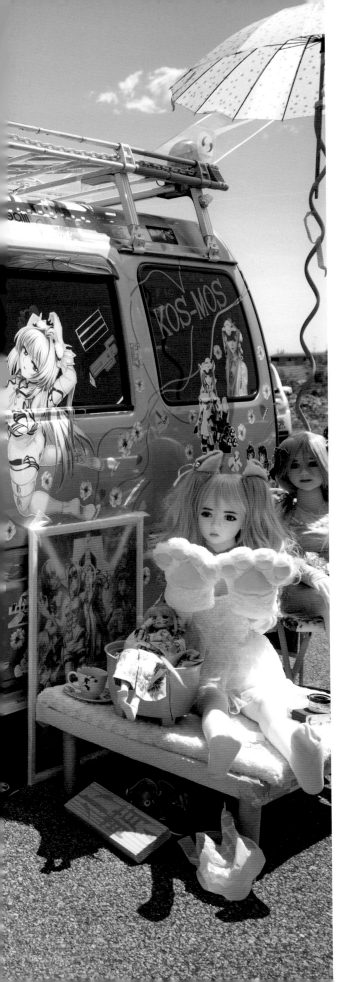

## ITASHA

Plastered from bumper to bumper with anime girls, these cars are the ultimate expression of otaku fandom.

It is said that otaku know no limit to expressing their passion, and the itasha is certainly proof of that. This car-modding phenomenon involves an owner plastering their car with decorations, decals, quotes, and every other imaginable thing related to their favorite character or anime. How much area should be covered? Every square inch if you can afford it. The result is eye-catching, sometimes even eye-watering. The term itasha is in fact a portmanteau of *itai* (pain) and *sha* (car), denoting the painful cringeworthiness these cars sometimes inspire when looked at. Despite this, the term is widely accepted and loved by itasha owners.

Natsume Kaede is an itasha owner who would, in normal times, attend meetups every week. "Distance is irrelevant to an otaku," he laughs, recounting times he has driven over 12 hours to reach events in Kyushu, the southernmost island in Japan. His car is an homage to *Girls & Panzer*, an anime about schoolgirls who drive military tanks. "I knew I wanted my own itasha when I saw others driving them around the streets," he explains. While the word itasha has negative connotations, itasha numbers have been steadily rising in recent years. Natsume correlates this to anime becoming more mainstream and accepted in Japan and the world over. "TV personalities are open about their love for anime these days," he explains. "Even pachinko machines are pretty much all anime-themed." This global anime takeover has fueled itasha enthusiasts to new heights in adorning their cars–inside and out–with their passion. Millions of yen are spent on getting the perfect custom design for full-body car wraps. "We'll spend any amount of money to show off our love," Natsume laughs. "Otaku money makes the world go around."

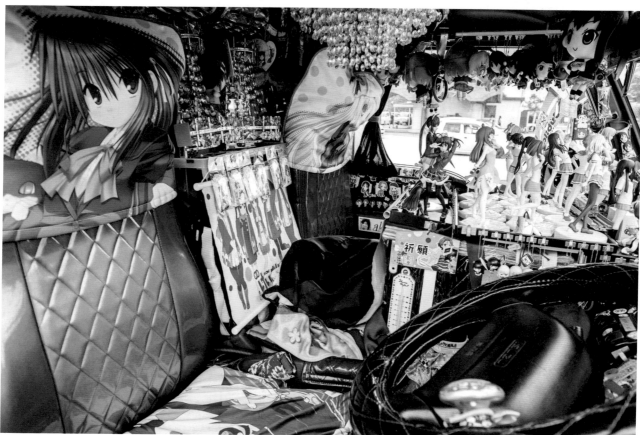

This page: Modifications are made inside the car as well as out. Opposite page: Natsume Kaede stands
in front of his itasha, a custom Mitsubishi eK Sport.

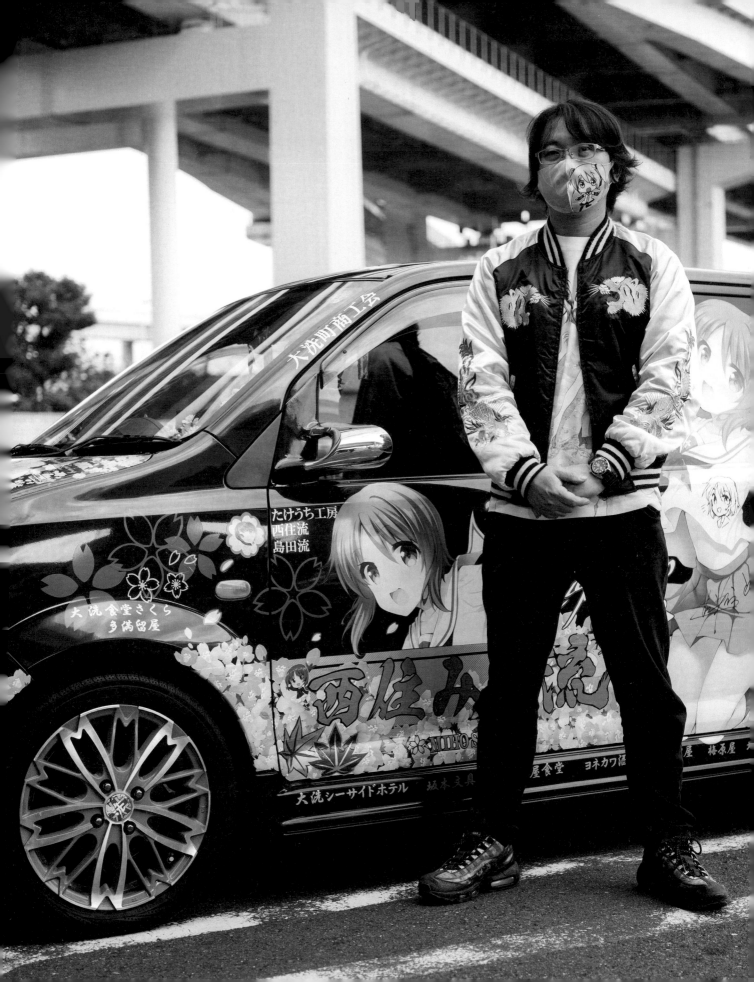

バンニング

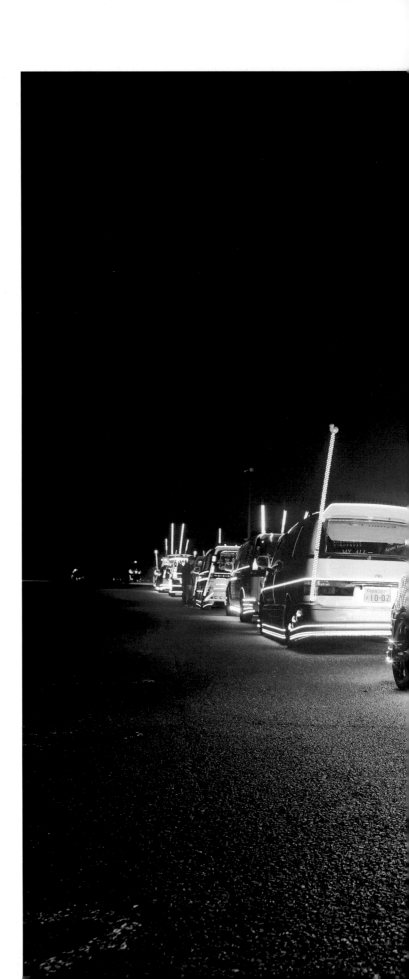

## VANNING

The hobby that proves any vehicle
can be modded to extremes.

In the Land of the Rising Sun, it's guar-
anteed that any vehicle category or its
subset has a developed modding culture
devoted to it. Sports cars notwithstanding,
if it has wheels and goes *vroom*, it can
and will be customized. Case in point:
vanning. While generally not seen as the
sexiest of vehicles, vans have a subculture
surrounding their customization that is
as maniacal as any other and has produced
some truly unique creations.

    Vanning originated in the United States
and is something of a blanket term for all
modifications done to vans. Classic vanning
generally involves a lovely detailing and
paint job on a vintage vehicle. Japanese
vanning adds oversized aero parts, fins,
and air scoops, often with no function other
than to look cool. A superfan might have
the image of a popstar or anime character
airbrushed large across the body. Add in
a bank of speakers that engulf the trunk
space and maybe a few flatscreens for
good measure, and you have a van you can
be proud of, albeit one that might not fit
into any roofed parking lot. Another course
of action might be to cover your van with
thousands of sparkling LED lights, and then
convince a bunch of your friends to do the
same. One thing's for sure–there's no limit
to the creativity of Japanese vanners.

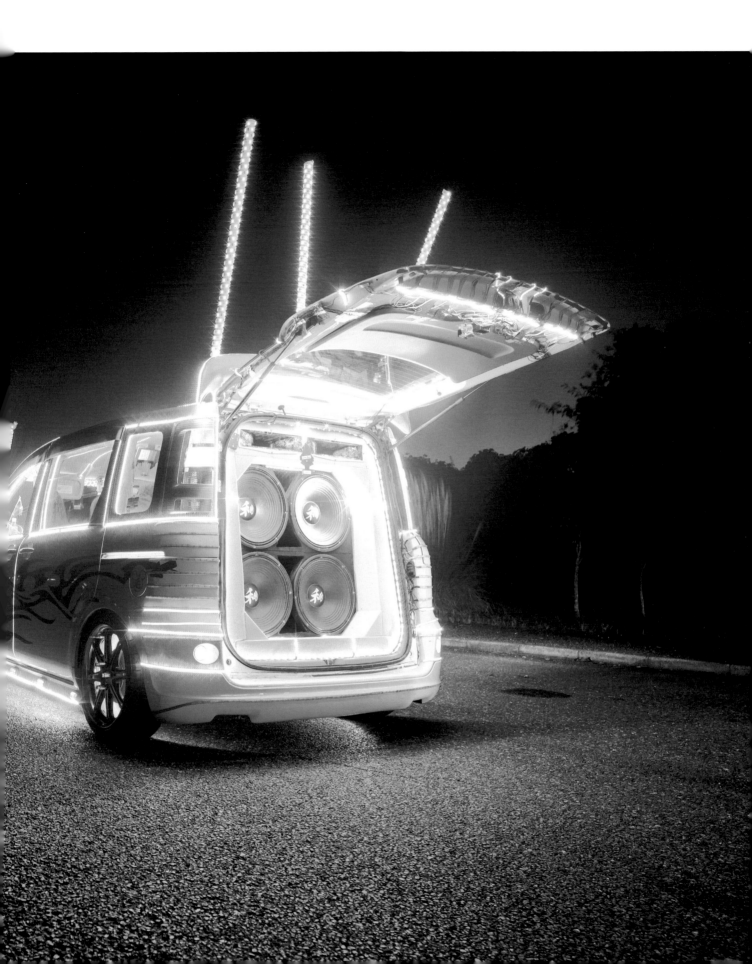

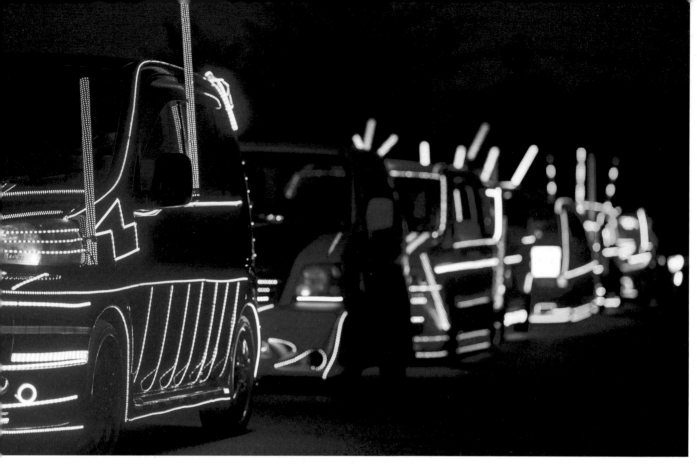

Top and bottom: Cars from the Daikoku Denshoku Association assemble for an event.

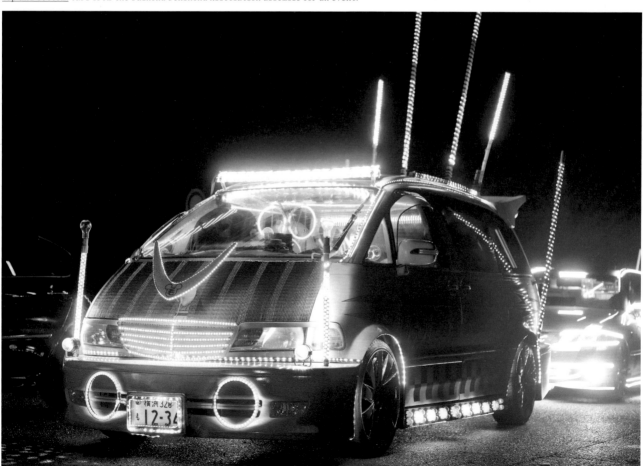

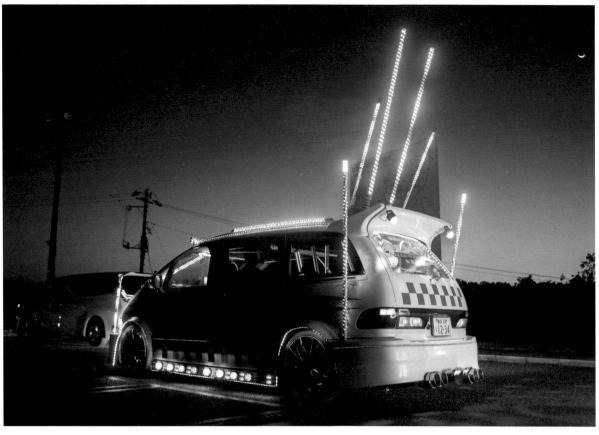

<u>Top and bottom:</u> Daikoku Parking Area is a Yokohama spot known as a meeting place for car enthusiasts.

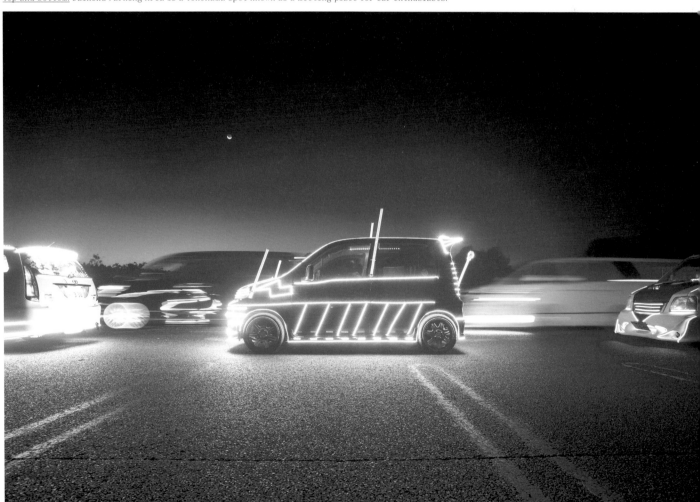

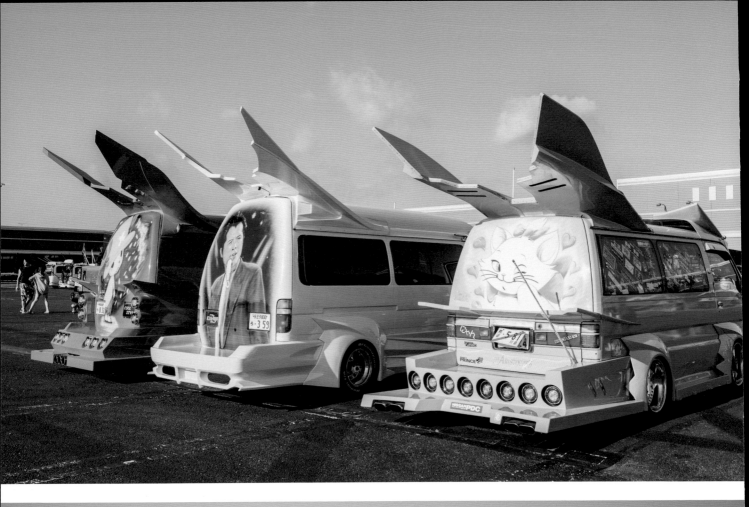
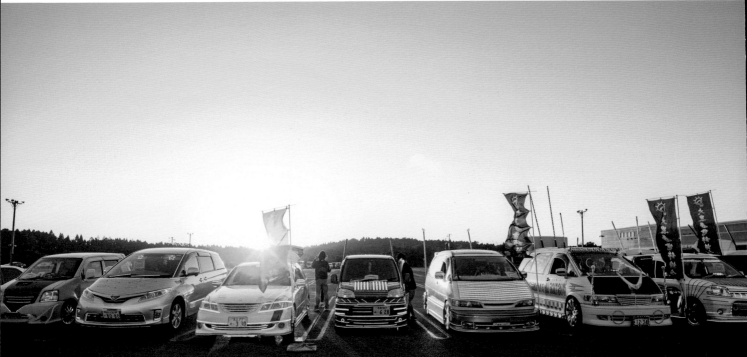

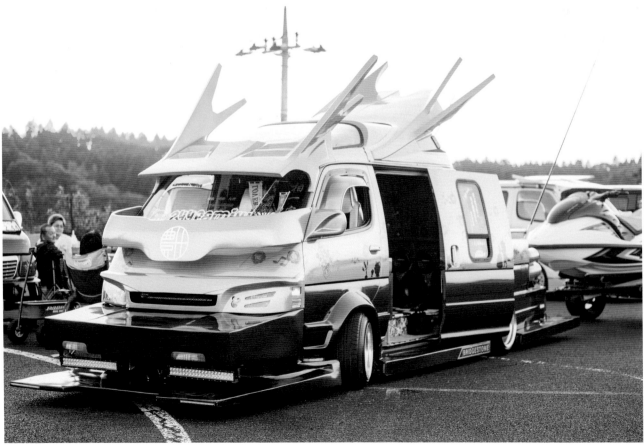

<u>This page and opposite:</u> Vans on display at the Yogisha Cup, an event that judges the dopest machine for cruising the streets at night.

街道レーサー

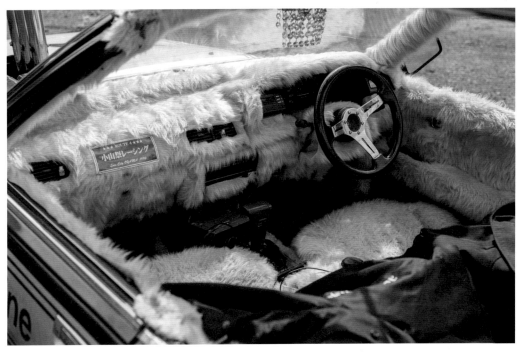

<u>Above:</u> Fluffy interiors are surprisingly common despite being extremely difficult to clean. <u>Opposite page:</u> Oversized fairings, bumpers, spoilers, and exhaust–this Toyota Mark II has all the hallmarks of a great Kaido Racer.

## KAIDO RACER

A uniquely Japanese spin on classic cars.

Delinquency and rebellion in Japan are generally associated with the deafening bikes of the bosozoku. But when bosozuku members grow up and leave the gang, they often end up buying a car and modifying it to the same extremes that made their bikes so iconic.

These cars are known as *Kaido Racers*, although they are often called *zokusha* or *shakotan* too. As with most custom-car cultures here, modifications tend toward the excessive: lowered chassis, extended exhaust pipes, and huge spoilers. Perhaps the most perplexing modification of all is the *deppa*, or buckteeth, a massively overlarge chin spoiler that is sure to hit any bump larger than a pebble. "Its purpose is to look cool, that's pretty much it," says Sekine Shun. Shun and his father Yuji are car-tuning enthusiasts who customize everything from American vintage cars to Kaido Racers. Shun's Toyota Mark II, bought from an upperclass-man, has been modded with parts he crafted from scratch. While he does occasionally draw attention from the police for driving such an outlandish car, upcoming changes to Japanese car-compliance laws should make it easier for Kaido Racers to attach impractically large modifications to their vehicles without repercussions.

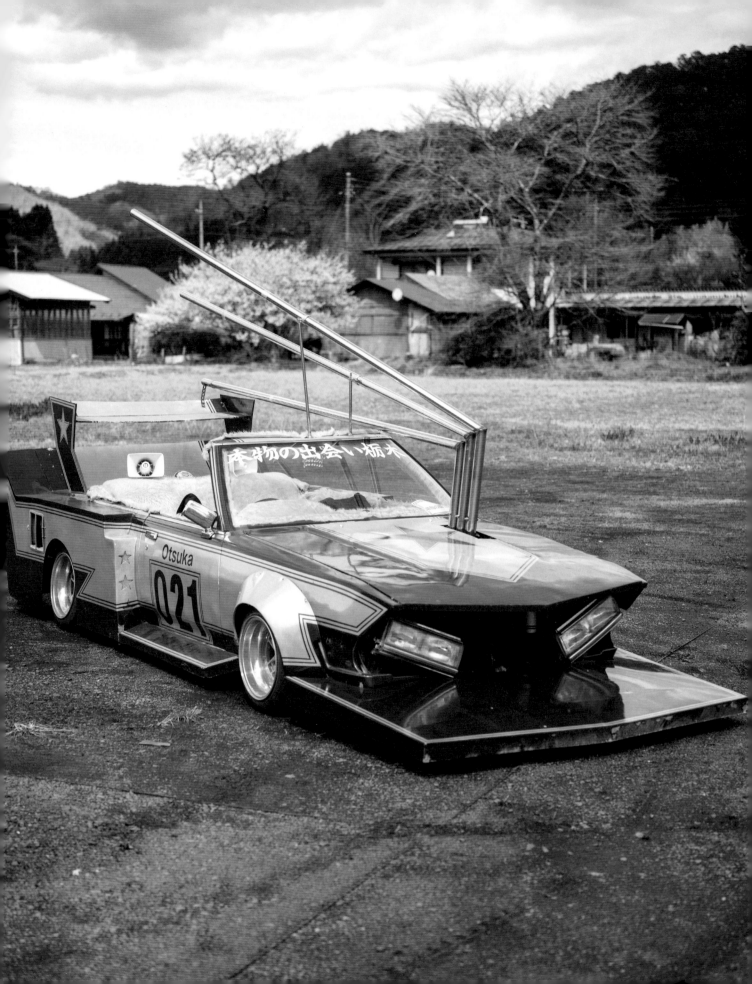

ロ
ー
ハ
ン
井
澤
A
R
T

D
E
S
I
G
N

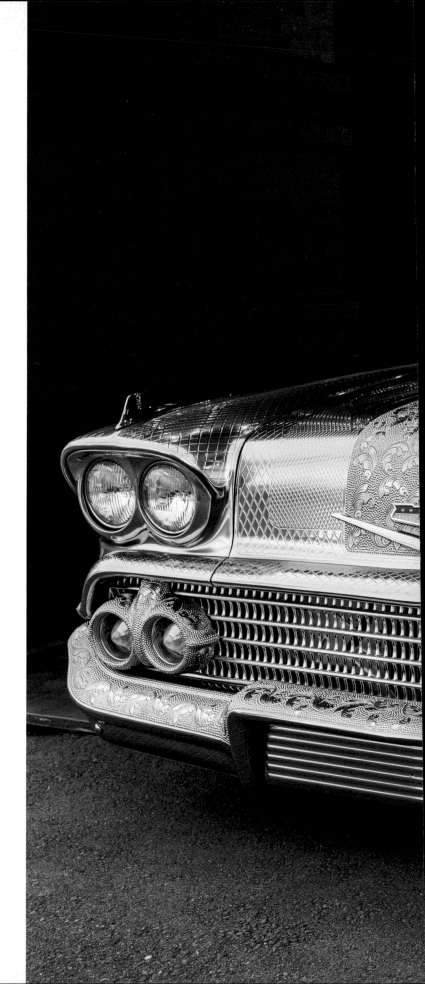

## ROHAN IZAWA ART DESIGN

A handcrafted approach to custom-car parts
has produced some of the most breathtaking
kits in the world.

Japan's custom-car scene is one of the
most exciting in the world. Where standing
out is currency, creations range from the
outlandish to the laughably bizarre. Izawa
Takahiko of Rohan Izawa Art Design in Nara
prefecture, however, has combined master
craftsmanship and new paint technology to
create stunning works of art. His most well-
known creation is the 1958 Chevrolet Impala,
a breathtaking chrome silver vehicle
covered in intricate Arabesque-inspired
patterning. The design was achieved by
using chisels to carve patterns into part
of the bodywork, then using a special
proprietary 3D paint to create the diamond
pattern on the rest. This staggering amount
of skill and labor does not come cheap—
the paint job is valued at $250,000. Izawa
developed the metal paint needed to give
the body its unique luster himself. "Coming
up with new paints has always been a hobby
of mine," he says. "It's not a hobby you
hear about often, but I'm a strange person
anyway." The Impala has skyrocketed Izawa's
fame, and he recalls a car show in the
United States where 500 people lined up
to get his autograph. "I want my work to
move people," Izawa says. "If you want
to move people, you have to show them
something they have never seen before."

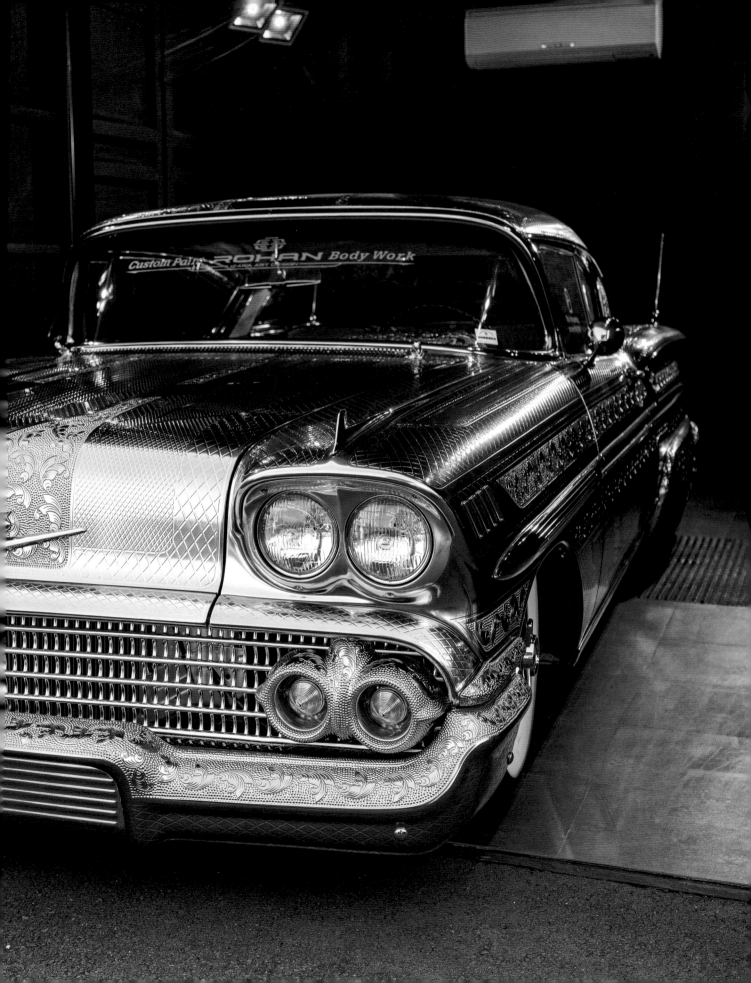

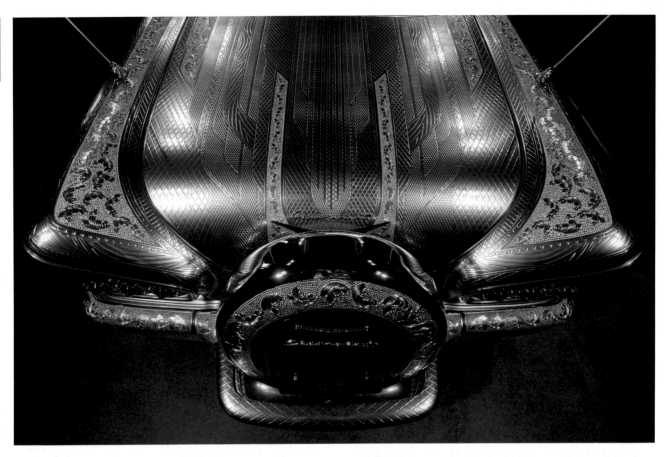

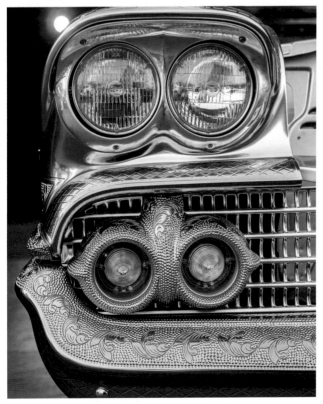

<u>This page and opposite:</u> Every square inch of the Impala has had hours of design and crafting poured into it, with eye-popping results.

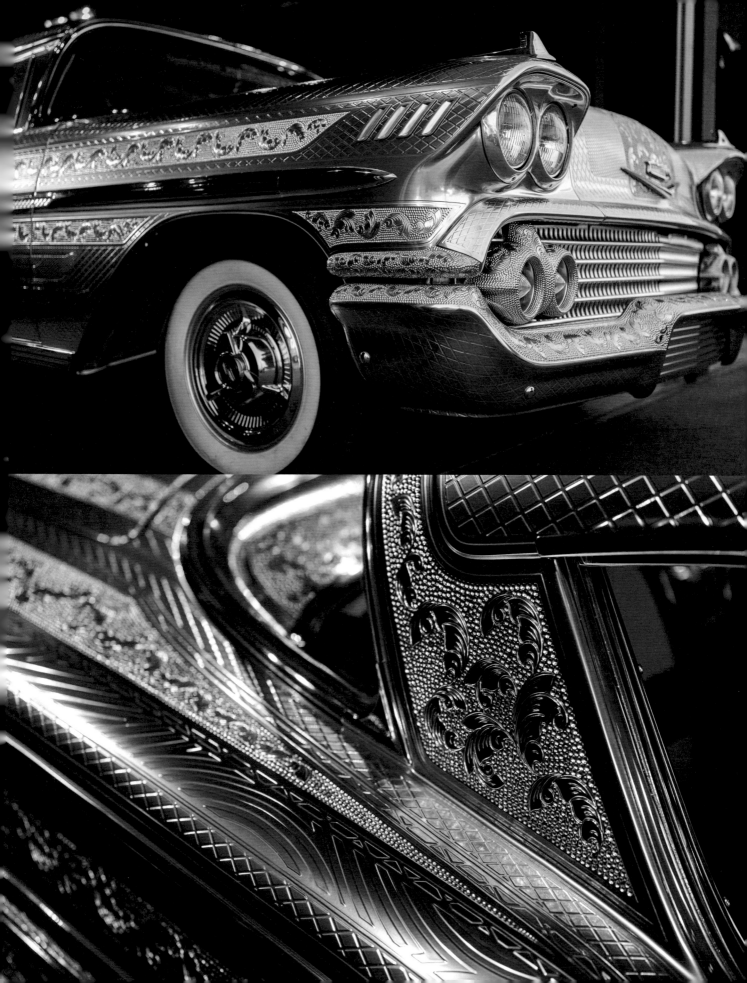

大阪C

55-55

Opposite page: Izawa Takahiko stands next to his most recent project: a Harley Davidson with which he hopes to win top prize at the next competition.

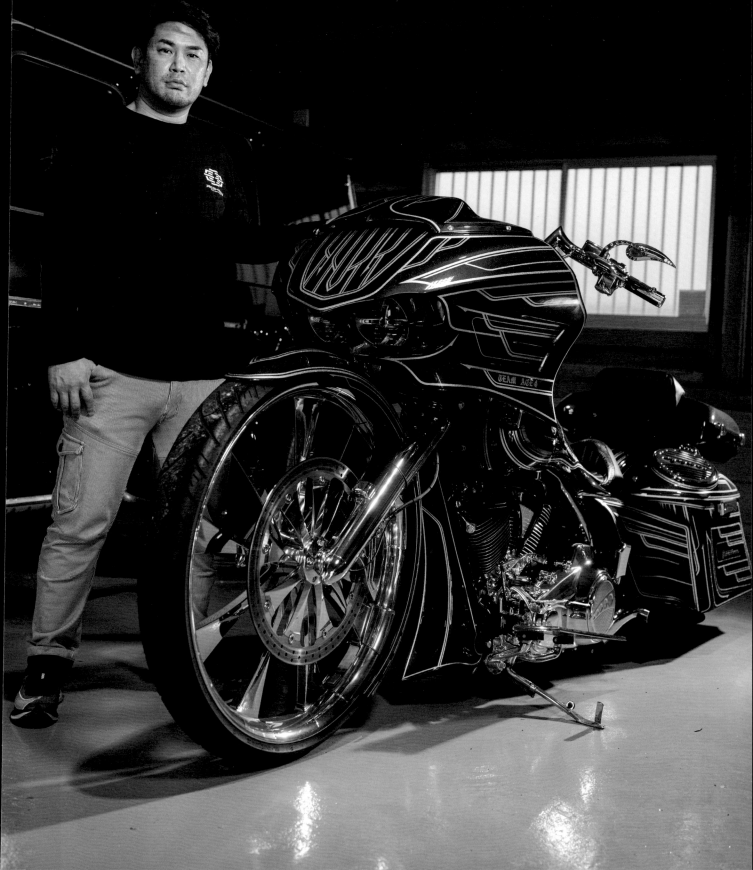

等身大フィギュアクラブ

## 1/1 SCALE MODEL CLUB

Modeling taken to the extremest of extremes.

Since the 1960s, Japan has been a global titan in the plastic model-kit industry. Beloved brands such as Tamiya, Hasegawa, and Bandai cater to enthusiastic modelers of all tastes and interests, from classic cars to military vehicles to futuristic robots. The attention to detail and reproduction quality should satisfy even the most hardcore fans of their preferred genre. For some, however, that is not enough.

Ohashi Yasuhiko is the president of the 1/1 Scale Model Club. "I always wanted to have a tank," he says. "But you can't legally buy one in Japan. So I decided to make one." True to its name, the 1/1 Scale Model Club, shortened to *Puraichi* in Japanese, makes replicas of things fully to scale. Ohashi and his friends formed Puraichi 10 years ago. The first model they made was a Zeon jeep from *Mobile Suit Gundam*. Amazingly, Sunrise, the studio behind Gundam, gave their blessing to the team. The model went ahead as an official project and made them a name in the modeling community.

Their *pièce de résistance* to date is a German Wiesel 2, an armored vehicle currently in use by the German Armed Forces. It took seven years to make and even has its own diesel turbo engine for short trips. "The treads were the hardest part," says Ohashi. "There were so many of them!" The replica Wiesel was so convincing that when the German manufacturer of the real vehicle saw photos of it online, they apparently called up the Japan Ministry of Defence to ask why there was a Wiesel 2 in Japan despite not having a contract with them. "They contacted me and asked me a few questions about it," grins Ohashi. "When I told them I built it myself their response was, 'Wow.'"

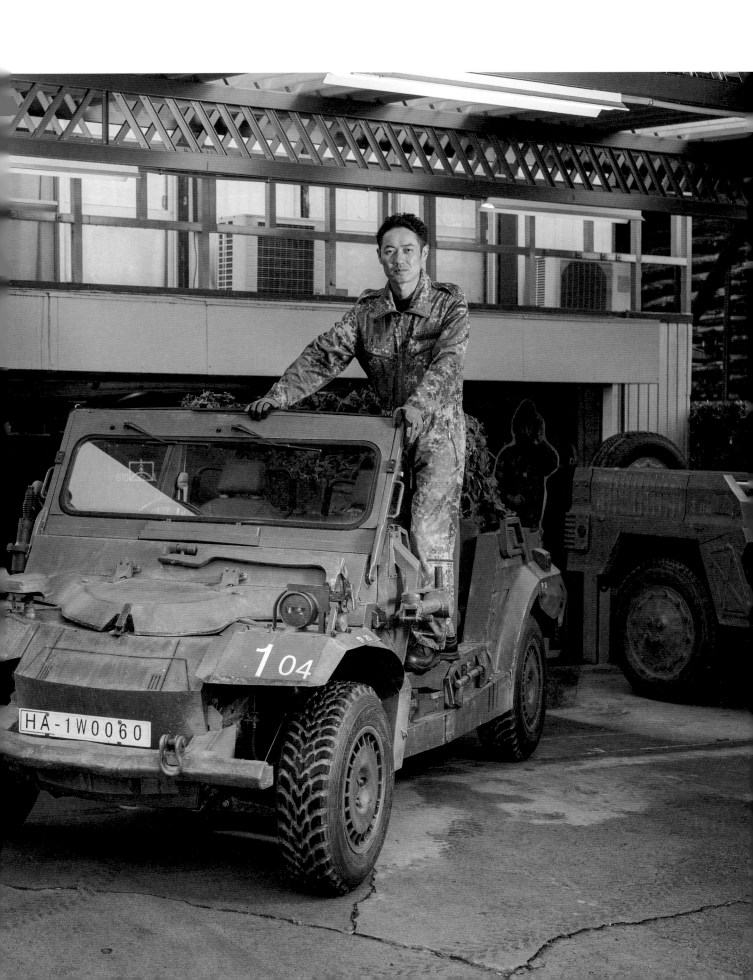

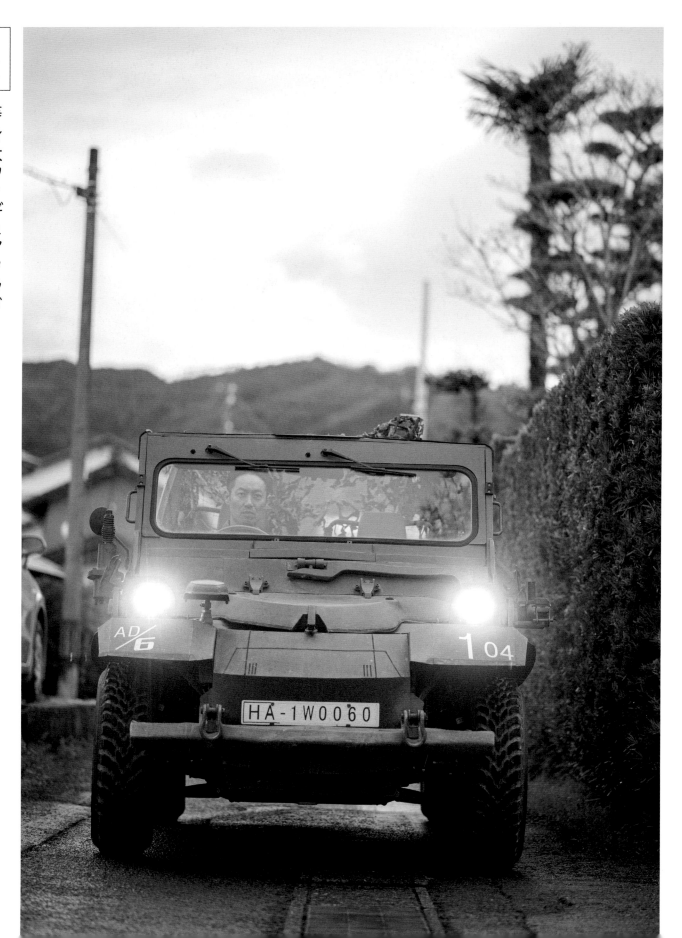

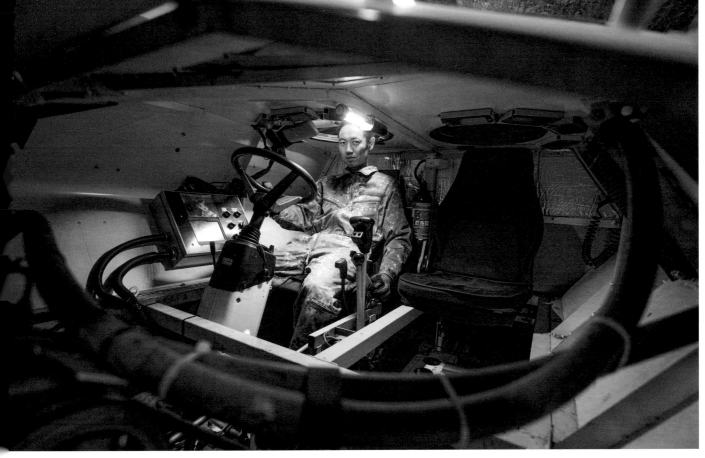

Top: The interior of the Wiesel 2. Bottom: Each part of the Wiesel 2 was built from scratch. Opposite page: Ohashi sits behind the wheel of his jeep, made in the image of a Zeon model from Gundam.

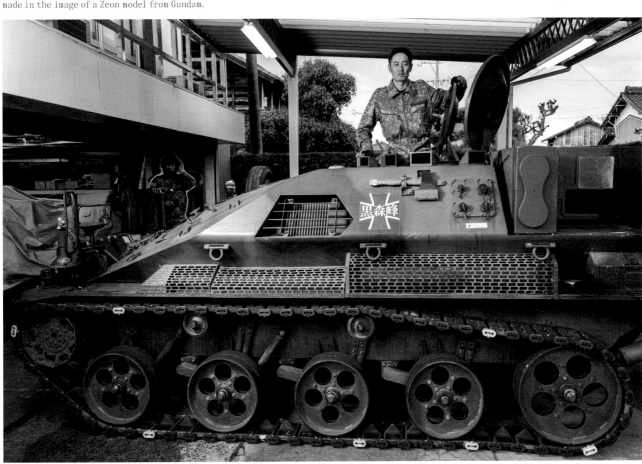

## DEKOTORA

An eye-popping level of truck customization with surprising links to philanthropy.

Japanese streets are no stranger to spectacle. The customized-car culture and cadres of dedicated enthusiasts have adopted and adapted modding influences from around the world and made them their own. Yet the biggest spectacle on Japanese roads—literally and figuratively—is an entirely homegrown one. The *dekotora*, short for "decoration truck," is truly a sight to behold. Studded with glittering lights, finished with gleaming chrome, outlandish attachments, and beautiful paint jobs, the presence of these garish long-haulers is a distinctive sight on Japanese highways, although their numbers have dwindled in recent years.

      Customizing trucks in Japan was not unheard of before the 1970s, but the release of the comedy movie *Torakku Yaro*

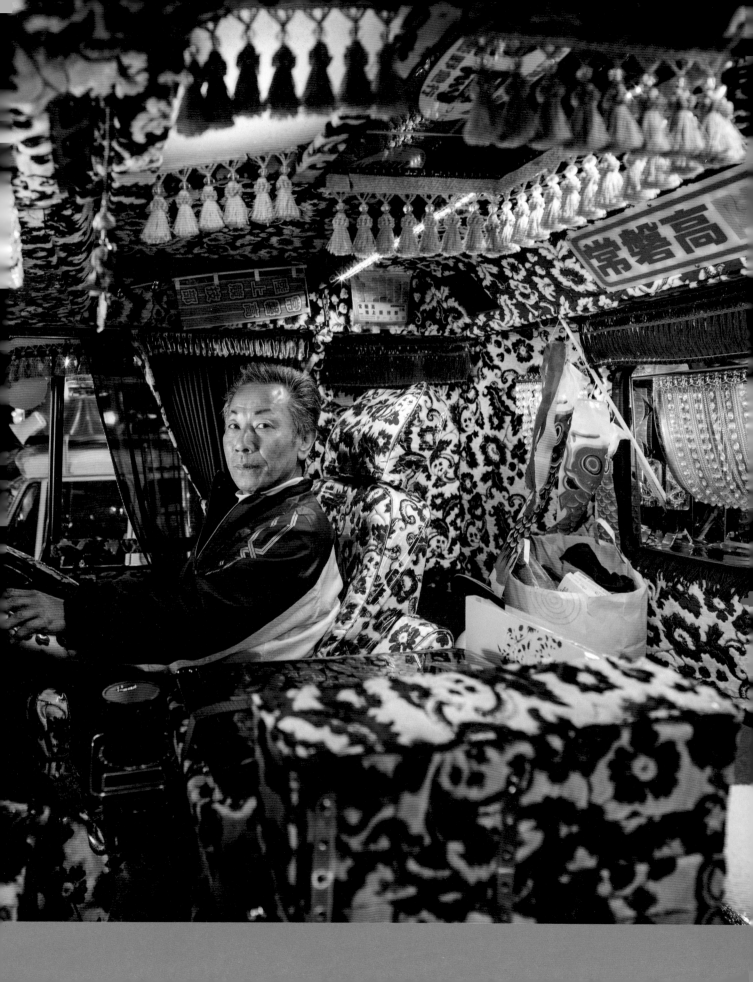

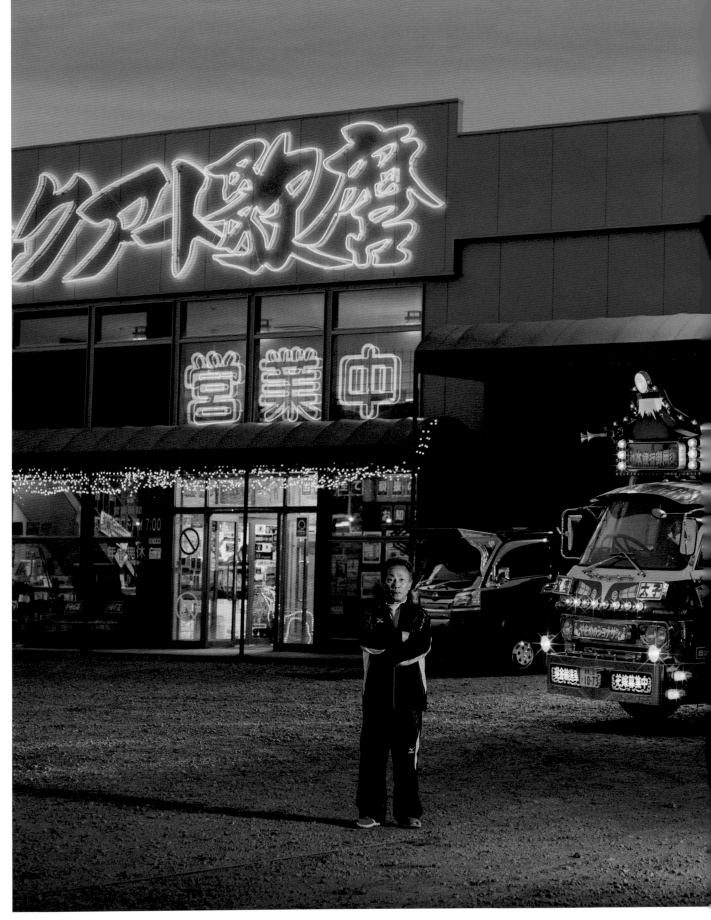

Utamaro's large lot is a great place to spot dekotora.

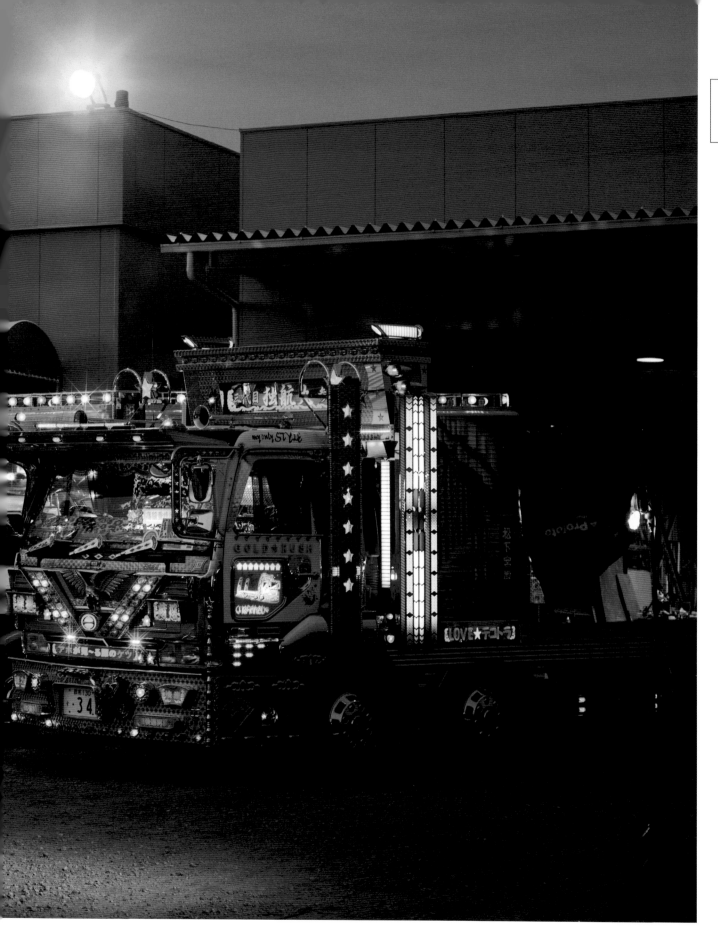

171

DEKOTORA

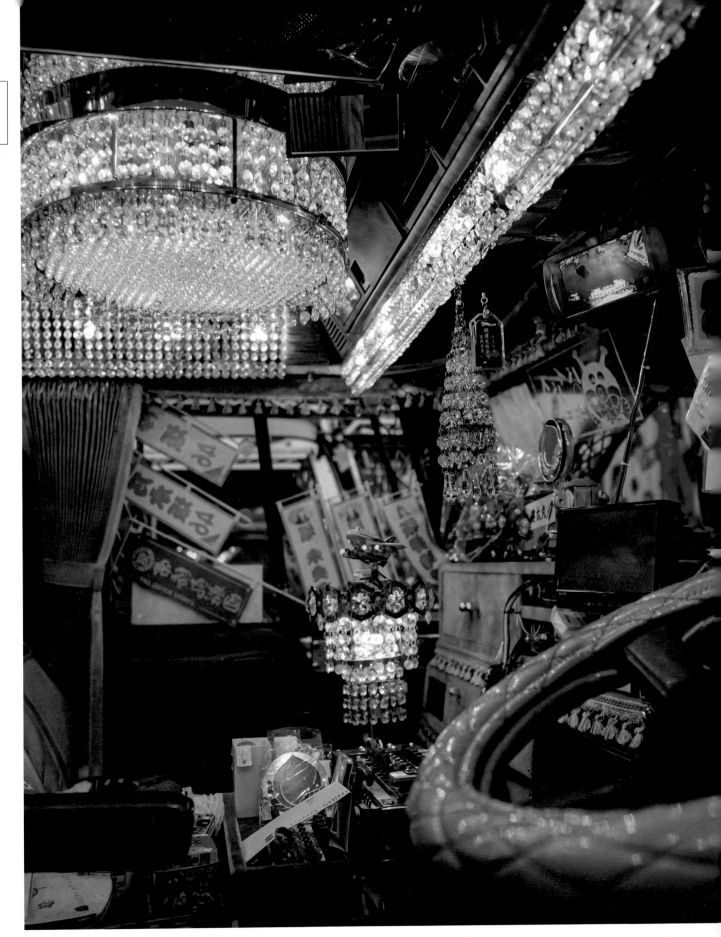

Dekotora interiors are often as spectacular as their exteriors, overflowing with the drivers' personalities.

*(Truck Guys)* was the real watershed moment for dekotora. The film and its subsequent sequels feature a hopeless-romantic truck driver and his sidekick who travel around Japan getting into scrapes with rival truck drivers, failed romances, and trouble with the law, all while ensuring

> **"Most owners of dekotora don't have an end result in mind when they start customizing their truck. They will continue adding or changing parts until they die."**

their deliveries are made on time. As well as being a huge hit, with ten sequels made in five years, the outlandish trucks featured in the film were the catalyst for the dekotora subculture.

Utamaro is a truck-parts shop and custom garage in Gunma prefecture. Few shops for dekotora parts exist, and fewer still also provide a customizing service like Utamaro. Onishi Yuya is the second-generation manager of this place and has grown up with dekotora his entire life. "Most owners of dekotora don't have an end result in mind when they start customizing their truck," he says. "They will continue adding or changing parts until they die. In which case," he adds, "the truck will be passed down to someone important to that person and the modding will continue." For these truckers, their vehicle is more than an important tool of their trade. "Most drivers will spend more time on the road than in their actual home, so it's natural they would want to make it a place they enjoy spending time," he says. Each dekotora is a statement of the pride each driver has in their job and an outlet for their personal creativity. "The lines of poetry or kanji that I get orders to paint

are carefully chosen by each driver to convey their individuality," says Iwai, who is a painter specializing in decorative paint jobs a short drive down the road from Utamaro.

Despite the popularity of the *Truck Guys* movie franchise and the occasional thrill of seeing them on the road, however, Onishi is aware that dekotora are not universally popular. "The whole subculture goes against the *keppekisho* of Japanese people," he says, using a word that conveys a compulsion toward fastidiousness. "Anything that is coarse or reminds them of *yankii* culture generates an automatic rejection reflex in most Japanese people. It's understandable—we Japanese have been conditioned to think yankii culture is bad." So it was a big surprise for the dekotora community to see one appear during the closing ceremony of the 2020 Tokyo Paralympics, giving the subculture a boost of visibility and legitimacy its proponents had never actively sought out. "To me, it was nothing short of miraculous to see our culture being represented on the world stage. To be honest, most Japanese people think dekotora are a thing of the past."

> **"Most drivers will spend more time on the road than in their actual home, so it's natural they would want to make it a place they enjoy spending time."**

Indeed, the average age of dekotora owners is increasing year after year, due to the shrinking disposable incomes of Japan's middle and working classes. Emerging from the burst-bubble economy of the 90s, fewer and fewer truck drivers had the economic wherewithal to spend

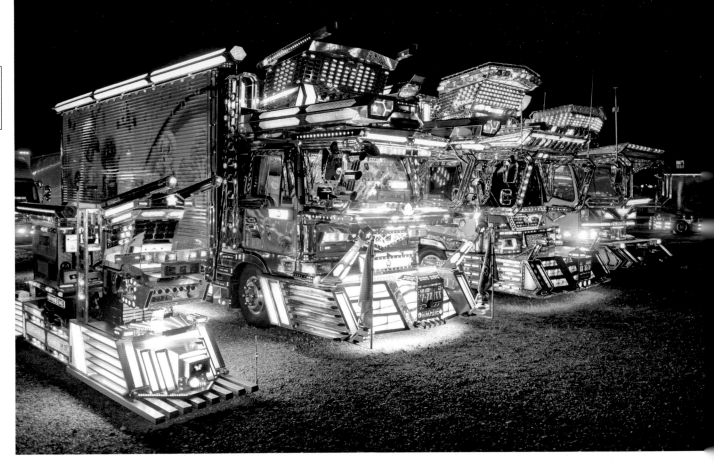

Top: An impressive lineup of trucks at a charity event in Chiba. Bottom: Onishi Yuya
in front of a vehicle that was famously used in the *Truck Guys* movie series.

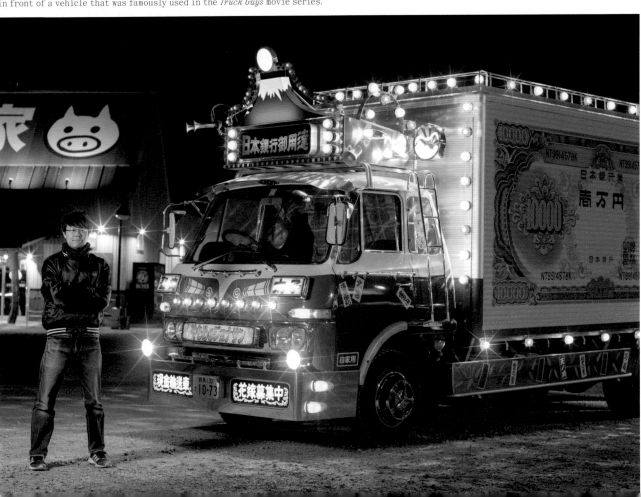

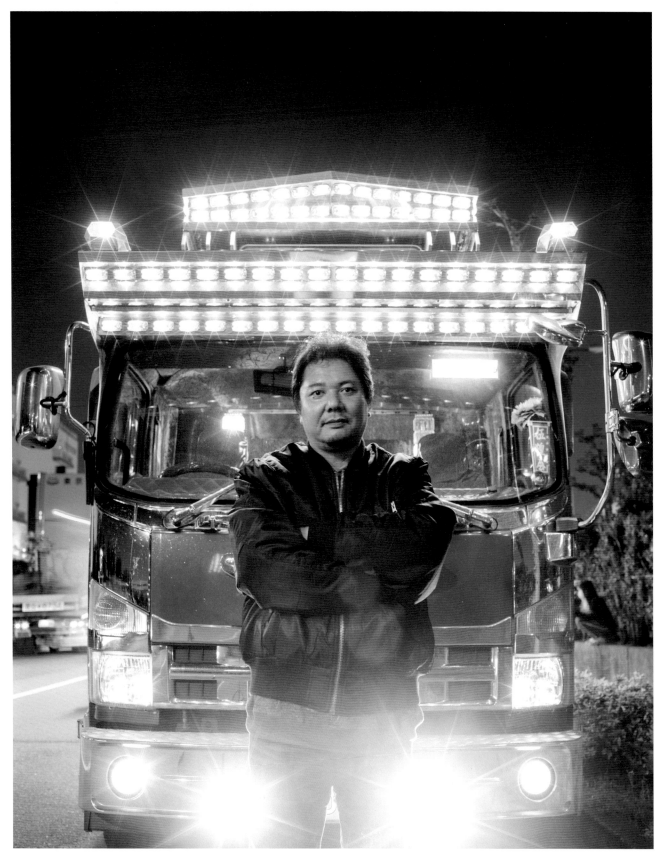

While dekotora are rarer sights on the roads these days, independent operators still take pride in their culture.

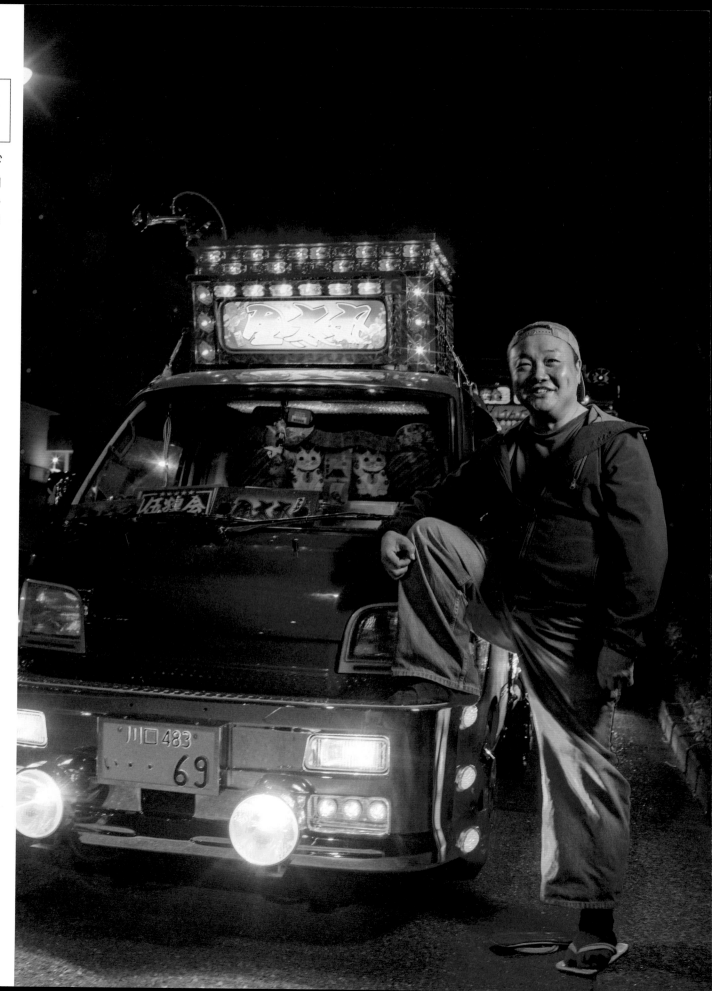

tens of millions of yen on flashy attach-
ments for their vehicles. In addition, the
rise of logistical megacorporations such
as Kuroneko and Sagawa either absorbed
or forced many small trucking businesses
out of operation. "Drivers these days don't
own their own trucks–if you work at a big
company, you don't even know which truck

**"Anything that is coarse or reminds them
of yankii culture generates an automatic
rejection reflex in most Japanese people.
It's understandable–we Japanese have been
conditioned to think yankii culture is bad."**

you'll be driving until you show up to
work," says Onishi. "It goes without saying
that they are very strict about vehicle
customization as well."

These days, most dekotora owners are
small-business owners with fleets of less
than five vehicles and the best way to see
them is to attend a charity event. Several
times a year, dekotora drivers from all
over Japan gather in large rural lots,
specially rented for the public to come,
admire, and take selfies. The entrance
fees and other proceeds generated are
donated to local welfare organizations.
This tradition of philanthropy is a
long one, started by the chairman of
the largest dekotora association in
Japan, Utamaro-kai, which has promoted
philanthropy for as long as Onishi can
remember. "When I was a boy, 'going to
charity' meant 'going to a dekotora
gathering,'" he says. "The two terms were
interchangeable for me."

Humanitarian activities for dekotora
drivers do not begin and end at photo
events either. Dekotora drivers are often
dispatched by Utamaro-kai to typhoon or

earthquake-hit areas to help with
cleanupsor provide fresh food and aid
stations. In the aftermath of the
Fukushima nuclear plant meltdown
following the tsunami of March 11, 2011,
large parts of Fukushima underwent
forced evacuation due to the radiation
fallout and were declared off-limits
by the Japanese government. Despite
this, there were people inside the zone
unable or unwilling to evacuate. Dekotora
drivers crossed into the exclusion zone
and delivered aid to these people when no
one else could, or would. As Onishi puts it,
"The chairman wouldn't sit idly by while
people waited for help. He always says,
'As long as there is a road there, we'll
go.'" These selfless actions undertaken
at great risk to personal health are a
hallmark of dekotora spirit. "These are
people who act on their feelings, and
Japan will be poorer if this generation
dies out."

While the numbers of dekotora drivers
are dwindling, there is no question that
the visual appeal and uniqueness of these
vehicles have captured the imagination of
creatives worldwide. They have appeared
in numerous overseas editorials and were
even used by luxury label Gucci in one of

**"These are people who act on their feelings,
and Japan will be poorer if this generation
dies out."**

their ad campaigns. Onishi believes the
sheer outlandishness of the trucks is
enough to overshadow any Tokyo tourist
attraction. "Park a dekotora anywhere
near a tourist spot, and you can pretty
much guarantee which thing will get more
attention," he laughs.

# AMESHA

A slang term for American cars, Amesha
culture thrives in Nagoya, where fanatics
celebrate their love for classic models.

Nagoya is known as a major manufacturing
hub for Japanese cars. Some of the world's
most recognizable automobile brands
are based in the area, including Toyota
and Mitsubishi. What is also well known,
at least amongst custom-car fans, is
that Nagoya is a hub for some of the most
renowned custom hot-rod and lowrider
workshops in the world.

"Why does Nagoya have so many work-
shops?" says Shimodaira Junichi, owner
of the fabled Paradise Road workshop.
"Everyone always asks the same question,"
he laughs. "People say that maybe it's
because there are so many car companies
here, but that isn't really the case. In
Nagoya, all the car fans get along. We don't
see each other as rivals. We recommend
other body shops to our customers." It's
this laid-back attitude that has seen
Nagoya become something of a hot rod

and lowrider mecca for fans across the
world, with classic American car fanatics
flocking to the city to tour the workshops
and regular car meetups. In contrast, the
Tokyo hot-rod and custom-car scene is
more fraught with rivalry, with different
car clubs often refusing to meet up with
each other. "All of us in Nagoya feel this
Central Japan kind of fellowship with each
other, so whether old or young, we all treat
each other equally," Shimodaira explains.

This camaraderie is evident at the
weekly PCM, or Pancake Car Meeting, accord-
ing to Shimodaira. "We used to gather in
the evenings, but we found it was easier
for people with jobs and families to meet
up in the mornings, so it became a pancake
meeting." Every Sunday, at a McDonald's
just inside Toyota city, a group of hot-rod
and lowrider enthusiasts gather to eat
breakfast and show off their rides in

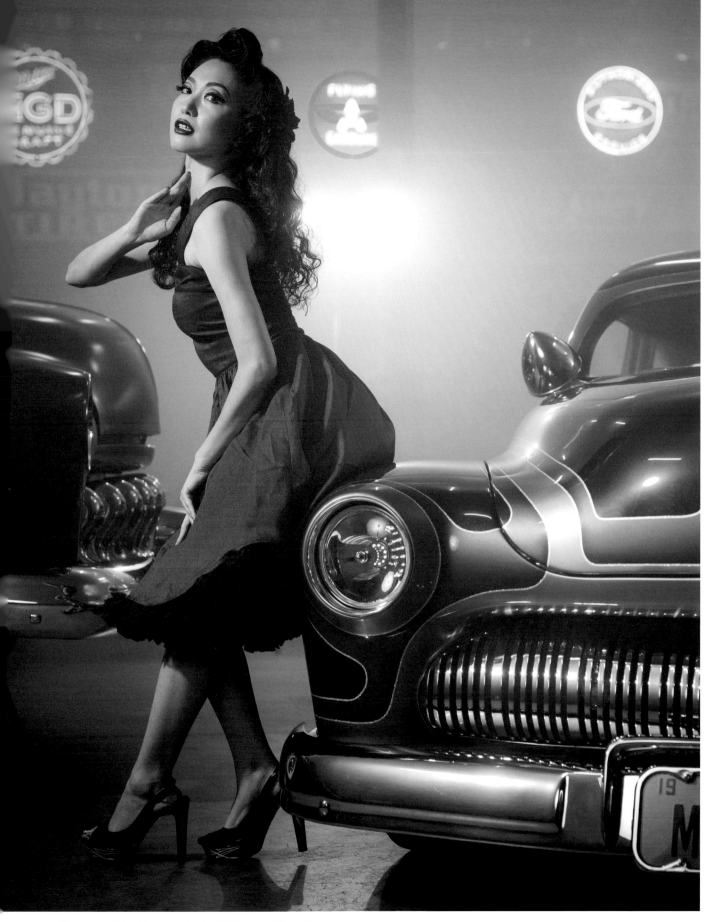

Pinup model Satomi leans against a 1949 Mercury "Merc 9."

<u>Top:</u> Arts Body is filled with classic cars undergoing refurbishment–some of them have been there for years. <u>Bottom:</u> Shimodaira (right) and his fellow founding members of the Pharaohs Car Club Japan. <u>Opposite page:</u> Paradise Road is a renowned body shop but also a repository of eclectic Americana.

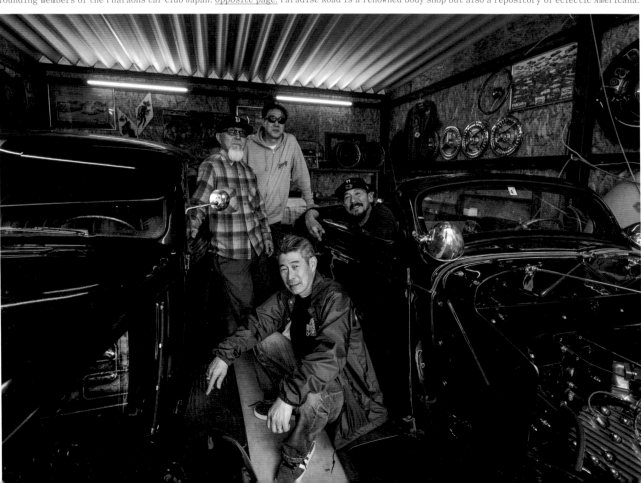

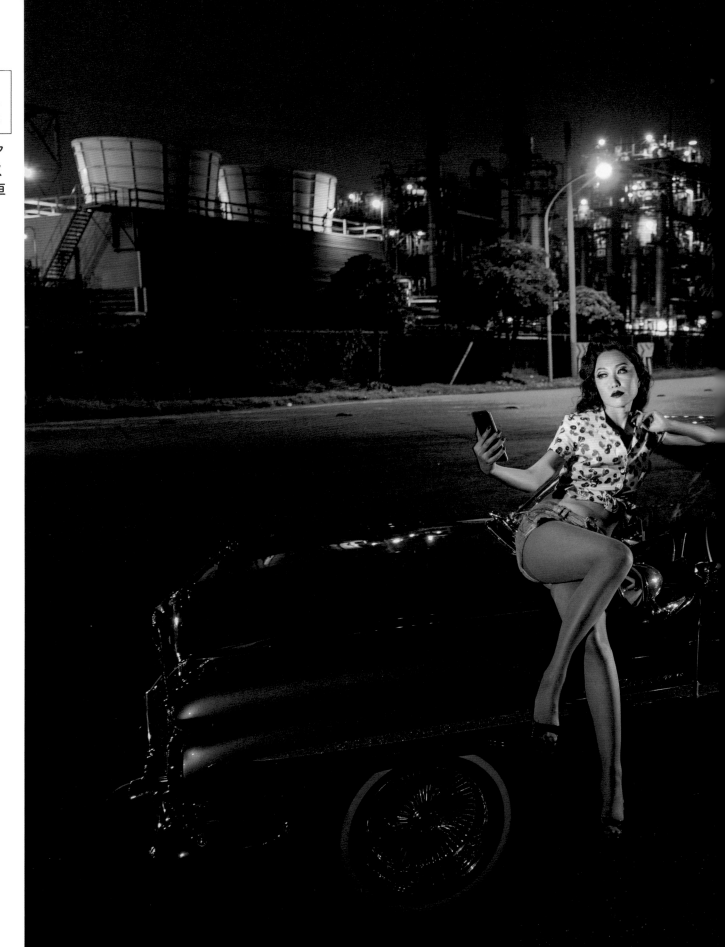

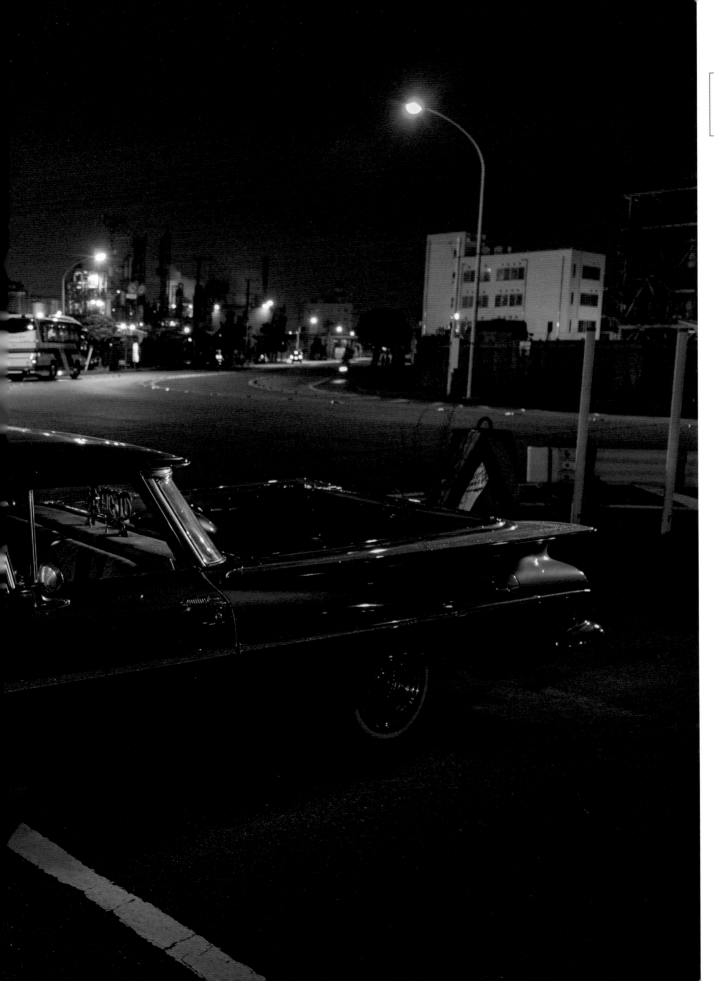

the spacious parking lot. The gathering spans decades of American car history, with Ford Model As mixing with Chevrolet Impalas and Lincoln Mark Vs. All vehicles are resplendent with custom parts and gorgeous interior detailing–an absolute treat for any classic-car aficionado. The gathering is informal and laid-back; after

**"In the 70s and 80s, tinkering with bikes and cars was seen as a teenager's hobby, something to grow out of."**

an hour or so of tire kicking and mutual admiration of each other's rides, the group disperses to get on with their weekend. "The Pancake Car Meeting is getting popular enough to have its own chapters in different parts of Japan," says Shimodaira.

Shimodaira's Paradise Road workshop is one of the most respected lowrider workshops in the world. Located roughly an hour outside of central Nagoya, it is filled with personal memorabilia from Shimodaira's 34-year career as a custom-car artisan. On a wall near a flight of stairs hangs an autographed picture of Bo Hopkins, one of the stars of *American Graffiti*. Shimodaira's love for the film and for classic American cars are closely intertwined–Paradise Road's name comes from the street at the end of the movie where the climactic drag race takes place; Shimodaira's car club is named The Pharaohs after the car club in the film; and his current car is a customized 1932 Ford Five-Window Coupe–the same as the protagonist John Milner's car. "I saw that film and it was a defining moment in my life," he says.

Shimodaira's journey to custom-car royalty didn't follow a straight line. He dropped out of school and ended up in a *bōsōzoku*, a teenage biker group typically filled with delinquents. At the age of 20, he received his driver's licence and

left bikes behind for automobiles. It was not long afterward that he found himself drawn towards Mexican-American-style lowriders and hot rods. "When you're in a *bōsōzoku* there are two ways you go," says Shimodaira. "The really bad kids join the yakuza and the rest buy a sedan and go on to be mean-looking grown-ups. In the 70s and 80s, tinkering with bikes and cars was seen as a teenager's hobby, something to grow out of." In classic lowrider cars, Shimodaira found something that allowed him to continue his love of working with cars, without the stigma of being an overgrown child. "Lowriders were new to Japan at the time, and no one had seen cars with a hydraulic system for lowering and raising the chassis," he explains. "It was definitely not something you could dismiss as a kid's hobby."

Still, young as he was then, he and his friends were only able to afford Japanese cars and do them up in the style of American cars. "My friends and I, we talked about going to America all the time to see the real lowriders," Shimodaira says. "All of us had jobs at the time, but

**"Lowriders were new to Japan at the time, and no one had seen cars with a hydraulic system for lowering and raising the chassis. It was definitely not something you could dismiss as a kid's hobby."**

we had a plan. Since we knew that they usually cruised on Friday nights, we would get on a plane in the morning in Japan, arrive the same afternoon, go see the night cruise, jump on a plane back to Japan the next morning and go back to work on Monday." In the end, it didn't quite happen that way; over the course of planning the trip, the four friends decided to quit their jobs altogether and travel the United States for a month. "We saw different cars and places every

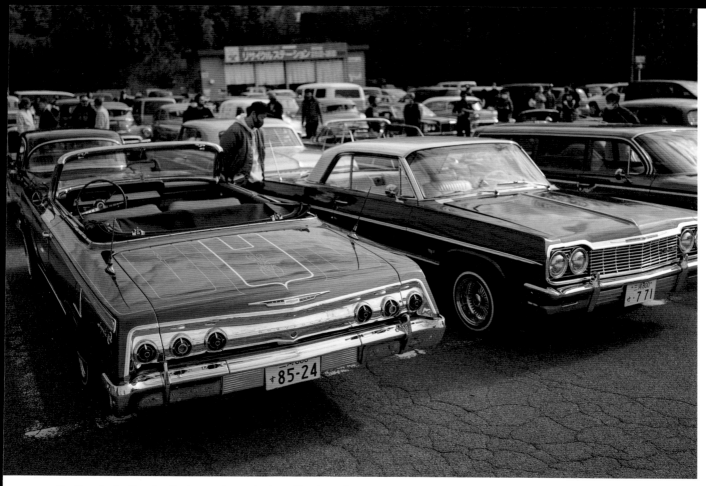

Top: Pancake Car Meet is a Sunday morning gathering of Amesha enthusiasts in Toyota city.
Bottom: Wada, a close friend of Shimodaira, drives his classic 1950 Chevy Fleetline.

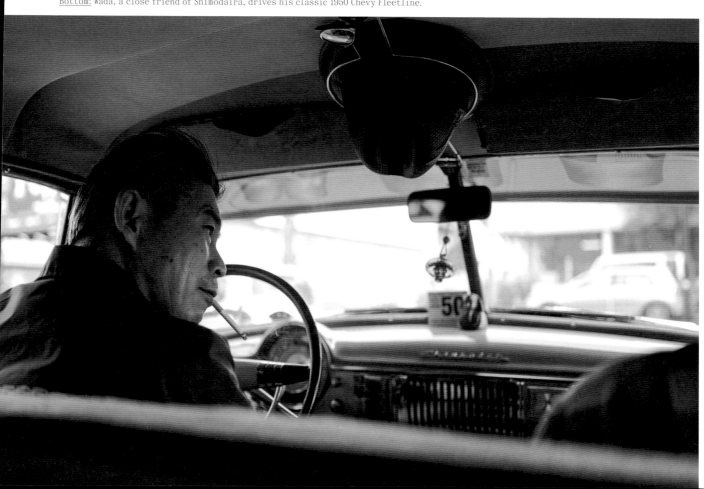

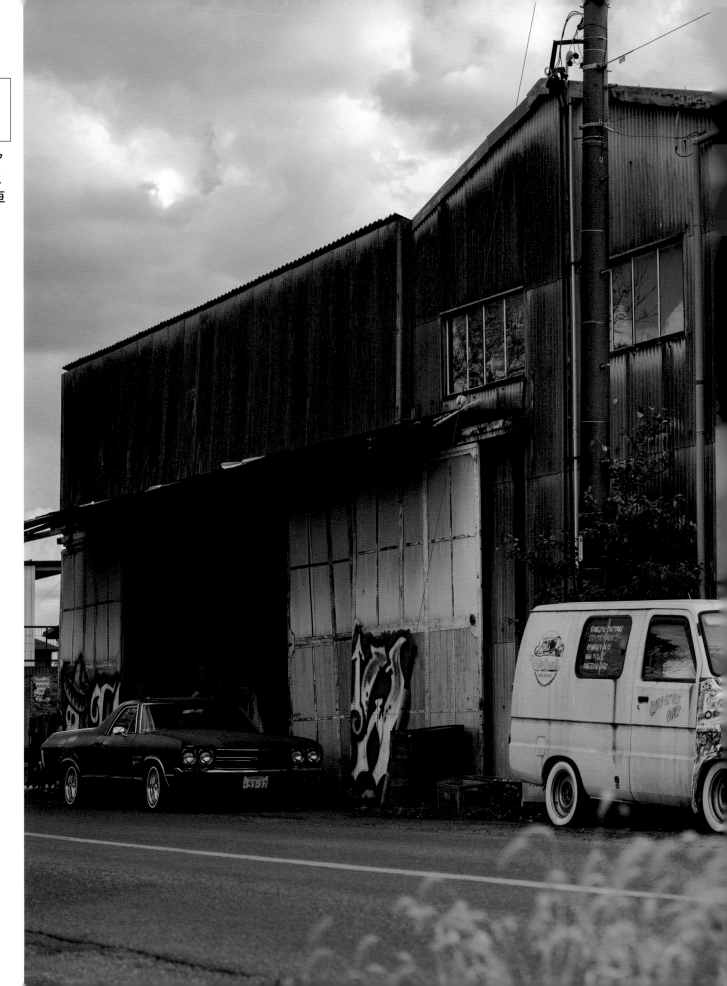

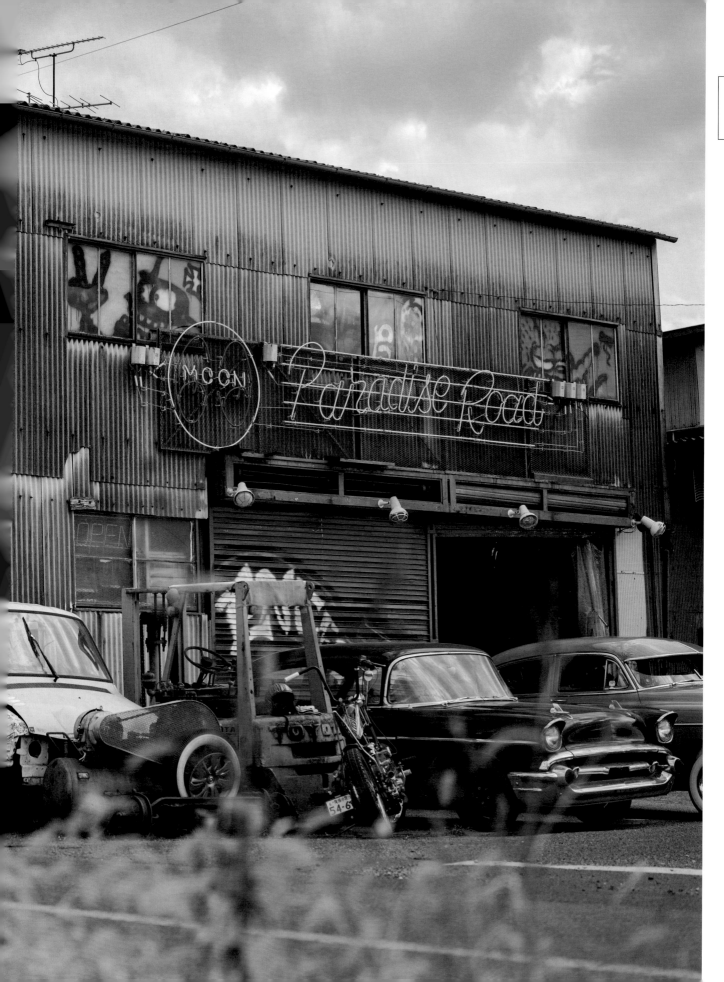

day," says Shimodaira. "It was a tremendous culture shock to me."

The trip proved to be a watershed moment in Shimodaira's career. Shortly after, he opened the original Paradise Road shop in downtown Nagoya, mainly selling Americana alongside some auto parts. "After that, we started getting gigs to customize cars and slowly became a workshop." Then came 1987, the

**"Lowriders are the entry point to Amesha culture. After that, if they want more, they get into hot rodding and end up here."**

year of the very first Japan Street Car Nationals, an event organized by Mooneyes, the most prominent workshop in Greater Tokyo. "There was no internet back then, but somehow everyone from around Japan showed up," says Shimodaira. "It was amazing to see people with the same passion gathering in the same place."

Across town in another garage called Arts Body, a former patron of Paradise Road is getting one of his cars looked at. The customer, Tetsu, was referred to Arts Body by Shimodaira some years ago and bought a hot-rodded 1931 Ford Type A on the spot. Since then, he has become a regular patron of Arts Body, which specializes more in hot rods than lowriders. "Lowriders are the entry point to Amesha culture," says Deguchi Shingo, the general manager of Arts Body. "After that, if they want more, they get into hot rodding and end up here." In general, most of the cars the Arts Body team works on are quite old, some going back to the 1920s, including Tetsu's current car, a 1929 Ford Type A that has had a Chevy 350 small block V8 dropped into it. It's an extremely expensive hobby, but as Deguchi says, once you're in, you're stuck. "My first Amesha came from an acquaintance that needed to disappear for a bit to escape from debtors," says

Deguchi. "He called me up and told me that if I could get cash together, he would sell me the car for real cheap, but it had to be that night. So I got the money together, and that's how I bought my first American car in an Aeon parking lot at 6:00 a.m.," he recalls. "A lot of us just kind of end up in this world, but down in Nagoya, it's very chill. Everybody knows everybody."

There is no disputing the fact that Shimodaira's Paradise Road is first amongst equals in Nagoya's Amesha scene, however. Of his many previous projects, Shimodaira's pièce de résistance, the Galaxian, is known worldwide in custom-car circles. Starting with a 1927 Ford Model T Roadster, he rebuilt the frame and paneling using hand-formed metal and tubing to have a low, sleek profile. Combined with furry upholstery, a wavy front grille, and a gold-speckled paint job, the Galaxian is a head-turning throwback to the psychedelic 60s, and a unique melding of L.A.-lowrider and hot-rod styles. Visitors to Paradise Road can see the legendary car occupying a corner of the garage, and it is clear to anyone who knows Shimodaira that the Galaxian is a mirror of his exuberant and quirky personality.

**"There was no internet back then, but somehow everyone from around Japan showed up. It was amazing to see people with the same passion gathering in the same place."**

"I don't think I have developed a personal style," says Shimodaira. "I just want it to stand out. And for that, you have to blend yourself with creativity." As for the future, after a lifetime of customizing cars, Shimodaira is ready to enjoy the fruits of his achievements by taking time to drive them: "I want to drive up and down Japan, barbecue with my car-club friends, and basically enjoy life now."

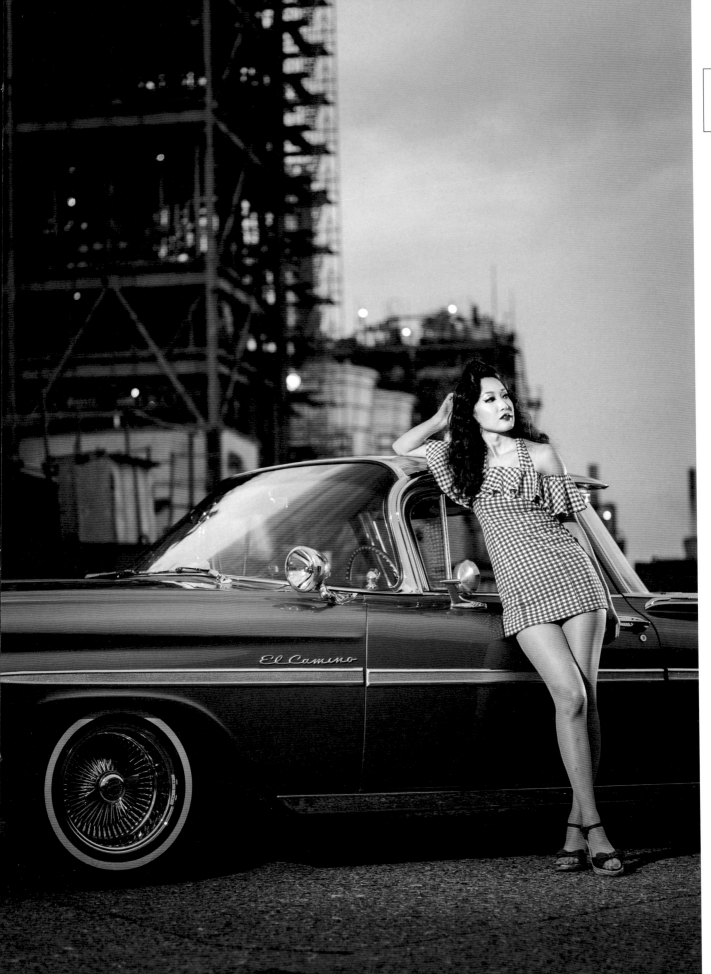

The rise of cute and girlish men
in fashion and digital subculture.

# OTOKO NO KO

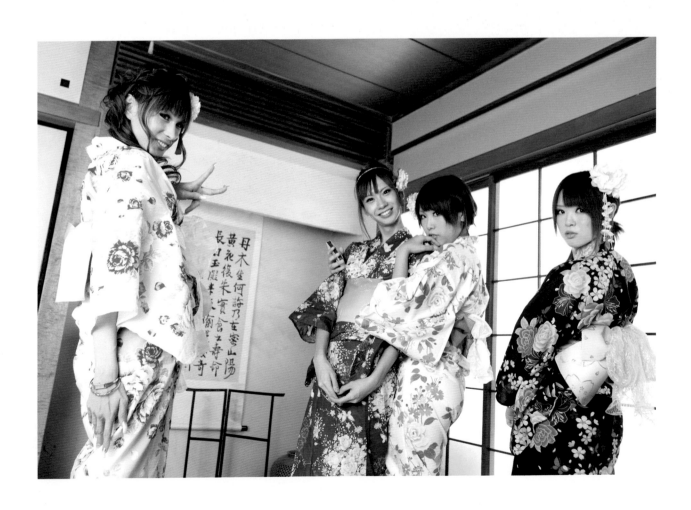

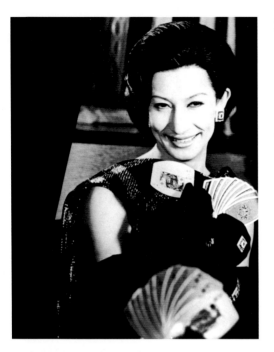

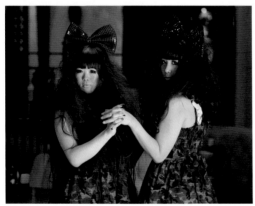

Top: Miwa Akihiro started out singing French chansons and doing cabaret in Tokyo's Ginza district in the 1960s. Bottom: *Otoko no ko* at play in the city. Opposite page: *Otoko no ko* provocateurs Sachiko, Kapinosuke, Chazuke, and Airi captured in cooling summer yukata.

In the twenty-first century, male to female cross-dressing (*josō*) has flourished in Japanese subcultures, becoming one of the most irreverent activities of nonconformist boys, rooted in cosplay, manga, and computer games. It has also been adopted into the heart of mass-media entertainment, modeled by stars from the late singer and comedian Yakkun to the boy band SMAP, resulting in advertising, television, and pop music that became distinctly girlish and camped-up from the mid-2010s onward. The name linked to the new mode of cute and girlish crossdresser is *otoko no ko*: a term that first appeared in 2006, in the amateur manga fanzine *Otoko no Ko COS\*H*, and which quickly spread from *moe* characters to live subcultures.

The stylistic sources of the *otoko no ko* are the *shōjo* aesthetic of frilly cuteness (*kawairashisa*) in fashion and girls' manga, and a male borrowing and interest in these innocent and girlish looks, which can be traced back through a long history of voyeuristic fascination with girls-only shōjo culture in the twentieth century. But the cute and animation-character look of otoko no ko is quite distinct from the femme-fatale postures of postwar cross-dressers such as the dramatic, languorous chanson singer Miwa Akihiro. Manga critic Nagayama Kaoru has suggested that two key manga genres form the roots of the "boy disguised as girl" tales of contemporary otoko no ko manga: Firstly, the many cross-dressed and hermaphrodite hero/ines created by Tezuka Osamu in the late 1940s and 1950s, which became the staple reading matter of children hungry for stories in the immediate postwar years and cultivated a norm of gender-ambivalence. Secondly, the Boys Love genre of girls' manga, first developed in the 1970s. Featuring beautiful, effeminate male youth in homoerotic romances, these stories have had a powerful crossover influence in the male manga imagination. The *shotakon* subgenre of girls' manga homoerotica that proliferated from the late 1990s, featuring a cute, junior boy coupled with an older, dominant boy, enabled a feminized and erotically charged "cute-little-boy" character to also crossover into boys' manga and computer games. As male readers consumed *shotakon* manga, a certain amount of homophobic resistance to same-sex love and cross-dressed boys eroded, creating a new tolerance for gender experimentation.

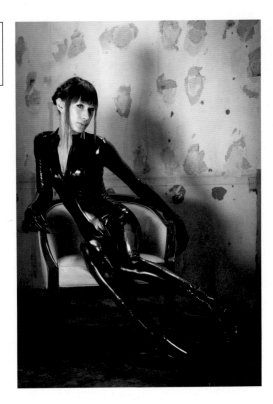

Chazuke, *otoko no ko* model and founder of Newtype, an *otoko no ko* bar and café.

A surge of "cross-dress youth" manga series became successful even in high-circulation and macho "boys'" magazines. One of the most popular was titled *Yubisaki Milk Tea* (2003-2010), serialized in *Young Animal*. The 2008 cosplay photography book *I Wanna Be a Girl!*, depicting young men in cosplay as cross-dress or girl characters, signaled a grassroots fascination spreading far wider than earlier niche readerships. Around 2010, cute otoko no ko characters, visually identical to *bishōjo* (beautiful girl) characters, moved via cosplay from 2D to 3D live fashion, makeup, and video-upload culture. On university campuses a wave of cross-dressing rock bands and *Misuta Bishōjo* (Mr. Cutie Girl) beauty and parody song contests raged, bringing otoko no ko into male university student culture.

Otoko no ko, most at home in the otaku culture and tolerance zone of Tokyo's Akihabara district, have distanced themselves from the sexual identity culture of gay, *nyū hāfu* (transgender), and the cross-dressing, based in Tokyo's Shinjuku Ni-chome area. Oshima Kaoru is a josō talent associated with the inner circle of otoko no ko and the first of a new generation of male AV *joyū* (adult video actresses) not required to undergo surgery or physical transition to act as a woman. With a cute face and full hairstyle coiffed in the mode of an animated shōjo character, Oshima also retains a masculine voice and speech. He is straightforward about stating that he is a man and has no gender identity disorder, nor does he feel that he can be categorized as transgender. Instead, he underlines the distance between otoko no ko like himself and earlier generations of cross-dressing minorities: "It isn't rooted in the two-dimensional world, and I wanted to become the physical embodiment of that difference in otoko no ko."

The young actor and band member Akutsu Shintarō also claims to find it difficult to locate a category for his *ikemen* (good-looking) cute style. He is not gay, and he feels the term cross-dresser (*josōka*) suggests a fetish for women's clothes to which he cannot relate. Akutsu rails against people who ask him if he wants to look like a girl: "For us," he says, "cuteness is the highest priority"–which is not the same as wanting to look like a girl. Cosplay researcher Tanaka Toko suggests that rather than being interested in becoming

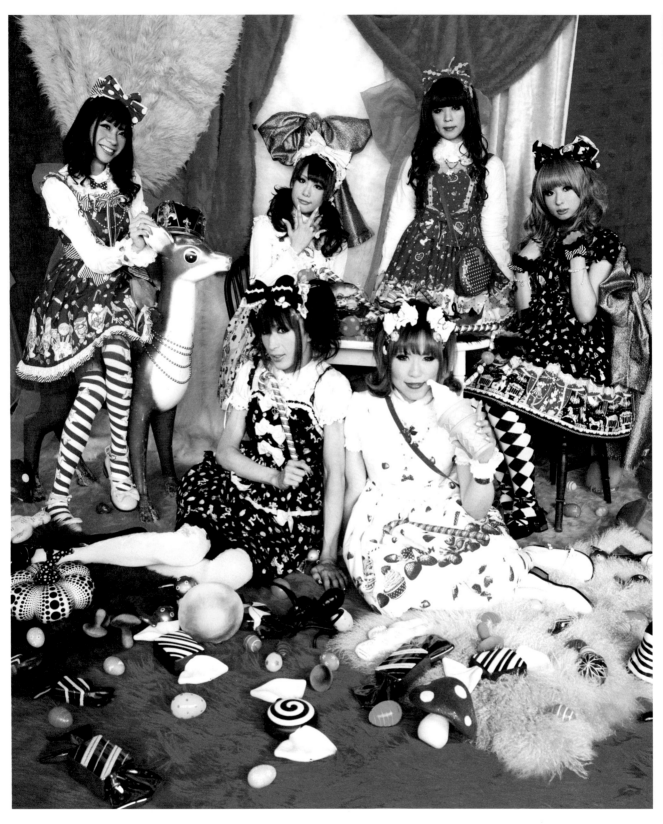

Café boss Chazuke with Newtype waitresses, shot by Ninagawa Mika for her 2015 photography book *Tokyo Innocence*. The collection captured the evolving world of cross-dressing cosplay as it rose to prominence in the 2010s.

オトコの娘

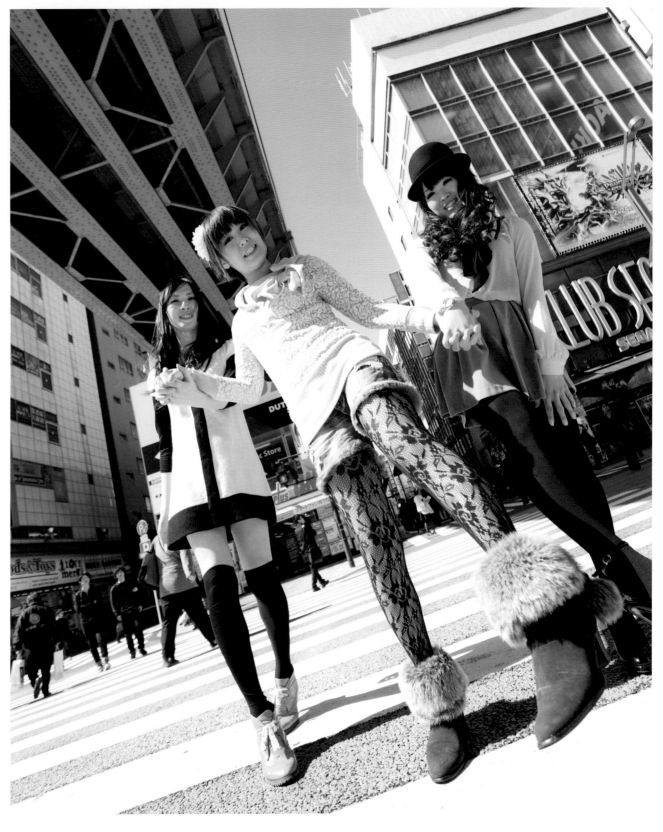

*Otoko no ko* standing out in the city.

KYOTO
手塚治虫ワールド

©Tezuka Productions

Top: Newtype waitress Kapinosuke, taken from *Meme Danshi* (*Female Men*, 2011). Bottom: Manga artist Tezuka Osamu created many cross-dressed and hermaphrodite hero/ines in the late 1940s and 1950s.

a different gender, the primary goal of otoko no ko has been aesthetic transformation–using makeup, girlish clothes, and cute accessories, otoko no ko enthusiasts transform themselves into what they consider more youthful, appealing, and desirable personas.

Cosmetics are a central feature of otoko no ko culture. The 2015 *Complete Josō Manual* has become a contemporary classic, focusing on tutorials for cosplay and new wave cross-dressing. In 2009, the not-quite-mainstream Tokyo Cosme Boy beauty contest for "beautiful boys" was launched, inviting teenage and college boys who fancied their chances to appearas contestants in its annual competitions through the 2010s. One Cosme Boy host was the (then named) Igarashi Nanami, the son of manga artist Igarashi Yumiko, famous for her drawing of the iconic 1970s cute girls' manga *Candy Candy*. Other teenage boys, mostly high-school students, attempted to pass as cute young girls on several different prime-time variety shows. Slots such as "Cross-Dress Paradise," a regular section of the hugely popular TBS variety show *Gakko e Ikkō!* (Let's Go to School!), aired around the same time otoko no ko emerged in manga and cosplay in 2008-2009.

While some participants have viewed otoko no ko as mainly "straight" and emerging out of two-dimensional culture, others have borrowed otoko no ko as a positive term to replace the pejorative, much-despised term *okama* ("bent") with which both gay men and cross-dressers have been labeled. The porn-publishing industry in Tokyo has also been keen to anchor a positive new non-heterosexuality in otoko no ko as a mechanism to overcome the earlier stigma associated with gay and cross-dress culture. Despite this, the sexuality or gender identity of these appealing boys has continued to elude definition: otoko no ko fashion and play blurring girlish and masculine traits has remained defiantly post-category.

**Sharon Kinsella** is a researcher and theorist of gendered subcultures and visual cultural production in Japan. She has worked on the politics, history, and social relations of *kawaii*, *otakuism*, *gyaru*, and the schoolgirl symbol. She is the author of *Schoolgirls, Money and Rebellion in Japan* (2014) and *Cuteness, Jōso, and the Need to Appeal: Otoko no ko in Male Subculture in 2010s Japan* (2019).

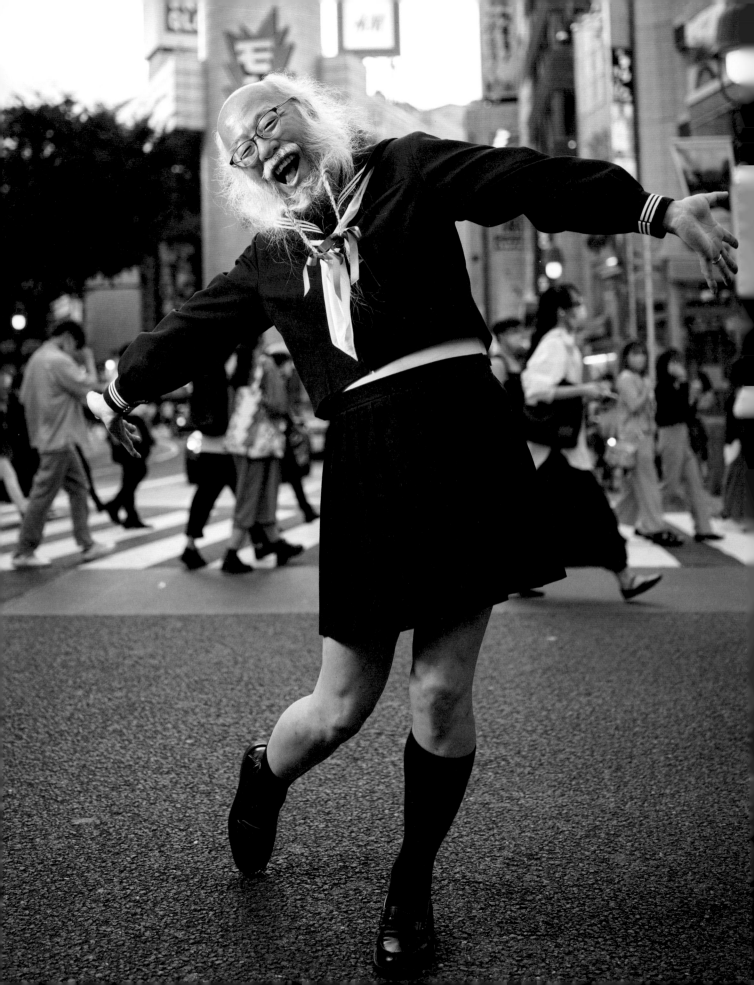

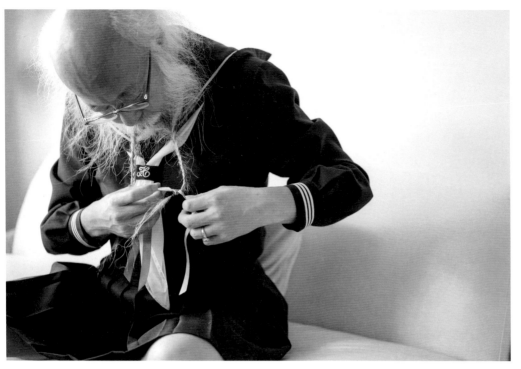

Above: It takes Grow Hair about an hour to "transform" into his schoolgirl persona. Opposite page: Grow Hair in the middle of Shibuya Scramble Crossing, moments before being swamped with requests for selfies.

## GROW HAIR

A ramen-shop dare that created
an international cute icon.

One of the rarest sightings one can have in the jungle of Tokyo is a silver-bearded old man dressed in a schoolgirl's sailor uniform. Tourists lucky enough to sight him can brag that they have seen the legendary Grow Hair, or Sailor Uniform Grandpa, a mythical figure in the kawaii fashion world.

Grow Hair, aka Kobayashi Hideaki, is 58 at the time of writing, and it was only in the last decade that he began dressing in a schoolgirl uniform. "I was always jealous of the cute frilly things girls could wear," he says. As a child, Kobayashi would swipe the hair accessories of girl classmates and wear them throughout the day, to his teachers' good-natured amusement. "Of course, I didn't have the courage to wear girl's clothing myself, except around friends as kind of a joke." The turning point came when a friend told him that a ramen shop was holding a campaign where anyone over 30 who wore a sailor uniform to the shop would get a free bowl of ramen. "I thought, at last! I finally have a reason to go outside wearing the uniform." Despite having the excuse ready in case anyone gave him a hard time, not a single person commented on Kobayashi the entire trip. "That was when I decided to see how far I could get with this thing."

He and his sailor suit have since been invited as guests of honor to Japanese cultural conventions in countries including China, France, and Russia, and his status as an unlikely ambassador of kawaii culture has landed him in documentaries for CNN and Vice. "I'm just a regular old guy who likes dressing up cute," he says. "And that's all it took for me to become famous."

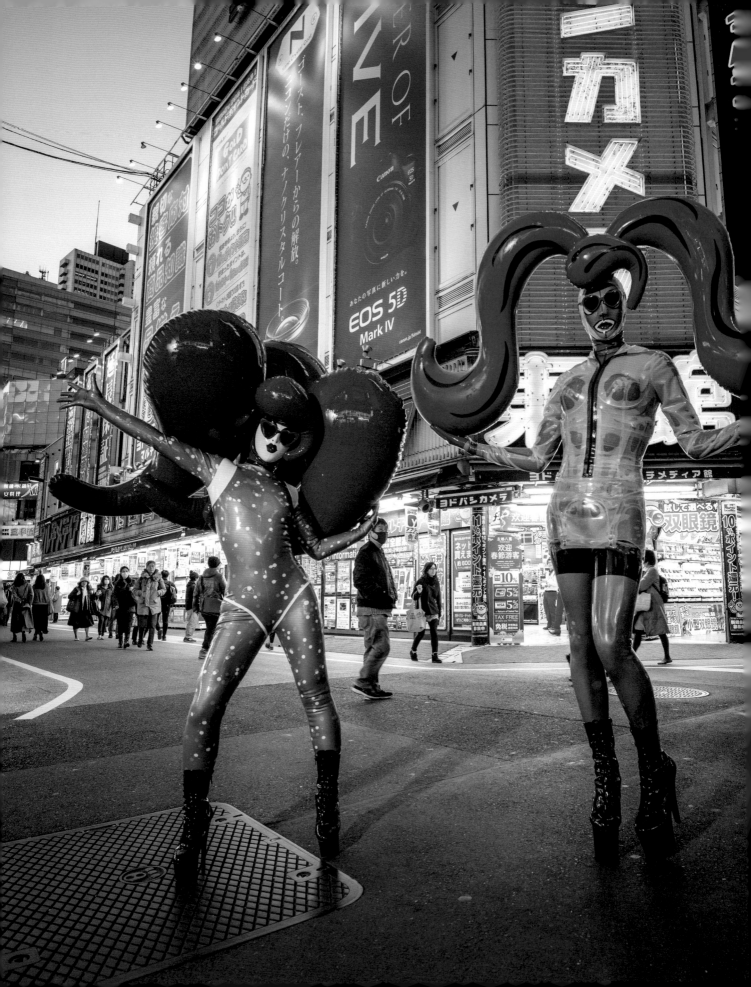

Hinako and Chrissie
Seams wearing Feitico
and Rubber Moscow,
styled by Kid'O.

## KURAGE

Latex is usually associated with fetish fashion,
but Kurage turns it into art.

Kid'O, the creator of latex brand Kurage, has an
interesting perspective on his label. "Kurage is like
a spaceship going out to uncharted territories," he
says. "Every now and then, however, we have to take a
detour to fix our ship or get supplies. Once that's done,
our journey begins anew." The journey is ostensibly the
path Kid'O is continuously charting through the fetish
latex world. Having already caused seismic shifts
in the way latex is considered as a medium for high
fashion, Kid'O is still searching on a personal journey
to his own vision of latex utopia.

"There is no one else in the latex world who comes
close to him," says Saeborg, a performing artist who is
known for her latex inflatable pig costume—made, of
course, by Kid'O. "When I first started out, I got Kid'O to
make all my costumes. I've been accused of monopolizing
his time by his other clients," she laughs.

Kurage's latex outfits are all handmade in Kid'O's
Tokyo atelier, each piece painstakingly cut and glued
into intricate designs. "Latex is a medium that can
express everything," he says. "It can be sexy or cute,
gothic or futuristic. It frees me to create my vision."
Besides latex, Kid'O has also incorporated other
materials into his designs, including upcycled bus
and car tires. One hallmark of Kid'O's designs is the
face hood that often lacks a mouth and emphasizes
the eyes. He traces this back to *Galaxy Express 999*, an
anime he watched as a kid, which features a blonde cyborg
woman with barely a line for a mouth and gigantic eyes.
"That was the first time I felt adult attraction for any-
thing. I guess my fetish is eyes."

Kurage and Kid'O have gained a cult following for
the lavish shows he has put on throughout the world,
while breaking new ground in what is possible with
latex and rubber fashion. He has designed costumes for
superstars in the Japanese entertainment industry
including Utada Hikaru, AKB48, and Kyary Pamyu Pamyu.
Who knows where his spaceship will take him next?

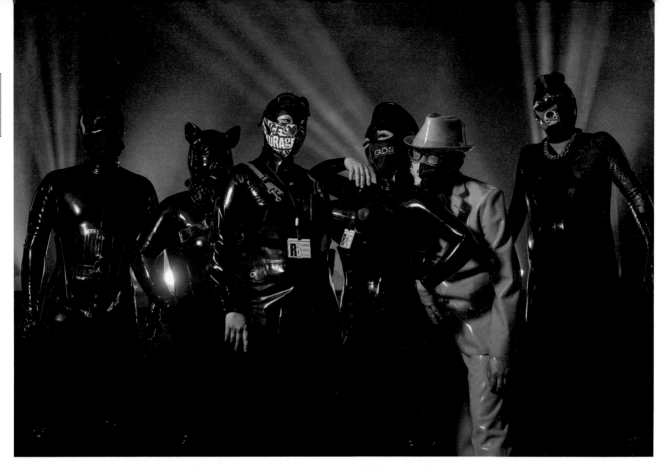

Top: A group of rubberists at Department H, Tokyo's premier FetLife event. Below: Kid'0's versatility and creativity have brought him international recognition. Opposite page: Performance artist Saeborg in her signature pig outfit made by Kid'0.

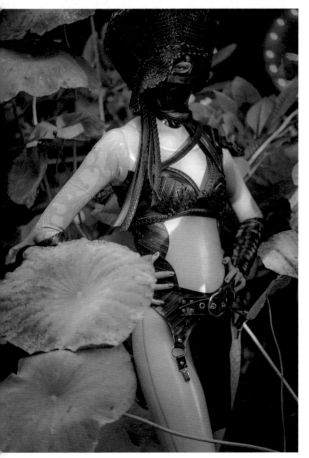

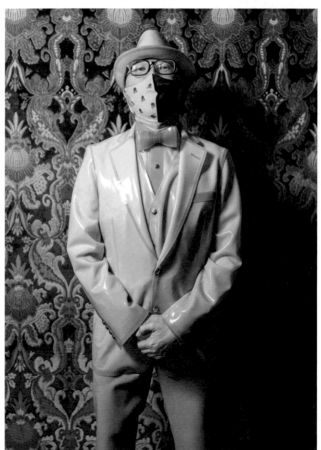

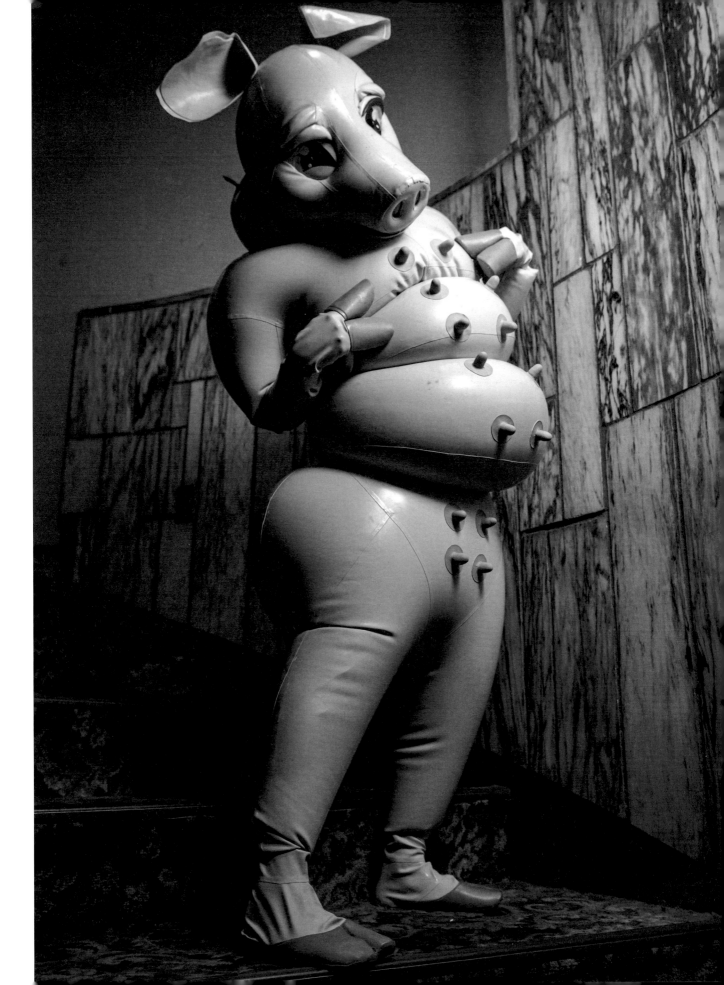

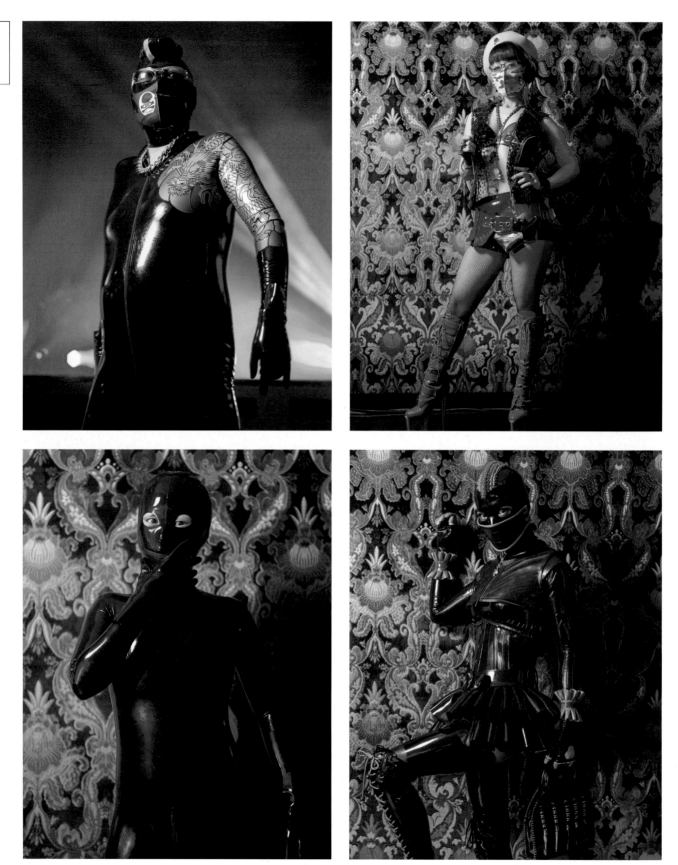

This page and opposite: Department H runs once a month and is open to any subculture, or even to those just curious to take a look.

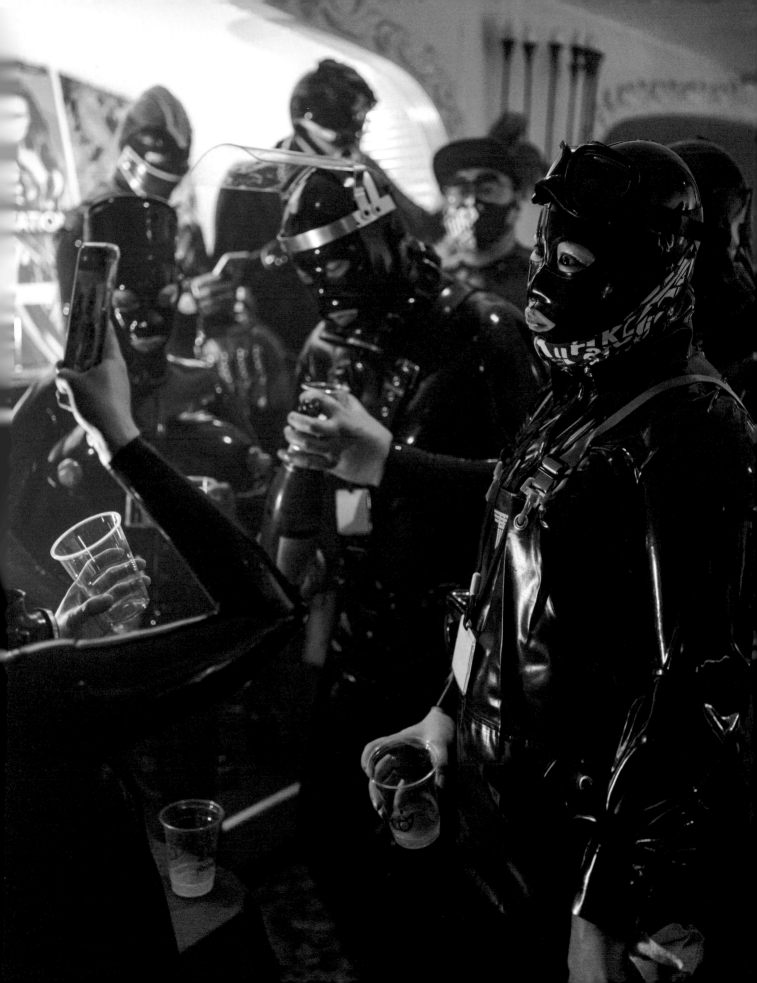

# DECORA FASHION

Playful, brightly hued, and accessory
heavy, decora fashion rose to
prominence in late-90s Harajuku.

"It's kawaii anarchy," says Chami, a colorfully dressed girl who works at the Harajuku store 6% DokiDoki. Looking at exponents of *decora*, the description is absolutely spot on. Characterized almost entirely by a riot of bright, vivid colors and an outlandish arrangement of rings, stickers, hairpieces, Band-Aids, and every accessory in between, decora has become one of the emblematic offshoots of Harajuku's fashion explosion of the 1990s. The store 6% DokiDoki, established in 1995, is one of several shops in the area selling cute decora goods, but with its 27-year pedigree, it is one of the oldest in the area.

"It's kind of like a Harajuku *shinise*," laughs general manager Yoshida-san, using a term that refers to Japanese businesses with over 100 years of history. Trends rise and fall so fast in Harajuku that boutiques come and go with regularity. Not so with the decora trend, which has stood the test of time and become one of Harajuku's iconic fashions.

Junnyan is a male decora fashionista, relatively rare in a world where the overly cutesy style associated with the look is usually associated with female clothing. "In the 1990s, there was a pedestrian area in Harajuku that was closed off to cars. Trendy young people would gather there

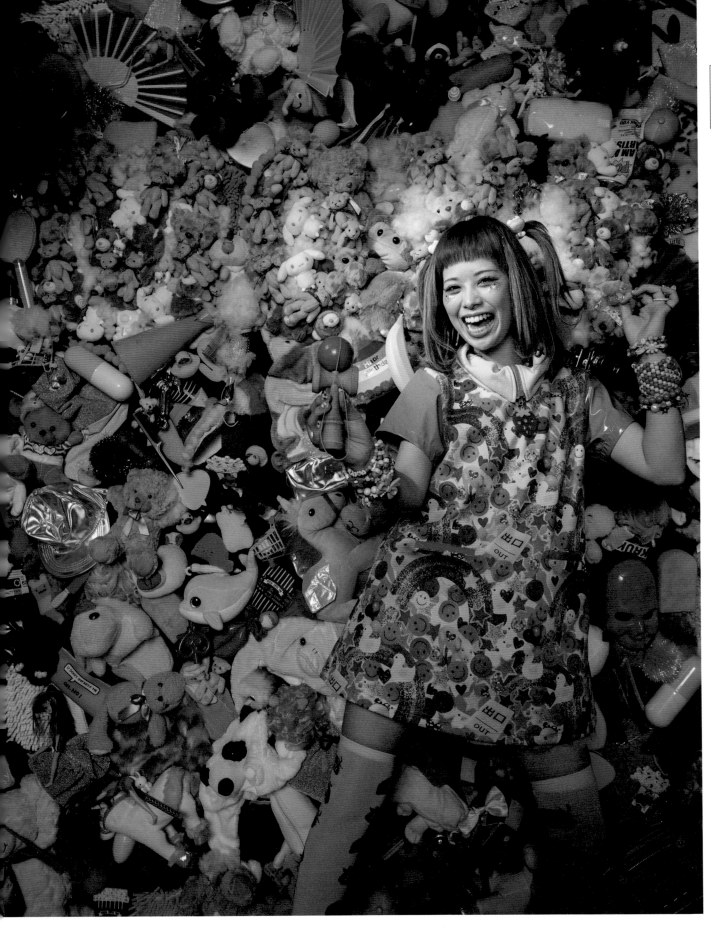

Kurebayashi poses with a kendama at an installation in MOXY, a trendy hotel in east Tokyo.

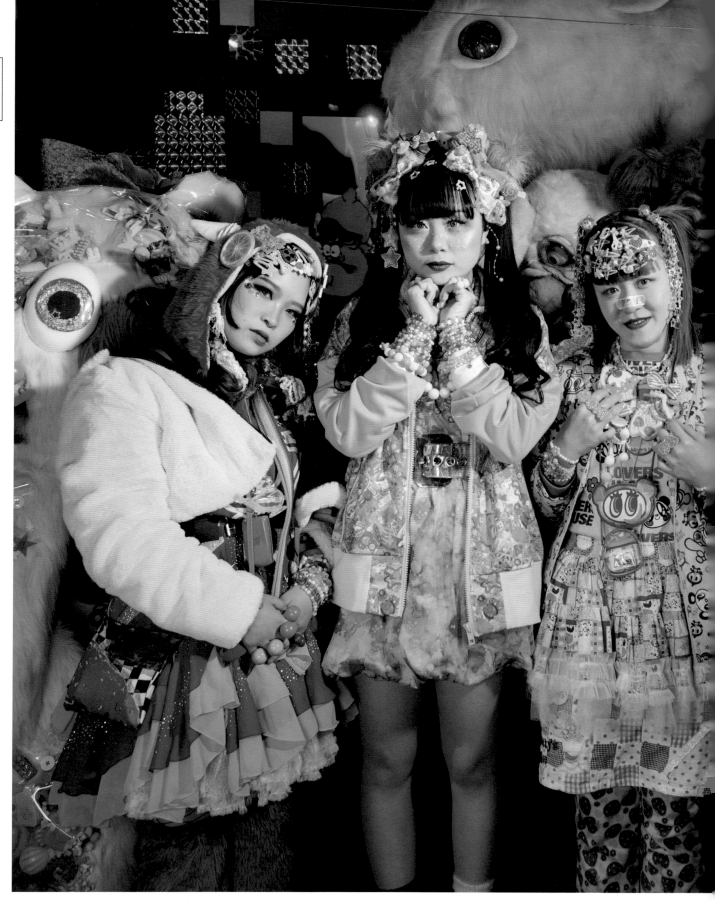

Purin, Chami, and Chii pose inside 6％DokiDoki, a Harajuku store devoted to all things decora.

regularly and began to silently compete with each other to gain prestige. It became kind of like the Galapagos Islands of fashion evolution." He is alluding to a Japanese business concept in which ideas or products undergo divergent and strange evolutions in an isolated environment.

**"Originally every decora accessory had to be handmade or assembled out of other pieces. At the start, there wasn't really a name for it; it had kind of come out of nowhere."**

This phenomenon is particularly relevant in an island country with a history of innovators and iconoclasts who have reformed entire industries when their inventions were unleashed upon the world. Technology giants Sony and Nintendo, for example, revolutionized personal and home electronics with their star products the Walkman and NES, with little input from the outside world. The 1990s in Harajuku is the fashion analog to this status-quo-breaking behavior, attracting all sorts of stylish characters eager to outdo each other in their quest to be noticed. This 1.4-mile (2.3-kilometer) stretch of road, affectionately known as *hokoten* (short for *hokousha tengoku*, Japanese for "pedestrian paradise") was a fertile bed from which sprang many of the distinctive fashions that Harajuku is known for today, from rockabilly to Lolita to decora. In 1998, the beloved hokoten was closed down, and a centralized place for the Harajuku fashion community to see and be seen has not been established since.

"Originally every decora accessory had to be handmade or assembled out of other pieces," says Junnyan. "At the start, there wasn't really a name for it; it had kind of come out of nowhere." The style began to be featured regularly in popular street fashion magazines like *FRUiTS* and was christened decora, short for "decorative," or, translated from the Japanese, *soushoku kajou*–over-decorated. Junnyan muses that the popular singer Shinohara Tomoe, known to her fans as Shinora, may have had some impact in popularizing the decora style, which was her signature look onstage. Specialty boutiques such as 6% DokiDoki also played a key role, enabling decora fashionistas to mix and match their accessories with greater freedom.

6% DokiDoki was established by artist Masuda Sebastien as an avenue to pursue his "sensational kawaii" concept of fashion. Chami remembers being irresistibly drawn to the colors and shapes in Masuda's art, which she discovered after moving to Tokyo from Yamanashi to attend Tama Art University. "His way of seeing things

**"It was amazing to see such seemingly random combinations of almost every color and shape and texture on paper, and still have it look harmonious. I wanted to become that."**

changed my entire life," she says. "It was amazing to see such seemingly random combinations of almost every color and shape and texture on paper, and still have it look harmonious. I wanted to become that," she laughs. Masuda's influence on kawaii

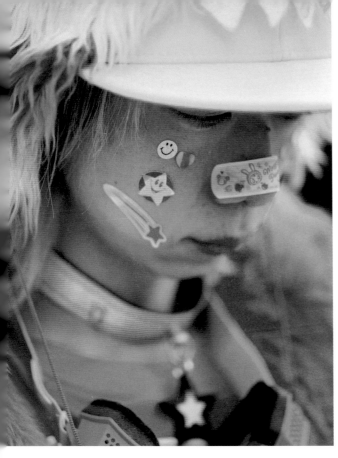
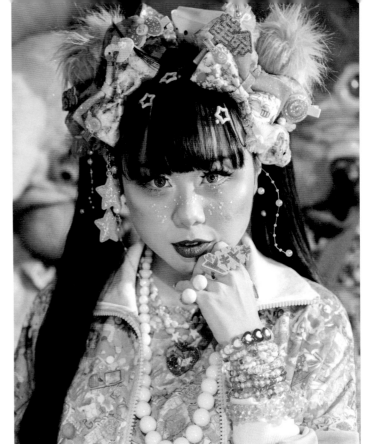
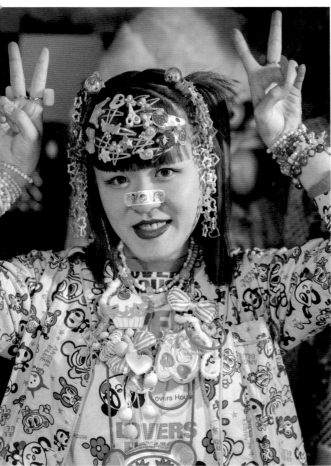
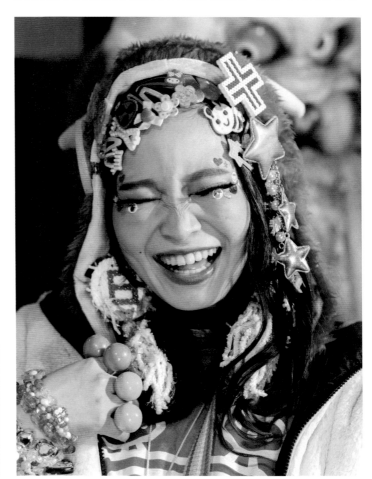

One of the hallmarks of decora is the attention to detail—the more you look, the more you see.

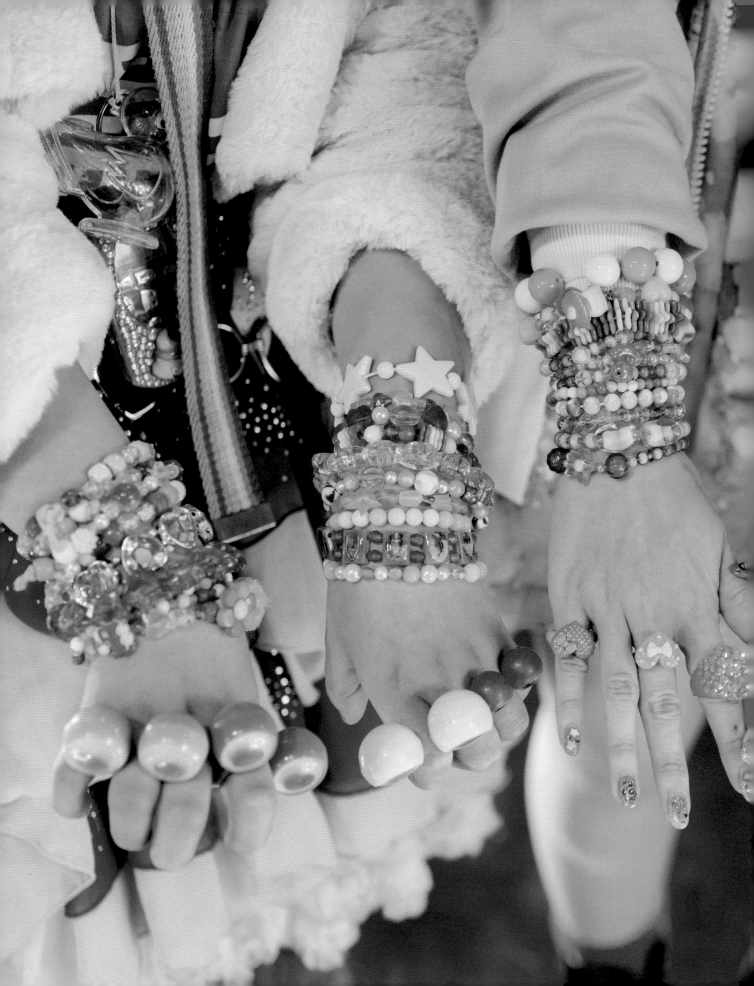

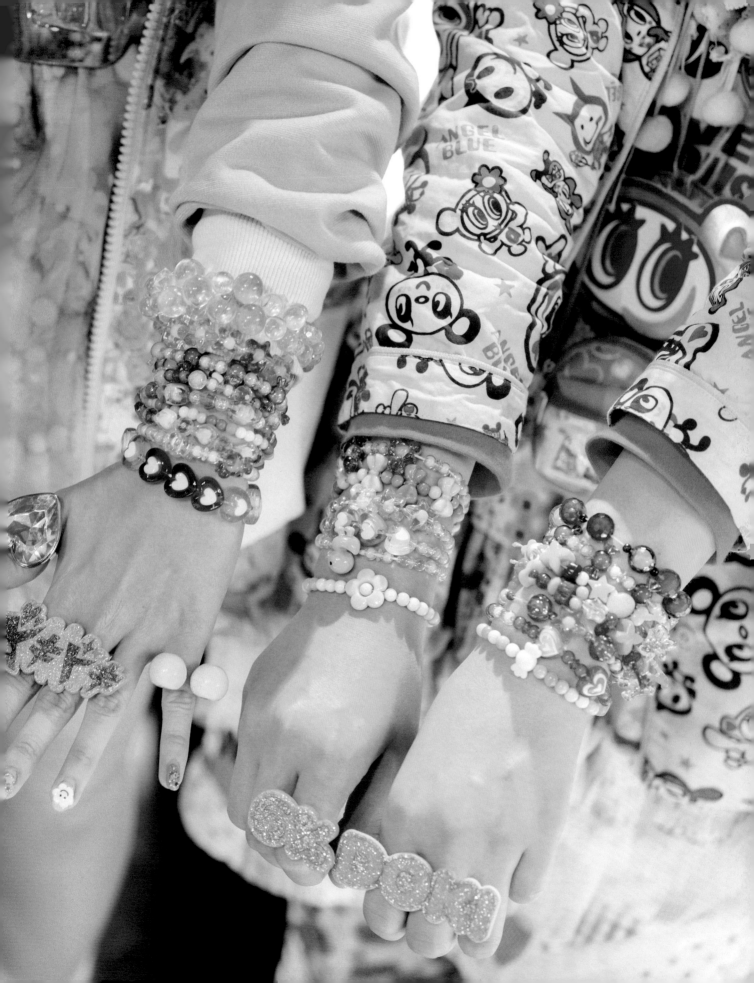

culture during the late-90s time is incalculable, and his style directly influenced the rise of *aomojikei*, a Japanese term with no easy English translation.

**"It's like how wearing a superhero costume makes you feel stronger and more confident. Wearing this fashion helps people be free from themselves in a way."**

It refers to casual, creative fashion that cares more about pleasing oneself than others, particularly the opposite sex. The many *aomojikei* magazines that populated the Harajuku fashion landscape at that time, such as *Zipper* and later *Kera*, were instrumental in turning Chami's friends into decora fanatics. One of these friends, Chii, recalls reading *Kera* magazine in junior high school and saving up money to spend in Harajuku boutiques that were featured in its pages. Another friend, Purin, also lists *Kera* as an inspiration, saying she drifted over to decora from gal fashion—the two styles borrow elements from each other.

Kurebayashi Haruka is one of the most famous models to appear in *Kera* magazine. Today, she is a decora fashion icon with a huge following, both domestic and international. "Fashion is the most visible part of your inner self," she says, striking a philosophical tone. Born in the countryside of Shizuoka prefecture, she developed an interest in fashion through her grandmother's "very unique" clothing. After moving to Tokyo and finding work as a model for various *aomojikei* magazines,

she now has her own brand and produces major fashion events, inspiring hundreds of thousands of fashion-conscious youths to be less inhibited with their wardrobe choices. "I want to let people know that being able to accept and compliment each other's fashion culture is a sign of an inclusive, diverse world," she says. "At the same time, it doesn't matter who you please, as long as you are doing it for your own enjoyment."

Junnyan also has a thoughtful explanation for how he ended up being a prominent decora exponent. "In some ways, you could say it was destiny," he explains. "I didn't set out with an incredible interest in this. In many ways, I ended up here through trial and error, trying to find something that would help me be more at

**"People have asked what fashion means to me hundreds of times. I'm not following a fashion trend. This clothing–this is normal. This is natural for me."**

peace within myself." Junnyan goes on to draw a comparison with cosplay. "It's like how wearing a superhero costume makes you feel stronger and more confident. Wearing this fashion, even though it may be more time-consuming, helps people be free from themselves in a way."

"People have asked what fashion means to me hundreds of times, and I always have trouble answering that question," Chami says. "I'm not following a fashion trend. This clothing–this is normal. This is natural for me."

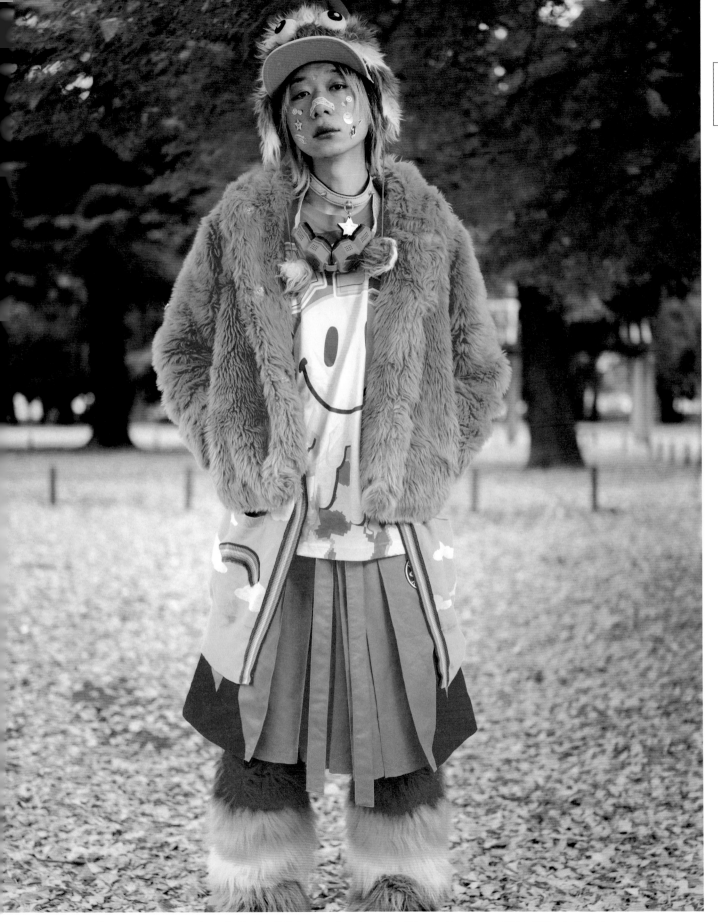

junnyan69's Instagram account Harajuku Fashion Walk is a popular chronicle of the creative energy still bubbling in Harajuku.

The style tribes that made Tokyo
street fashion world famous.

# A STROLL DOWN MEMORY LANE IN HARAJUKU

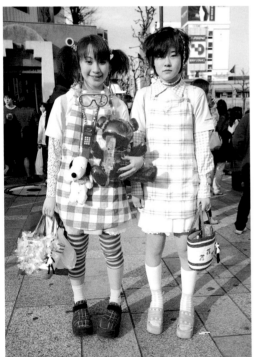

Japanese street-style magazine *FRUiTS* helped bring the fresh and flamboyant aesthetic of Harajuku youth culture to the world stage.

It's a sunny Sunday in Tokyo in the 1990s. Omotesando, Harajuku's main thoroughfare, is closed to traffic and the wide lanes, empty of cars, are instead dotted with huddles of Japanese youths, squatting, standing, mingling, and chatting amidst the flow of pedestrians around them. Some slink away to shop, perhaps getting accosted on the way to have their photo taken for a magazine. Others arrive back with purchases from underground emporia. These young people are all strikingly attired, eccentrically even, especially to Western sensibilities. There seems to be no common thread or aesthetic to their outfits: a cyber samurai here, a grungy goth there … This snapshot conjures a brief glimpse of what was arguably the apex of Japan's rich and diverse history of street fashion: late-90s Harajuku.

The scene was famously documented by the monthly magazine *FRUiTS* (from 1997) and later *Tune* (which exclusively features men's street style). The diversity and originality of the looks found in their pages quickly garnered a following and were collected into books that sold around the world. Harajuku street style peaked in the global mainstream with Gwen Stefani's 2004 solo album *Love. Angel. Music. Baby.*, which featured four Japanese and Japanese-American backup dancers dubbed the Harajuku Girls. Stefani also launched a clothing and perfume line titled Harajuku Lovers.

How did 90s Harajuku incubate one of the most creative style scenes in the world, one that drew top international designers keen to co-opt a street cred unlike anything that could be found in Europe or the United States? A combination of the history of Harajuku, Japan's twentieth-century sartorial and economic history, and the physical and social space that turned the area into a pedestrian paradise (*hokoten*) every weekend from 1977 to 1998 created ideal conditions for an already bubbling street style to reach boiling point.

Street geography plays a crucial role in styles that don't trickle down from the global fashion industry—from catwalks, magazines, brands—but bubble up from young bricoleurs, whose antiestablishment attitudes lead them to create looks outside of the mainstream. When youth reject the rat-race career track and hang out on the street instead, their outlaw attitude and the desire to signal it can give rise to diverse and inventive street

Top: Modern girls were Japan's equivalent of America's flappers. They were depicted as living in cities, being financially and emotionally independent, and choosing their own suitors. Bottom: During the 1920s, women following westernized fashions and emancipated lifestyles were known as "modern girls" (mago).

styles. Harajuku from the 90s to the early 2000s may be the most famous example of Japanese street style—but even Harajuku's rich cornucopia of street fashion has been dampened since the start of the new millennium by the onslaught of international fast fashion and malls full of faceless chain stores. Whether the heyday of Japanese fashion is behind us remains to be seen.

### The development of street style in Tokyo.

The sartorial expression of Japan's early fashion tribes, or *zoku*, often provoked public outcry. They marked the first of an explosion of Tokyo street styles, some ephemeral, some tribal or subcultural, which reached its peak in the 1990s.

The earliest such tribes in Tokyo were the *moga* and *mobo*, or "modern girls" and "modern boys" who shocked a somber interwar Japan with their flaunting of bodies and conspicuous consumerism on the streets of Ginza in the 1920s. These young people were the first to play with and enjoy the relatively new Western clothes that had arrived toward the end of the nineteenth century but had hitherto been largely the domain of Japanese royalty and high society. Japanese girls with bobs and 1920s flapper-style dresses promenaded the streets of Tokyo's Ginza shopping district at the weekend with their mobo companions, who kept their hair slicked back and parted. Together they frequented dance halls until their delinquent image led to the movement being targeted by police surveillance during the 1930s. When war broke out with the United States in 1941, dance halls were closed down completely.

But the moga kicked off Ginza's status as a fashion hotspot. They were succeeded in the mid-1960s by the *Miyuki-zoku* style tribe, who hung around Ginza's Miyuki street. They sported Ivy fashion, referencing the preppy look of Ivy League colleges: button-down shirts and Bermuda shorts with white socks for men and long skirts, sweaters, and scarves for women. Ginza has continued its fashion trajectory to become the swankiest retail district in Tokyo today, where international luxury brands and numerous department stores back onto alleys that still see kimono-clad hostesses shuffling to and from their exclusive clubs. Ginza is the spiritual Tokyo fashion home of the well-heeled (there is no smarter classic store than Wako on the famous Ginza 4-chome

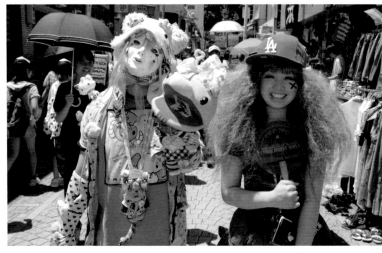

Left and right: Harajuku is known internationally as a center of Japanese youth culture and fashion.

intersection), although with its diversity of boutiques, including Comme des Garçons' Dover Street Market, which connects via walkway to a flagship Uniqlo, it is not only those with conservative tastes who flock there to shop.

While Ginza on the eastside of central Tokyo was the backdrop to somewhat chic youth fashion, Harajuku on the west fostered a more raucous, rebellious street-fashion scene. Harajuku was firmly put on the map as a trendy area in the 1960s: The postwar occupation residences and stores that popped up around them in Harajuku gave the area a flavor of the exotic. This atmosphere attracted young men, the so-called *Harajuku-zoku*, who would race their cars up and down the long Omotesando boulevard, a scene that peaked in 1965. The next group to really make their mark on Harajuku, from 1979 to 1981, were the *takenoko-zoku*, young people who would dance and socialize on the pedestrianized main boulevard. Their bright, shiny costumes, often in the shape of balloon-legged harem suits, were bought from a boutique called Takenoko (meaning bamboo shoot), from which the tribe got their name. In contrast, as the district of Aoyama developed into Harajuku's more sophisticated extension during the early 1980s, the dourly dressed *karasu-zoku* (crow tribe) sloped around the vicinity in their black, fashion-forward getups. While the *karasu-zoku* favored the designs of Yohji Yamamoto and Comme Des Garçons, who were making waves in the Paris collections, Harajuku was cementing its fashion status as the location for the "mansion makers"–designers who worked out of small apartments in Harajuku–and their role in the

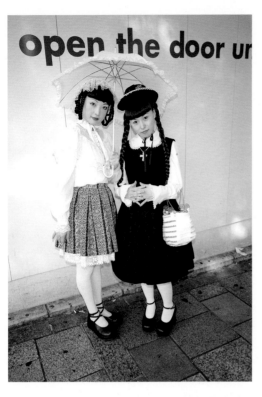

A pair of gothic Lolitas showcase a darker, Victorian-inspired aesthetic.

DC (designer and character) brand boom that peaked around 1986. Japanese fashion brands were gaining a cult following on an increasingly wide scale.

Harajuku in the 1990s brought its street style to international attention as outlaw tribes gave way to trendsetting fashion styles or *kei*. Nigo, the wunderkind behind A Bathing Ape and his mentor, DJ and designer Hiroshi Fujiwara, were early movers and shakers on the scene. In 1993, they launched Nowhere, a store in the backstreets of Harajuku (*Urahara*) that was instrumental in the formation of the spin on the American hip-hop/skater look that became known as *Urahara-kei*. At the same time, young Japanese fashionistas who saw fashion as a hobby and frequently an object of study or career too, started to congregate in the area, fueling the explosive street-fashion spectacle. At the top of Omotesando boulevard was another stylistic scene that firmly put Harajuku on the international fashion and tourist map: Lolita–girls in their mash-up of Little Bo-Peep bonnets and Victorian pannier skirts–would join cosplayers and fans of a spectacular gothic/rock music and style genre known as *visual-kei*, to hang out on the bridge near Harajuku Station in the mid-2000s. Laforet, the funky Harajuku department store that championed the DC-brand boom still has its basement devoted to punk, goth, and Lolita looks that constituted the visual-kei aesthetic.

Shibuya, the bigger, brasher shopping and commercial hub down the road from Harajuku has a street-style scene to rival that of its neighbor. It has been famous for the preppy *Shibukaji* American casual looks from as far back as 1988 and the formidable, fun-loving *gyaru* (gals) of the 1990s, who carried out their socializing in its fast-food restaurants or huddled on the thoroughfares outside. The gyaru–with their garish makeup, flirtatious fashions, dyed, coiffed hair, and bling accessories that included spectacularly adorned fingernails–and their attendant *gyaruo* (gal guys)–in their bouffant long hairstyles, skinny jeans, and pointy boots–quickly became so numerous and influential they reached into the mainstream, inspiring the fashion of kids throughout Japan. Subdivisions of gyaru range from the flirtatious, tanned *kogaru* (little gal) with her famous ruched white socks to the notorious, deeply tanned *ganguro* and the white-haired, panda-eyed

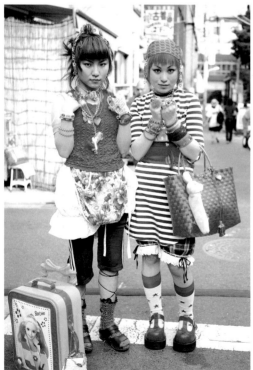

Mix-and-match styles on the streets of Tokyo as captured by photographer Shoichi Aoki in the pages of *FRUiTS*.

*yamanba* of the 1990s. Where Harajuku has Laforet, Shibuya's street fashion stalwart department store is Parco: the two are still going strong, legendary beacons amongst the ever-changing array of independent boutiques and brand stores around them.

Shibuya, Harajuku, and Ginza are the main fashion centers of Tokyo, but as in any major city, there are numerous other districts that nurture their own social scene, often with their own styles: the bohemian vintage vibes of Shimokitazawa and Koenji, the international moneyed high fashions of Roppongi, or the hipster creative hub of Nakameguro. There are other subcultural styles that, rather than being tied to a specific area, come alive at events and online across the country–styles such as the *a* who paint their skin alabaster-white as part of a color-reversed goth look and (while not strictly fashion) the cosplayers for which Japan is famous. And while Tokyo is the epicenter of Japanese fashion, Osaka, in particular, also has its own rich street-style culture: Many street fashion brands and stores, such as Takuya Angel and Dog, started in the more vibrant and cheaper environment of Osaka and then moved to Tokyo.

### The why and how of street style in Japan: history, culture, and space.

The streets of Japan have been a parade ground for youth styles–from the babyish to the macabre, from subcultural to modish fashions–since the early twentieth century, when Western dress first found a foothold in Japan's sartorial landscape.

The safety of public spaces (children walk to school alone from the age of six) means that egregious and even shocking appearances on the street rarely attract open threats or violence but are mostly ignored or, at worst, sneered at. This provides an unusually protected environment in which emergent styles can flourish in public spaces throughout Japan.

While Japan's street styles can appear flamboyant, behind them is the role of the obsessive fan bordering on nerdiness: the otaku. Mastering the intricacies of the looks, which brands are in or out, how to accessorize and coif one's hair to suit one's outfit–all require detailed knowledge. To the untrained eye, there might be little difference between the Lolita and the maid

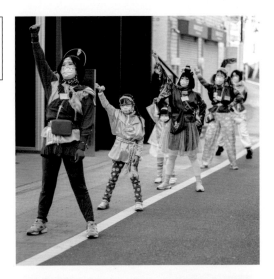

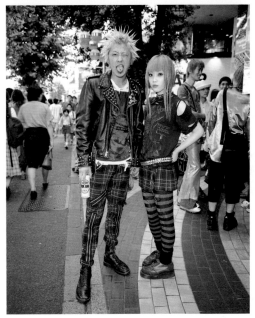

Top: The *kekenoko-zoku* perform on the street. Bottom: 90s grunge, Japanese-style, as captured by *FRUiTS*.

look, but a real Lolita knows her brands and knows to keep demurely covered, whereas maid clothes are typically generic and more revealing. The denim fan can spot a certain selvedge at a distance.

The die-hard fandom of the otaku means that styles rarely disappear completely, even if some have disappeared from the streets. Even the *takenoko-zoku* have now been reincarnated by the *kekenoko-zoku*, who hold scheduled parades, dancing through Harajuku in similarly garish getups. *Yamanba*, the black-faced, white-haired "mountain witches" are passé now amongst their wider gyaru tribe but still exist in hardcore pockets. The 90s Harajuku cyber-Japanese brand du jour Takuya Angel sells online to devotees and can still be spotted in Tokyo's underground clubs.

In some ways, it is quite remarkable that Japan has developed such a rich, diverse, and influential street-style scene, when daily Japanese clothing was still very common, for women especially, well into the 1940s. To foreigners, clothing in Japan might bring to mind the image of uniforms, reflecting the country's supposed penchant for conformity. It's true that Japanese society is famously proscriptive, and the extremes to which Japanese youth can take their fashions is perhaps not a coincidental reaction to the identikit outfits expected of them on many occasions, from strict school uniforms to the plain, almost regulation suits used for job-hunting.

But in a sense, street style was in evidence hundreds of years ago during the Edo period, when kimono flaneurs exposed a risqué print on their lining here or a new way to tie obi there, and enjoyed showing off their getups as their geta clip-clopped along the alleys of the floating world. The subtleties of style and fashion of kimono—the length of a sleeve, the fine tie-dye of the silk on an otherwise standardized garment—also give us clues to a Japanese sensibility that played a part in the postwar explosion of street styles: *kodawari*, or a kind of obsessive attention to detail much like the approach of the otaku.

And while uniforms still have a special emphasis in the public sphere, they also reflect the idea that what is on the surface is important in Japan—a philosophy that perhaps allows one to be freer to play with sartorial identity. Many of Japan's street-style pros can be seen dragging small suitcases containing a change

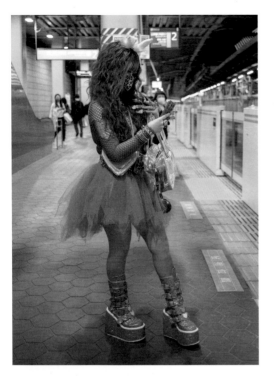

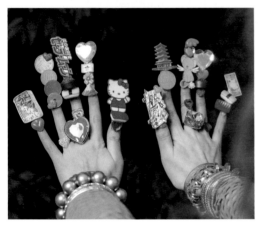

Top: Cyber-gyaru Dede waits for a train at the newly refurbished Harajuku Station. Bottom: Her rings and nails are a fusion of decora and gyaru influences.

of clothes and transforming their identity in public changing rooms or toilets: Ephemerality is accepted and a permanent subcultural fashion identity irrelevant.

As intimated in Roland Barthes' Japan-focused book *Empire of Signs*, the country is the ultimate post-modern society in its frenzied recombination of signs and symbols. Japan's relatively recent history of Western dress also permits a certain recklessness when it comes to combining sartorial elements: The connotations of certain looks and rules pertaining to class and status can be more freely ignored. There is also far less of a prudish, disapproving view of fashion as something that is superficial and frivolous than in the West: for many Japanese, fashion for the sake of fashion is OK.

A constellation of all these elements lead to a particularly creative fashion system–bolstered by a booming postwar economy that saw not just street fashion but also high, avant-garde fashion (famously Yohji Yamamoto, Issey Miyake, and Comme des Garçons) taking the world by storm. Those names in turn lent more legitimacy to the Japanese street-style scene.

## Tokyo street style: present and future.

Street styles are nurtured, displayed, and contested by the act of hanging out in public spaces. When those public spaces become compromised–when organic collections of boutiques on backstreets are replaced by luxe retail complexes and encroached upon by international fast fashion–street styles decline and fade from public view. In their place is a blander social environment of domestic and international tourism, in Tokyo most recently from the burgeoning Chinese middle class. Furthermore, in the time of coronavirus, the sartorial streetscape of Tokyo has descended to a pitiful state. But the attendant disruption of the social and physical environment of Japan may yet prove to be a breeding ground for the next generation of disenfranchised youth to hang out and spearhead a Japanese street fashion renaissance.

Philomena Keet was born in London but has spent the best part of 20 years in Japan. She has lived in Osaka, Kyoto, and Tokyo, and during that time has produced one Social Anthropology PhD, two books on Japanese fashion, and three children. Her PhD looked at the social hierarchies behind the Harajuku street-fashion scene in the mid-2000s.

東京ストリートファッション

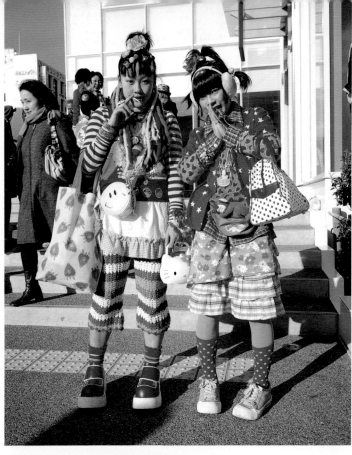

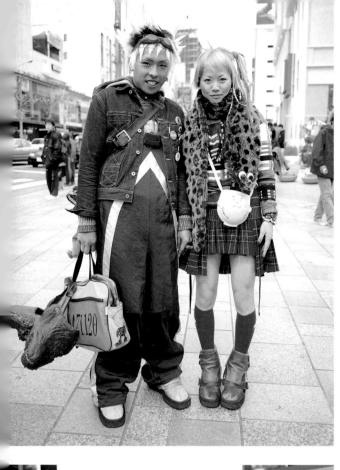
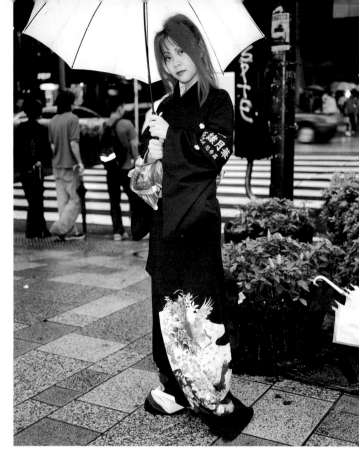

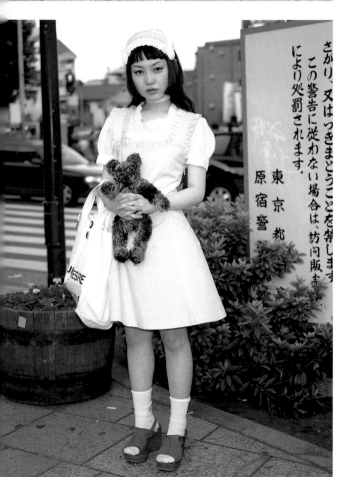

さがり、又はつきまとうことを禁じます
この警告に従わない場合は、訪問販売
により処罰されます。

東京都
原宿警

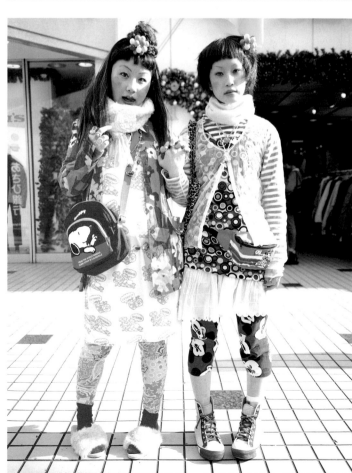

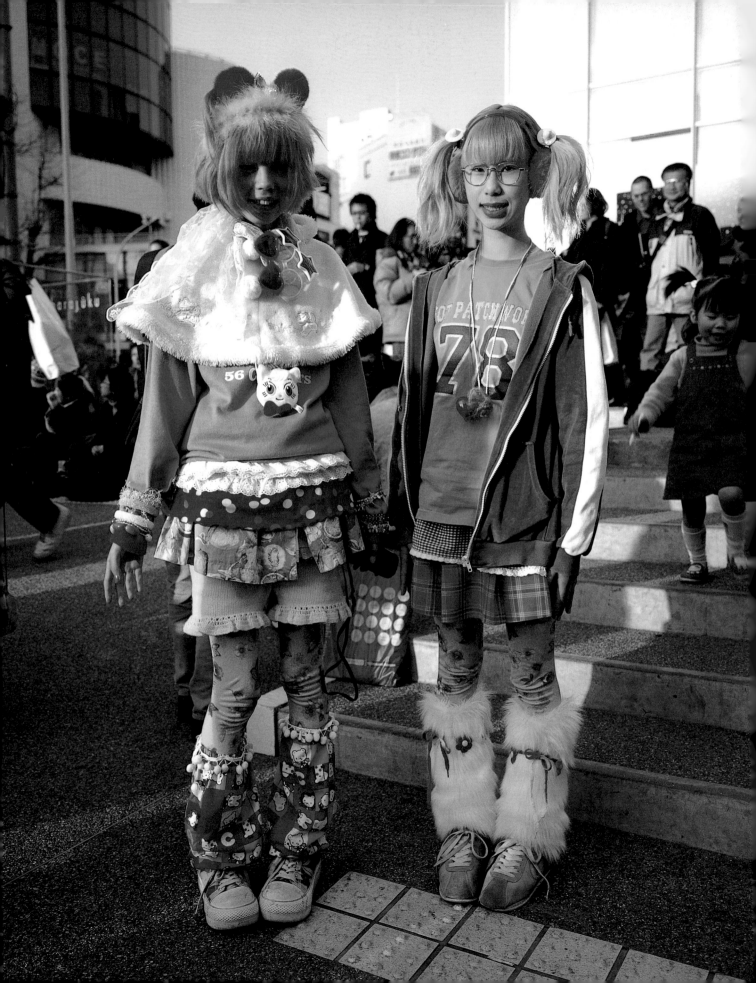

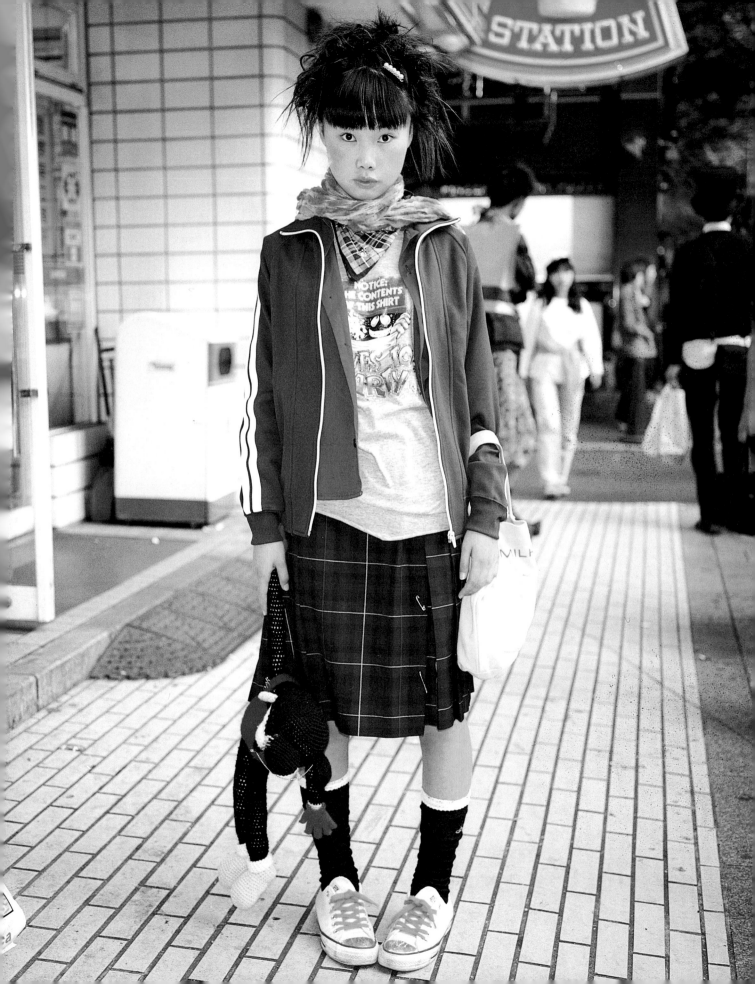

仮
面
女
子

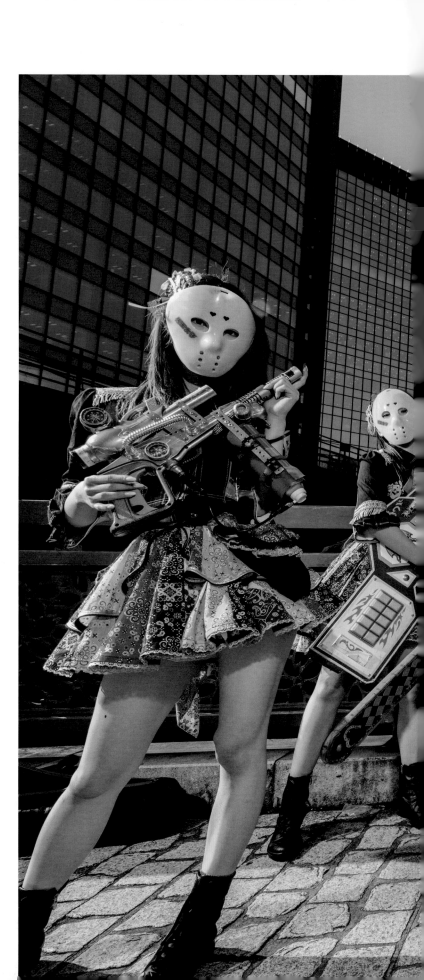

## KAMEN JOSHI

In the crowded world of chika idols,
Kamen Joshi reigns supreme.

The world of J-idols is roughly delineated
into two strata. *Chijou* (above ground)
idols are mainstream groups that receive
coverage from media and fill huge stadiums.
*Chika*, or underground idols, can be loosely
defined as indie idols who play in small- to
medium-sized venues. Their fans, however,
are no less devoted than their mainstream
brethren. *Kamen Joshi* have a knack for
attracting devotees through their ex-
travagant costumes, highly choreographed
routines and, not least, their propensity
for wearing hockey masks throughout their
performances. "The girls are a gathering
of those who did not make it mainstream,"
says Sasanuma Youko, the group's manager.
"Wearing masks gives rise to a stronger
group identity at the cost of abandoning
individuality." Their fanciful costumes
take cues from horror, steampunk, and
medieval fantasy, and the girls often take
to the stage sporting prop weapons such
as chainsaws, rifles, and laser guns.
"We wanted to get away from the notion
that idols have to be neat and pretty,"
says Sasanuma.

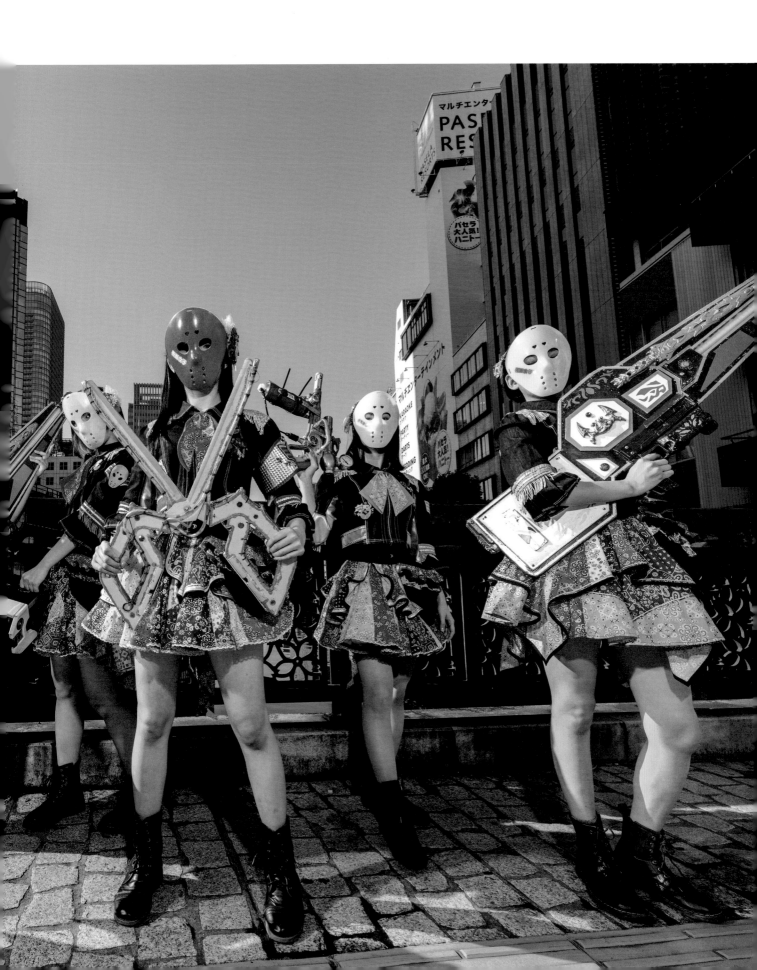

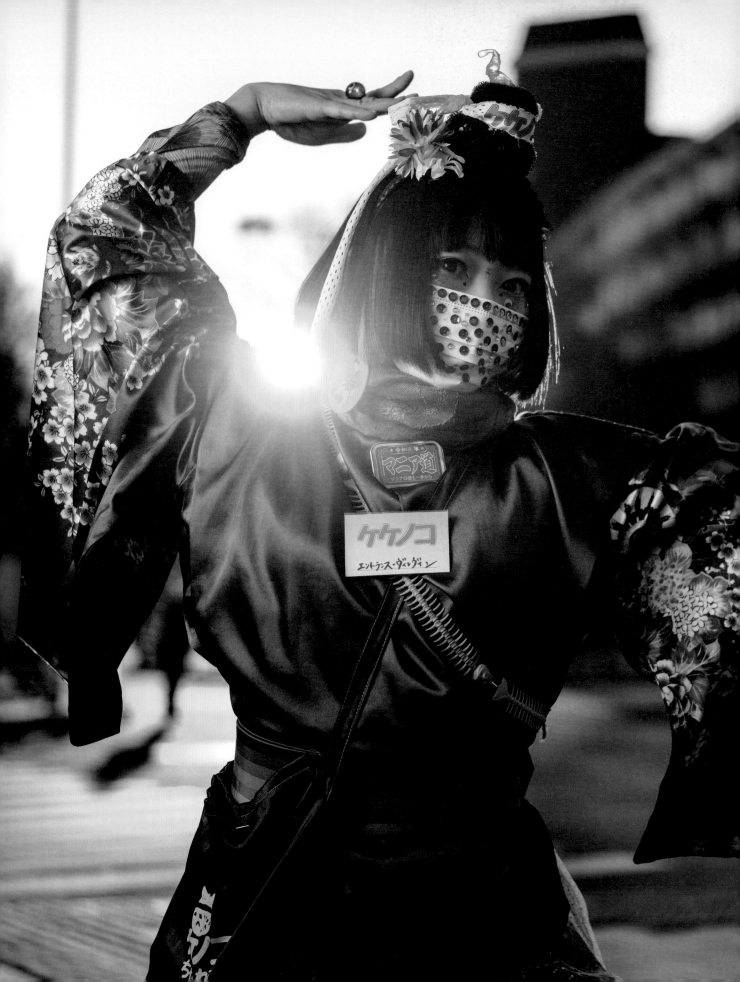

## KEKENOKO-ZOKU

This dance group is a new take
on a Harajuku tradition.

In the middle of Harajuku's Takeshita Street, there
is a shop called Boutique Takenoko. Its status in
fashion-conscious Harajuku is legendary, and it is
known for eye-catching, unique designs, many of which
were incorporated into the flashy street-dancing
groups known as *takenoko-zoku*, which were active in
the 1970s and 80s. Fascinated with these groups, Keke
Hisatsune got a job there soon after moving to Tokyo
in 2003. "I wanted to ask the owner about *takenoko-zoku*,"
she laughs. She also visited former members of the
dance groups, many now in their fifties. "They were
not very welcoming of outsiders, preferring to relive
the glory of their youth within their own cliques,"
she says. So in 2017, Hisatsune decided to make her
own Harajuku dancing crew, *kekenoko-zoku*, who wear
fashion reminiscent of the bright flowing clothes of
the takenoko-zoku. In the absence of Harajuku's former
pedestrian paradise, they now dance on the street
amongst regular shoppers. "I wanted to make a
space for people who wanted to express themselves
through fashion and dance without any fussy rules,"
says Hisatsune.

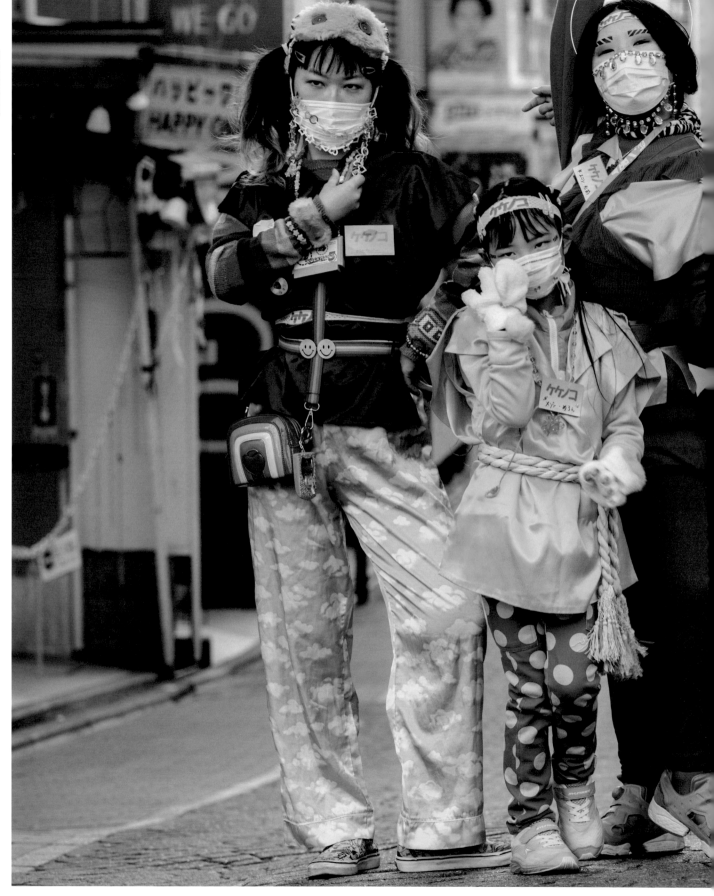

The kekenoko-zoku pose at the entrance of the famed Takeshita Street in Harajuku.

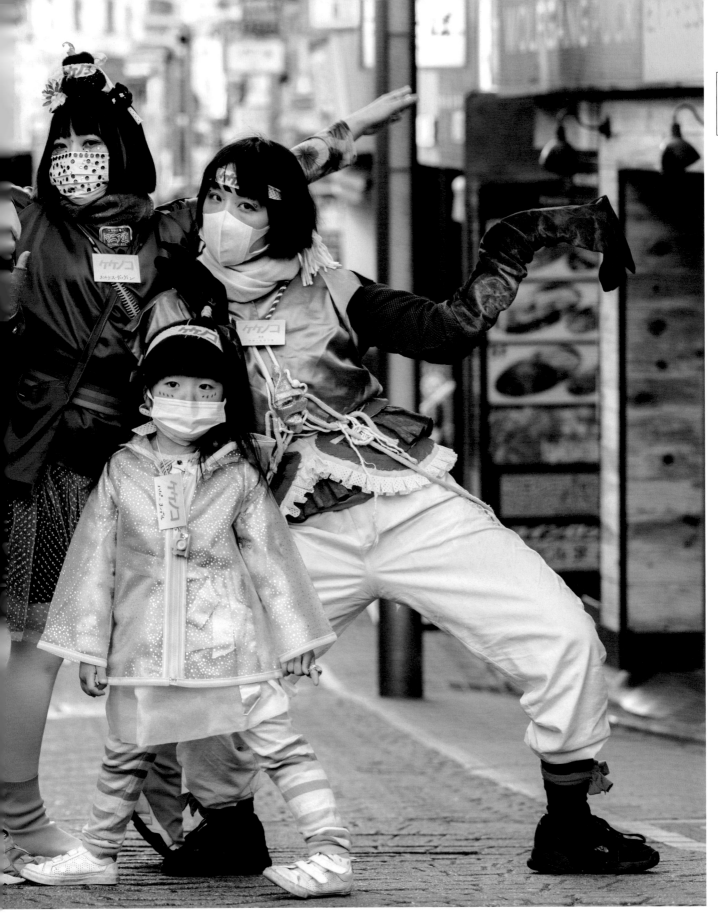

<u>Above:</u> "Technology," written in katakana, is an apt way to describe Galden's approach to fashion. <u>Opposite page:</u> Galden has recently published a how-to book to get more people interested in electrifying their fashion.

## GALDEN

A homemade electronic remix of Tokyo street fashion.

It would take a lot to stand out against the futuristic backdrop of Tokyo, but Galden Kyoko's flashy outfits certainly do just that. Her fashion style gives a nod to gal, dekotora, and yankii influences amongst others, but it is her electronic wearable accessories that propel her firmly into her own category. "I was heavily influenced by cyberpunk and science fiction when I was a teen," says Kyoko. "Then, when I started pole dancing in my 20s, I wanted to wear outfits with lights on them but they were too expensive and broke easily during performances. That's when I started to look into making my own." She began tinkering with toys from 100-yen stores, learning the basics of how LEDs worked and soon moved up to programming interactive accessories with the open-source electronics platform Arduino. Some of the wearable gadgets she has made include a facemask that flashes red when someone gets too close. Kyoko is conscious of keeping her inventions simple in order to inspire any young person with an engineering bent and a little money to try it out for themselves. "It was difficult learning at first, but these days, there are so many resources to learn with," says Kyoko. "There's never been a better time to combine electrical engineering and fashion."

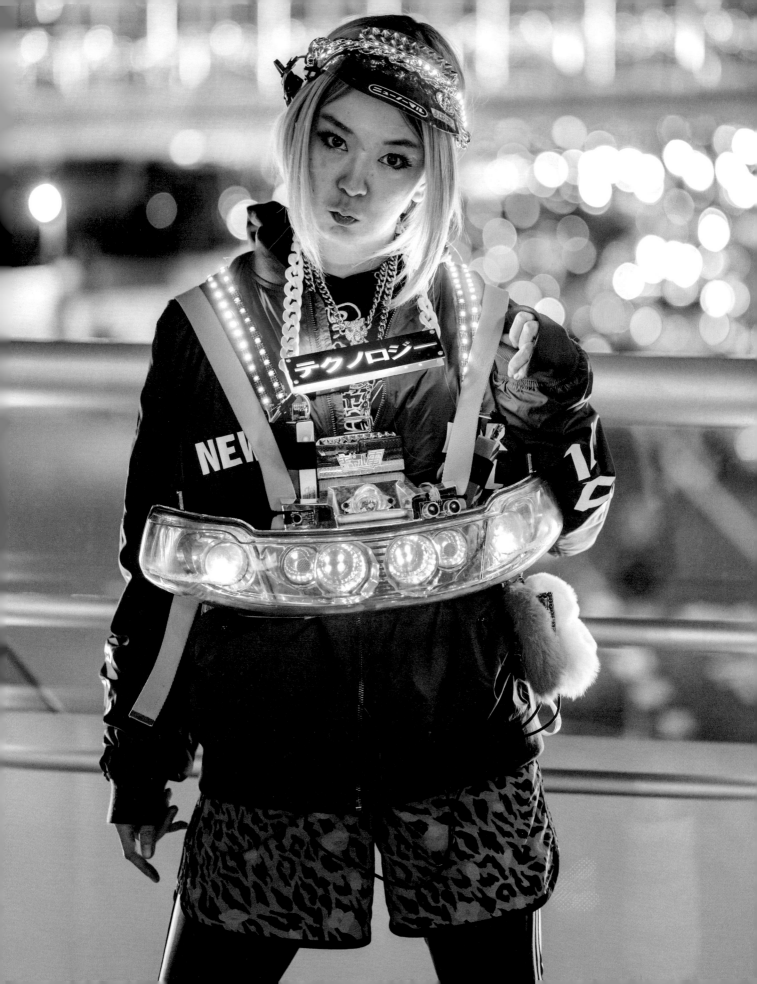

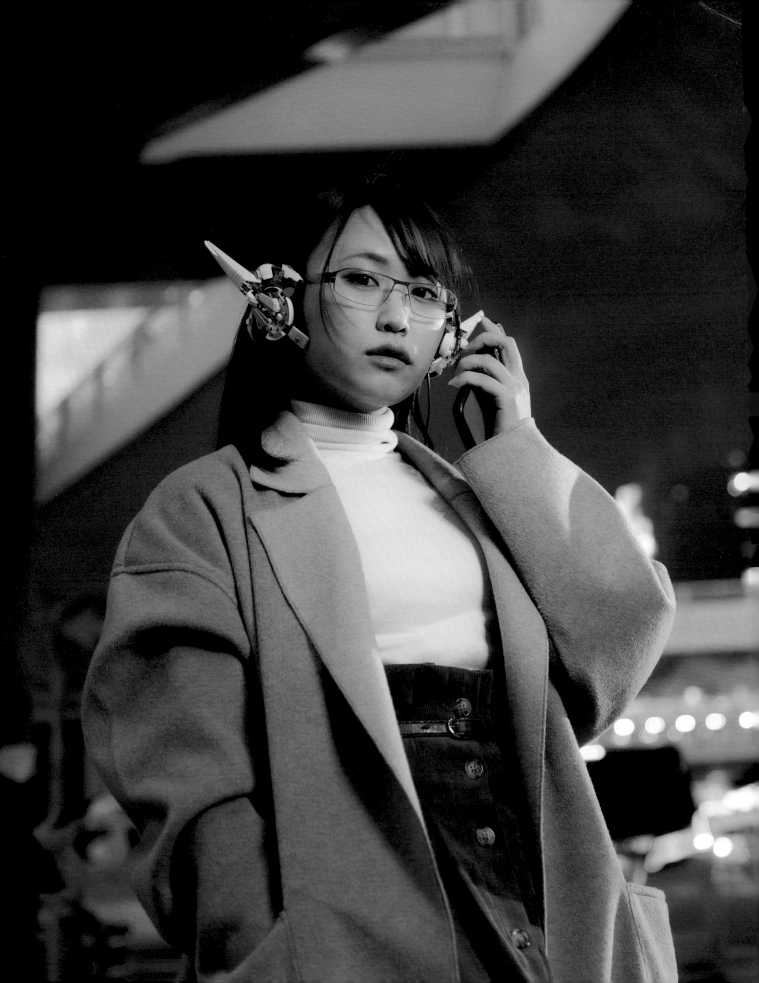

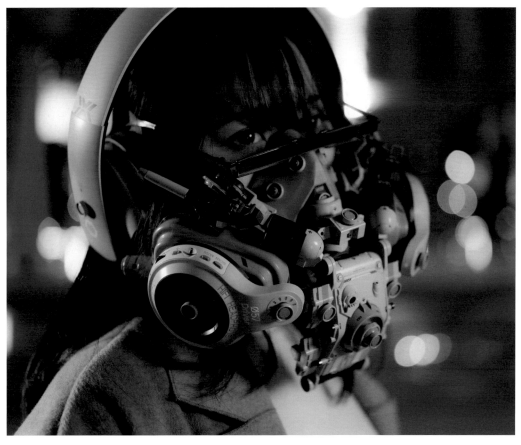

Model Minase Chika wears several variations on
Ikeuchi's work, ranging from chic to hardcore.

## IKEUCHI PRODUCTS

**A plastic modeler using kitbashes to grab
the attention of major fashion brands.**

Ikeuchi Hiroto is reclusive, but his custom, science-fiction-inspired headgear has been picked up and featured worldwide. His creations have appeared on album covers, advertisements, a collaboration with fashion brand Prada, and even inside the pages of *Vogue Italia*. "It was nothing to do with fashion at first," he says. "I was just a regular otaku and I wanted to make a headpiece similar to what anime girls sometimes wore." To do that he repurposed parts from various Gundam and military plastic-model kits, arranging them into his own elaborate pieces. Ikeuchi's design sense captured the imagination of internet users almost immediately, and his following exploded in popularity, spawning several imitators. "I remember getting comments from William Gibson and Hideo Kojima," Ikeuchi says, speaking about the famous cyberpunk author and video-game auteur respectively. Ikeuchi's creations are an example of something that started in the otaku world and ended up somewhere else entirely—in this case, the high fashion world.

Ikeuchi's creations don't look out of place against the evening backdrop of Shibuya.

池内啓人

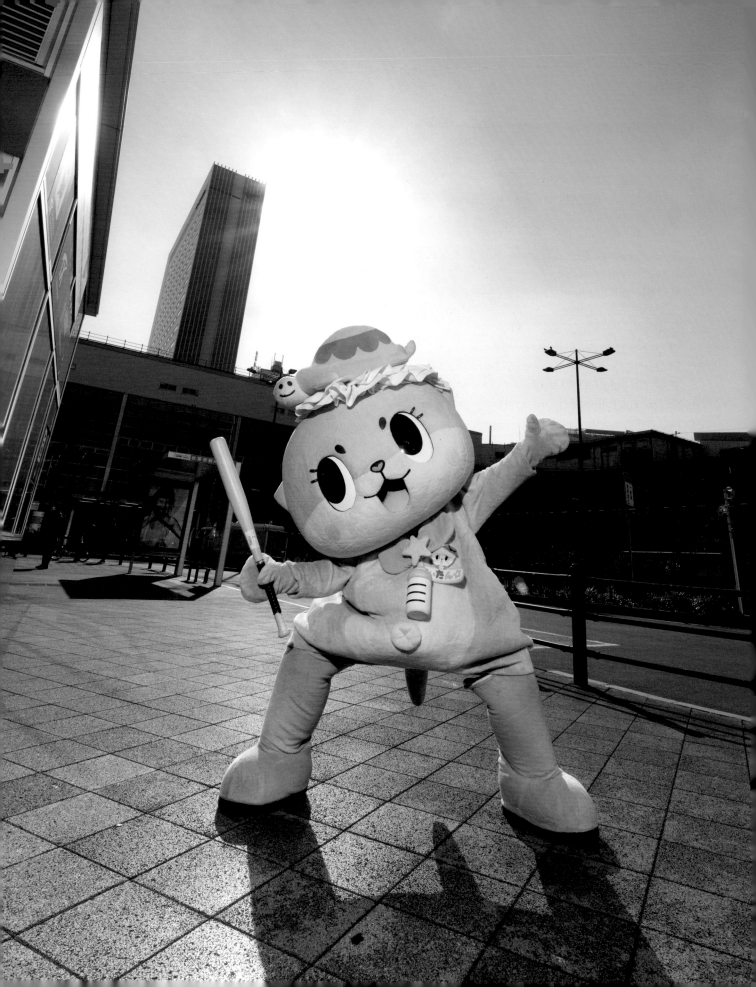

# INDEX

*All photography is by Irwin Wong, unless otherwise stated below:*

# THE OBSESSED

### Otaku, Tribes, and Subcultures of Japan

This book was conceived, edited, and designed by gestalten.

Edited by Robert Klanten and Lincoln Dexter
Contributing editor: Irwin Wong

Text and preface by Irwin Wong
Essays by Patrick W. Galbraith (6-11), Joshua Paul Dale (30-35),
Dino Dalle Carbonare (140-145), Sharon Kinsella (190-195), and
Philomena Keet (214-221)
Copy editing by Hannah Lack

Editorial Management by Lars Pietzschmann

Head of Design: Niklas Juli
Design by Ilona Samcewicz-Parham and Isabelle Emmerich
Layout and cover design by Isabelle Emmerich

Photography by Irwin Wong
Photo Editor: Madeline Dudley-Yates

Typefaces: Panama by Roman Gornitsky, Hermes by Gilles Gavillet
and David Rust, and TBUDRGothic by Morisawa

Printed by Printer Trento s.r.l., Trento, Italy
Made in Europe

Published by gestalten, Berlin 2022
ISBN 978-3-96704-008-1

For more information, and to order books, please visit www.gestalten.com

Bibliographic information published by the Deutsche Nationalbibliothek.
The Deutsche Nationalbibliothek lists this publication in the Deutsche
Nationalbibliografie; detailed bibliographic data is available online at www.dnb.de

This book was printed on paper certified according to the standards of the FSC®.

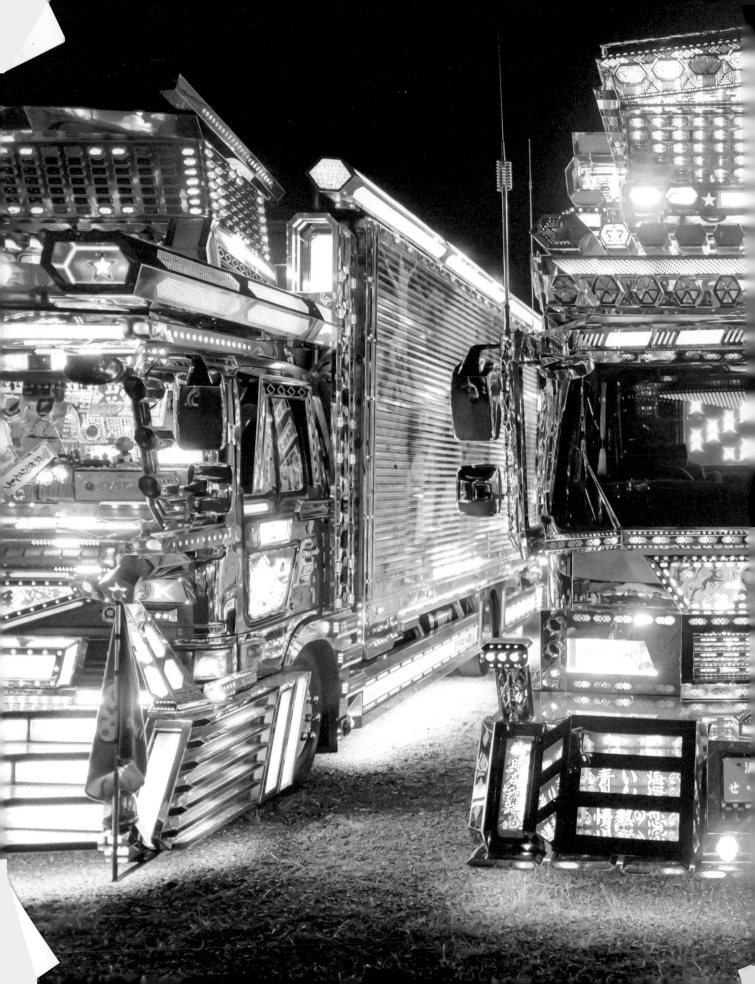